exposures

EXPOSURES is a series of books on photography designed to explore the rich history of the medium from thematic perspectives. Each title presents a striking collection of images and an engaging, accessible text that offers intriguing insights into a specific theme or subject.

Series editors: Mark Haworth-Booth and Peter Hamilton

Also published

Photography and Spirit John Harvey

Photography and Australia Helen Ennis

Photography and Cinema David Campany

Photography and Science Kelley Wilder

Photography and Flight Denis Cosgrove and William L. Fox

Photography and Egypt Maria Golia

Photography and Literature François Brunet

Photography and Africa Erin Haney

Photography and the USA Mick Gidley

Photography and Italy

Maria Antonella Pelizzari

CANCELLED

reaktion books

For Leonardo and Robert

Published by Reaktion Books Ltd
33 Great Sutton Street
London EC1V ODX
www.reaktionbooks.co.uk

First published 2011

Printed and bound in China

British Library Cataloguing in Publication Data
Pelizzari , Maria Antonella
 Photography and Italy. – (Exposures)
 1. Photography – Italy – History
 2. Historiography and photography – Italy
 3. Photography – Social aspects – Italy – History
 4. Photography – Political aspects – Italy – History
 I. Title II. Series
 770.9'45-DC22

ISBN: 978 1 86189 769 5

Contents

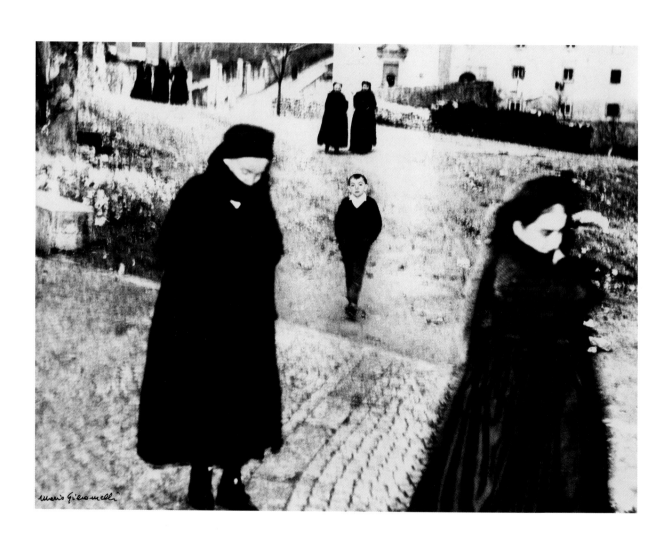

Introduction

This book fills a cultural gap. Even today the history of photography in Italy is not well known beyond its borders, thanks to a lack of translations and to an art market that has remained peripheral to other European and Asian regions. The concept of 'periphery' may seem strange for a country which is usually perceived as the cradle of Western art, yet from a North American or British perspective Italian photography is limited to just a handful of photographers: the Fratelli Alinari and Macpherson, Bragaglia, the *paparazzi*, Giacomelli and a few contemporaries – Vitali, Barbieri, Basilico, Jodice, Wolf, Niedermayr, Lambri – thriving in the art market. The aim of this book is to provide names and pictures that are equally worthy of study and speculation.[1]

Paradoxically, what makes this history 'Italian' is its polycentric, even somewhat foreign, character. The geographical configuration of Italy, and its history of fragmentation into many sub-states from late antiquity on, have affected its artistic tradition. The emphasis on regionalism, put forward by Ginzburg and Castelnuovo in their study of art history in Italy, is equally valid for photography.[2] In the nineteenth century many towns and cities were imagined and defined, initially, by foreigners – hence the inclusion of British, French and German photographers in the first part of this book. Italy was not a unified country until 1860; photography was a vehicle of modernity and political unification but it also worked in the service of national memory, preservation, antiquity, melancholy and nostalgia. These distant, 'foreign' interpretations wound down towards the end of the nineteenth century, as Italy became increasingly more aware of the role of photography in defining modern

1 Mario Giacomelli, *Scanno*, 1957–9, gelatin silver print.

7

life, modern art and the modern economy. Thus, in the early twentieth century, while Bauhaus artists flew to Italy for work, Milanese studios and graphic designers were already operating beside Italian industries; though Walker Evans and American literature became critically important for Elio Vittorini's anti-Fascist project, other Italian photographers were able to guide this pursuit; while Paul Strand worked with Cesare Zavattini on *Un Paese* (1955), local photographers were also seeking to achieve visual narratives. Even during postwar reconstruction, the country continued to produce fragmented regional activities, photo clubs and manifestos. Polycentrism reigned – north, south, east and west.

Luigi Ghirri's *Viaggio in Italia* (1984) – a book and exhibition of twenty photographers redefining the image of the Italian landscape – was a clever statement about the need to go beyond the traditional and stereotypal Grand Tour images. The book suggested a new type of photographic dictionary for the country, looking at the local and everyday landscape. Ghirri's project became one of the rare moments in which photographers worked together towards a common goal, sharing a similar experience of place. This lesson has continued to influence more recent works, where the diversity of Italian regions has been further complicated by new immigration, overt racism and the incapacity of the current government to acknowledge multiculturalism. Today photographers look for clues in an increasingly complex world. They also draw on digital technology and installation art to reframe their personal memories and perceptions.

The historiography that has shaped and interpreted this narrative has been equally complex. It began during the postwar years, with photographers (Zannier, Gilardi, and later Cesare Colombo) and writers (Turroni, Racanicchi, Schwarz) involved in the interpretation of their contemporaries, and with a smaller group of connoisseurs (Silvio Negro and Piero Becchetti, focused on Rome) and art critics (Lamberto Vitali) looking at the nineteenth century. In the late 1960s historians and art historians (Quintavalle, Bertelli, Bollati) gave fresh critical interpretations and were followed soon after by Miraglia, and by more recent generations of writers and curators (Bonetti, Maffioli, Paoli, Morello, Cavanna, Prandi, Tomassini, Costantini, Valtorta, Calvenzi, Ginex, Maggia, Guadagnini,

Serena). A cursory look at the Select Bibliography in this book shows that the production of books on photography is very active in contemporary Italy, but they are not widely distributed outside the country. It remains a history written only for the locals, despite its solid premises and significant contributions.

Photography and Italy takes into consideration the incredibly rich polyphony orchestrated by Italian scholars, while it tries to pursue its own voice and path. The selection of illustrations directs this search for a non-linear narrative, unusual and, at times, beautiful for its contradictions. I have sought ways to dispel the idea that photography in Italy was the result of a mainstream tourist industry, and instead to prove that this medium thrived within the country's immensely rich visual culture. Commitment to this history does not lie in the redemption of its masters nor in the need to discover new ones, but in the idiosyncratic, unusual, ironic and passionate ways in which photographers engaged with the culture and revealed its nuances. Only in this way, I feel, can this history fill the existing information gap, and uncover a surprising and new view of the old country.

Modern Pictures of an Ancient World

An impression of stillness and timelessness filters through early photographs of Italy. What dominates is the monument, the city as ruin, the cracks in the stones and the awe for a present that lives, paradoxically, in the past. These striking records respond to the travellers' romantic view of the scenic and the antique and to the locals' pride in the vestiges of an ancient civilization. Posing in photographic studios across the country, a population of military officers, noblemen, artists and freedom fighters reflect this society's transition from severe aristocratic rule to liberal middle class. In their fragile beauty and nostalgia, in their complex social texture, these images provoke fundamental questions: is Italy a modern place, and what is the role of photographs within this modernity?

In 1839, when the news of Daguerre's and Talbot's discoveries was publicly announced, Italy was not a country but a mosaic of competing foreign states. The Grand-Dukes from the House of Habsburg-Lorraine ruled over Lombardy, the Veneto and Tuscany; the Spanish Bourbons governed Naples and Sicily; the Pope oversaw Umbria and the Marches; the House of Savoy governed the Kingdom of Sardinia-Piedmont. The news of Daguerre's invention arrived right away. On 15 January 1839 the *Gazzetta Privilegiata di Milano* (the official press of the Austro-Hungarian government) translated almost verbatim a short article from *Le Moniteur Parisien* from 9 January; opticians and scientists demonstrated Daguerre's process at royal academies and museums – in Florence on 2 September, and soon after in Pisa, Turin, Milan, Rome and Naples. A French version of Daguerre's manual was published in Genoa that year, and Italian translations came out in Bologna and Rome in 1840.[1]

Itinerant daguerreotypists, mainly from France (among them, Alphonse Bernoud, Alphonse Thaust Dodero, Philibert Perraud), worked side by side with a growing number of Italians. These were generally opticians (Alessandro Duroni in Milan; Carlo Jest in Turin; Lorenzo Suscipj in Rome), engineers (Giacomo Luswergh in Rome) and painters (Antonio Sorgato in Padua). As the most recent study on this subject has confirmed,[2] there are no large and cohesive groups of portraits identified with any of these studios. Some of them are notable for their social significance and impeccable craft, like those by Lorenzo Suscipj, fabricator of his own cameras, who summed up the personality of the Italian patriot

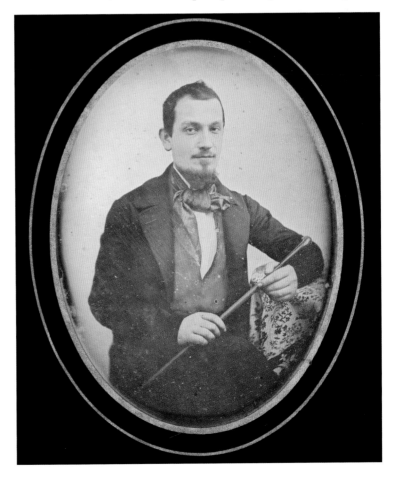

2 Lorenzo Suscipj, *Eugenio Brizi*, c. 1842, daguerreotype.

3 Antonio Sorgato, *The Artist's Self-portrait with Models*, c. 1847, daguerreotypes.

and conspirator Eugenio Brizi, a follower of Giuseppe Mazzini in the pursuit of independence (illus. 2). The portrait is finely hand-painted, conveying an elegant grandeur that speaks of this man's courage before he was captured and imprisoned.

A different kind of message is conveyed by an unusual sequence of daguerreotypes created by Antonio Sorgato (illus. 3), where a casual self-portrait with a colleague friend (top left) is framed together with models from a lower class, suggesting this painter's studies for future canvases. Sorgato put together 21 images in four frames of this kind, including his own image in each group. The representation of workers in their daily clothes, common in the so-called 'occupational' daguerreotype produced in the United States, was rare in Italy. This uncommon vernacular composition brings up new questions about a social class whose identity was slowly gaining status as an image.

If common knowledge has it that the daguerreotype became more successful for portraiture, in the case of Italy the most remarkable application became architecture. For this genre, exceptionally large bodies of work have been traced that reveal the dynamic exchange between local and foreign photographers. Rome, in particular, attracted professionals who had first-hand practice of the process. One of them was Pierre-Ambroise Richebourg, student of the optician Victor Chevalier, the father of Charles Chevalier, who was Daguerre's supplier. His image of the Arch of Janus (illus. 4) is part of a small group he made in Rome around 1844 – a contemplative view of antiquities aimed at the tourist market.[3] This record belongs to a tradition of pictorial voyages and Piranesian fantasies

4 Pierre-Ambroise Richebourg, *The Arch of Janus, Rome*, c. 1844, daguerreotype.

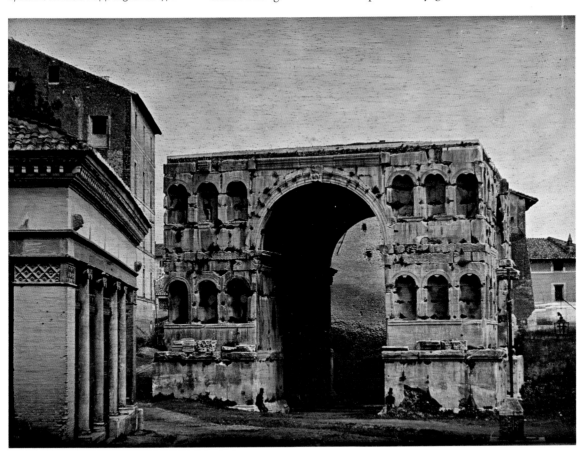

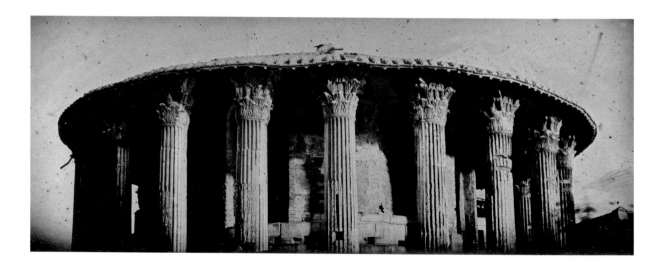

that had imagined the fourth-century arch as an abandoned ruin, disfigured by time. Richebourg's precise architectural study framed the Roman monument along the portico of the Church of San Giorgio in Velabro, inserting within this massive structure the still figures of two men in bourgeois attire – miniscule living presences posed by a shadow of the past. On the right, a gas lamp reveals the presence of modern street life within this calm and eternal tableau. In its sharp beauty this scene was laterally reversed, as Richebourg did not apply a corrective mirror to his camera at this early stage.

At this time France had reached a mature understanding of the value of historic preservation for the creation of a national patrimony. This had contributed to the collecting of architectural and sculptural works in the first public repositories (such as Lenoir's at the Abbey of Saint-Denis) and to the compilation of *Voyages pittoresques*.[4] The daguerreotype became an important tool, shaping a new visual literacy in which accurate illustration of monuments multiplied into a fresh source for historians. This is the case in the astounding number of daguerreotypes (almost a thousand) made by a French draughtsman and antiquarian Joseph-Philibert Girault de Prangey in his tour of Italy, Greece, Egypt and the Middle East between 1842 and 1845. As a founding member of the Société Historique et Archéologique of Langres (1836) he had helped organize a small museum in the Gothic chapel of Saint Didier, while focusing his scholarship on Islamic architecture and vernacular traditions.

5 Joseph-Philibert Girault de Prangey, *The Temple of Vesta, Rome*, 1842, daguerreotype.

Trained in the daguerreotype in France, possibly by Hippolyte Bayard,[5] he used a custom-made camera and an exceptionally large whole plate (19 x 24 cm), which he subdivided into smaller sizes, depending on his pictorial needs. He was in Rome for three months in the Spring of 1842, where he produced unorthodox panoramic images of architecture, both in vertical and horizontal format. Most probably, his view of the Temple of Vesta (illus. 5) was obtained by dividing in half the large daguerreotype plate, and making two slightly different exposures (the other image, conserved at the J. Paul Getty Museum, reveals a solarized blue sky). This striking detail highlights the shape and ornament of the architecture, separating it from the surrounding context (significantly, this circular temple is very close to the Arch of Janus) and focusing on the conical roof, ribbed columns and Corinthian capitals. This daguerreotype was not made for tourists but for scholars of antiquities like Girault de Prangey, who undertook comparative analysis of architectural details and decorative patterns.

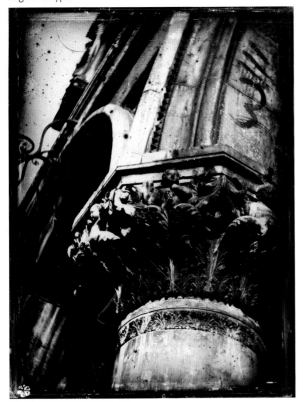

6 John Hobbs (attr.), *The Cherub Capital, Ducal Palace, Venice, c.* 1845–52, daguerreotype.

Similar considerations apply to the large collection of daguerreotypes (more than 200) assembled by John Ruskin in Italy, beginning in 1845, when he encountered an anonymous French daguerreotypist in Venice, and later, when he provided his valet John Hobbs and, subsequently, Frederick Crawley, with daguerreotype equipment.[6] Taken by different people whose identities are still not clear (some of these could also be Italian), these daguerreotypes worked for Ruskin as accurate records of architectural details that he could not delineate quite as well with his pencil (illus. 6). The recurring frustrations of this draughtsman attest his compelling need to fully grasp and reproduce Gothic buildings (in Venice, Verona, Florence, Lucca, Pisa and Siena) that seemed threatened by modern restoration and vandalism.

One can deduce from Ruskin's writings that his involvement with photography was aesthetic but also political. As Italy became an important testing ground for his architectural theories, the daguerreotype was praised as 'the most marvellous invention of the century . . . just in time to save some evidence from the great public of wreckers'.[7] The daguerreotype records of the exquisite details of marble inlay, structural polychromes and window-tracery – found on Venetian palaces (illus. 7), the walls of

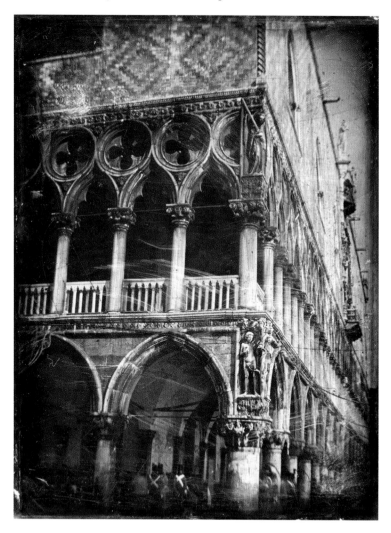

7 John Hobbs (attr.), *Ducal Palace, The Adam Angle, Venice*, c. 1845–52, daguerreotype. A rare image since it includes Austrian soldiers standing at the southwest corner of the Ducal Palace and not behind the iron fence, installed later.

Orsanmichele, the Tower of Giotto in Florence and the elaborate facades of Siena and Lucca Cathedrals – functioned like memory aids of monuments that had to be saved from the passing of time.

Chock-full of architectural beauty, Italy became a contested site for foreign politics of preservation. Meanwhile, a publisher and print dealer in Milan, Ferdinando Artaria, launched a project directed at another kind of goal: that of compiling a collection of Italian views that reflected a renewed national spirit. Titled *Vues d'Italie d'après le Daguerréotype* (1842–7), the project was close in nature to Lerebours' *Excursions Daguerriennes* (1841–3), translating the daguerreotype into a reproducible print (none of the original plates have been retraced). Nonetheless, the spirit of these publications varied significantly. Artaria focused exclusively on Italian cities (Milan, Brescia, Como, Genoa, Florence, Rome, Pisa, Naples, Padua and Venice) while Lerebours incorporated Italy (24 sites) within a more global geography of 111 views.[8]

Most important, Artaria's views went beyond the codified Grand Tour tradition and revealed a whole new sensibility for civic monuments

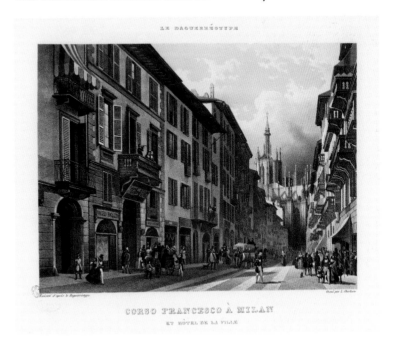

8 Louis Cherbouin, 'Corso Francesco à Milan et Hotel de la Ville', *Vues d'Italie d'après le Daguerréotype*, Ferd. Artaria et Fils Editeur, c. 1845, aquatint.

(triumphal arches), arenas of middle-class leisure (cafés, theatres) and new public works (hospitals, cemeteries). [9] Milan, in particular, showcased 22 sites, half of which were of recent construction. Significantly, many of these subjects were selected or proposed by the general public – readers of local newspapers and consumers of contemporary advertising. A sign of these editorial strategies is also demonstrated by Artaria's collaboration with local entrepreneurs interested in promoting their activities through civic images. As a matter of fact, the view of Corso Francesco (illus. 8) aimed to publicize the Hotel de la Ville. Its insignia was included, albeit discreetly, below the elegant balcony on the left, as well as in the title of this view of Milan, with its Cathedral and the middle-class strollers on the main street.

Aware of Lerebours' and Artaria's publications, a British scholar of wealth and leisure, Alexander John Ellis, conceived a similar anthology of 60 engravings from a larger number of daguerreotypes, which he would title *Italy Daguerreotyped* (this project never materialized, leaving the original 159 daguerreotypes intact). Ellis's collection responded to a renewed fashion for Victorian travels to the Continent, following the intermission of the Napoleonic Wars. A traveller and daguerreotypist himself (from May to June 1841, he covered Pozzuoli, Naples, Pompeii, Rome, Assisi, Pisa, Florence and Venice), Ellis explained that his engravings were to supplement the picturesque descriptions of William Brockedon's *Road Book from London to Naples* (1835). His emphasis was on accuracy and 'verisimilitude', [10] as confirmed by his careful annotations with title, date and exposure time on the reverse side of the plates (the exposures lasted 5–35 minutes).

This was the first time in history that a photographer took on the role of editor and publisher, planning to add to his own work three views of Milan published by Artaria, and including daguerreotypes of Rome by Achille Morelli and Lorenzo Suscipj. He also commissioned multi-panelled panoramas of this city, exceptional at this time. It is obvious that Ellis was not working in a vacuum. As a Victorian scholar versed in mathematics and phonetics he was a friend and colleague of Italian scientists, equally involved in early photographic processes. A clue to his

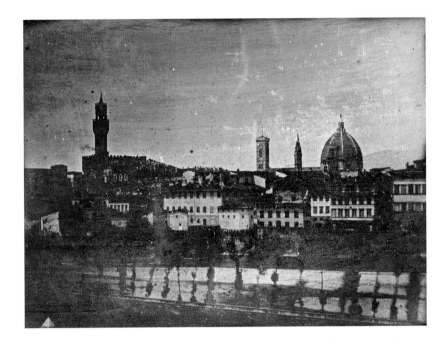

9 Alexander John Ellis, '*Florence. View from Casa Demidoff, at present the residence of Prof. Amici. In front is the Arno, half dried up (. . .) – 12:38-12:44 pm, 29 June 1841*' (handwritten by Ellis on the verso), daguerreotype.

influential network is a view of Florence that he took from Villa Demidoff (illus. 9). Chosen as a strategic location for his camera, this villa was culturally significant: originally the residence of the Russian Prince Anatole Demidoff, it was occupied at the time of Ellis's photograph by the scientist Giovanni Battista Amici, Director of the Astronomical Observatory of the Royal Museum of Physics and Natural History in Florence, and himself an early photographer.[11]

Amici was, in fact, a scientific contact for Talbot at the moment of the announcement of his discovery. News of the British process reached the local press immediately, but more sporadically than the news of Daguerre's process, and an early Italian translation of Talbot's *Some Account of the Photogenic Drawing*[12] did not have much impact on the use of this process, which remained difficult and unreliable when judged in comparison to the precision of the daguerreotype . It was a different kind of community (a non-commercial one) Talbot appealed to, as he sent early photographic samples to Antonio Bertoloni, Professor of Botany at the University of Bologna, and Michele Tenore, Director of the Botanic Gardens in Naples.

In 1844 he gave the first instalment of *The Pencil of Nature* to Amici, who discussed the calotype improvements at the sixth congress of Italian scientists in Milan during that year.[13]

It is somewhat paradoxical that Talbot's impulse towards the invention of photography was generated in Italy, during his honeymoon on Lake Como in 1833, but that he did not record Como's scenery with the new process. It was not until 1845 that the calotype really flourished in Italy, practised by foreigners and Italians alike. As Talbot knew, his invention was ideal for those 'wanderers in classic Italy'[14] who, like him, aimed to record the texture of the stones and the beauty of the scenery: the paper

10 Revd Richard Calvert Jones, *Interior of the Colosseum*, 1845, salted paper print.

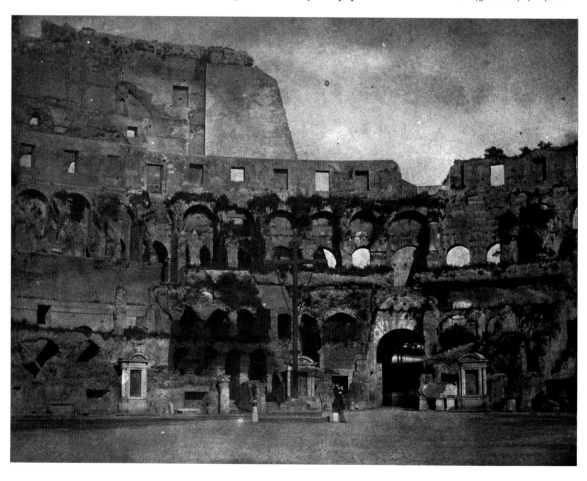

negative was light, could be prepared (that is, iodized and sensitized) in advance, and could even be mailed by post. Most important, it generated multiple copies, and those pictures could be sequenced in the pages of an album, like a personal travelogue. These were very different conditions from the daguerreotype, and it is no wonder that the calotypes of Italy achieved great results.

Two early records by members of Talbot's circle (Talbot's cousin, 'Kit' – Christopher Rice Mansell – and his close friend, the Revd Richard Calvert Jones) reveal the charm of these raw and seemingly spontaneous excursions. Departing for Malta on Kit's yacht *Galatea* in the late fall of 1845, both amateur photographers had their negatives printed at Talbot's Reading Establishment (this was also the case with the Revd George Wilson Bridges, whom they met in Malta). Between 1845 and 1846 Calvert Jones made more than one hundred negatives in Malta, Sicily, Pompeii, Naples, Rome and Florence, exchanging images and letters back and forth with Talbot, and even proposing a commercial output for these views.[15] His pictures reflect both the romantic conventions that appealed

to Victorian travellers and his personal impressions of a family tour. In a Colosseum interior (illus. 10) the monument and the sky are impregnated with a special light that enhances the antiquity of the stones, while the little figure with top hat posing in the middle is a suggestion of Calvert Jones's travelling companion.

It is a study of light and composition that renders Kit's sculptural record (illus. 11) expressive of a physical tension and struggle – almost like a mythological figure in Ovid's *Metamorphoses*, seeking freedom from darkness. It is tempting to view Kit's expressionistic response to this environment as personal and symbolic if one considers that he had recently lost his wife, who died in Malta.[16] The blur of the trees, the low vantage point and the drama of a statue that fights its own immobility are all striking visual elements for such an early travel record. This typology of the Victorian wanderer, using the calotype for leisure and discovery, persisted till after 1855.

The French calotype in Italy – and in Rome in particular – involved a different type of bohemian society, which converged and settled around the French Academy, located at the Villa Medici on the Pincio Hill. An article of this period mentions the existence of 'a photographic clique'[17] gathering by Piazza di Spagna and the Caffè Greco, in a zone surrounded by artists' studios, booksellers and printsellers. This early photo club (composed of aristocrats and artists – Count Frédéric Flachéron, Prince Giron des Anglonnes, Eugène Constant and Giacomo Caneva) shared successes and failures in their photographic excursions in Rome and surrounding Campagna.

Flachéron exemplified this group's lifestyle, creative ambitions and technical achievements. The son of a well-known architect in Lyon, he was an artist and moved to Rome in 1839. There he married Caroline Hayard, the daughter of an art supplier located nearby. Such a relationship helped him to build an even stronger liaison with contemporary role models of French art, such as Dominique Ingres, Director of the French Academy until 1840, the architect Charles Garnier, *Prix de Rome* at the French Academy between 1849 and 1853 and the painter Jean-Hippolyte Flandrin. Immersed in such a fertile milieu, and aware of the commercial

12 Frédéric Flachéron, *The Temple of Castor in the Roman Forum*, 1851, calotype negative.

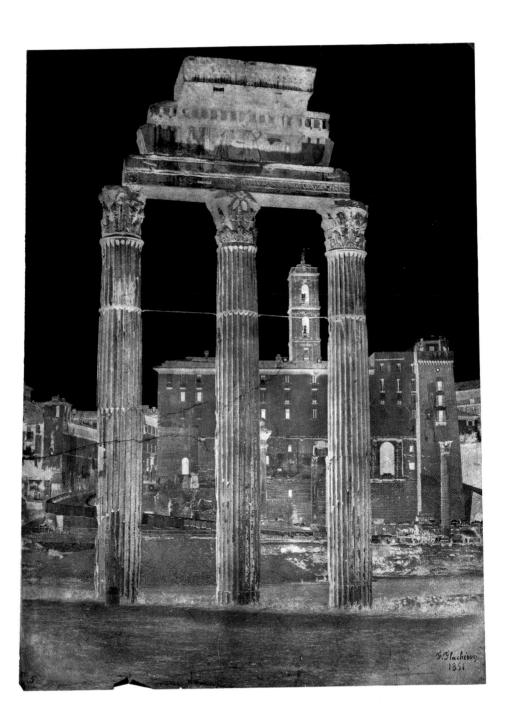

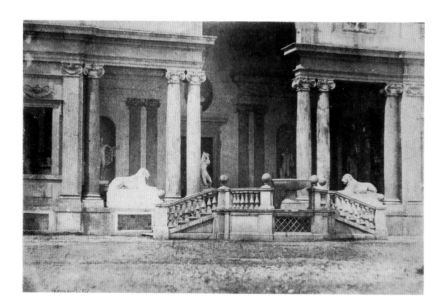

distribution of views of Rome, Flachéron worked as a photographer between 1848 and 1852 (dates which he carefully marked on his negatives). He further improved the French modification of Talbot's process – the wet paper negative of Blanquart-Evrard .[18] His knowledge and familiarity with the monuments of Rome, combined with an artistic sensibility towards light and composition, contributed to some of the great achievements of early architectural photography. His personal connection in Rome in 1851 with the British photographer and publisher Thomas Sutton was a possible conduit to his inclusion in the Great Exhibition held in London that year, where he presented seven views of Rome, as Flachéron-Hayard.

The *Prix de Rome* architect Alfred-Nicolas Normand, *pensionnaire* at Villa Medici between 1847 and 1852, can be considered the first architect-photographer in history. Friend and colleague of Charles Garnier, he encountered Maxime Du Camp and Gustave Flaubert when they stopped in Rome in 1851 on their way back to France from Egypt. The calotype process became a visual aid that complemented his relief drawings in the survey of the Roman Forum and plans for subsequent restoration. Beside his professional dedication to photography and archaeology, Normand used the camera in his daily note-taking amidst the sculptures

and fragments of the Villa Medici's gardens (illus. 13), as well as in his excursions to southern Italy and Greece.

In recent years an exceptionally homogeneous group of calotypes of Rome, Pompeii and the Amalfi coast has surfaced in several French and North American collections. The group is extraordinary for the quality of each image – comprising natural landscapes, the ruins of Rome and Pompeii and vernacular dwellings along the Amalfi coast –

14 Firmin Eugène Le Dien and Gustave Le Gray (attr.), *The Trinità dei Monti from Via Sebastianello, Rome, c.* 1852, coated salted paper print from a waxed paper negative.

and for the photographer's numbering of each view, almost as if he intended to compile a catalogue. Printed from waxed-paper negatives (the process launched by Gustave Le Gray in 1851), they present a whole range of tones, from brown to purple, conveying the impression of looking at these sites of antiquity for the first time – all incredibly peaceful and void of people. The results of intricate research, in which this author was involved, have led to an attribution to Firmin Eugène Le Dien, who travelled in Italy in 1852–3, together with the painter Alexandre de Vonne and the photographer Leon Gérard.

A view taken at the foot of the Pincian Hill documents, with an unusual angle, the backyard of the apartment leased by these artists in Via di San Sebastianello, just below the Villa Medici (illus. 14). This 'view from my room' type of impression attests the spontaneity and joy of travelling with a camera and a new frame of an otherwise familiar landscape of Rome's monuments. It is likely that Le Gray printed a few of these negatives in Paris, possibly becoming the distributor. The blind stamp found on some of these views, indicating his name and, in a few cases, the accompanying title of a series *L'Italie Photographié par Le Dien et Gustave Le Gray*, seem to confirm this thesis.[19] For the purpose of this history, it is tempting to think that a master photographer like Le Gray, involved in the preservation of historic sites in his home country, might have travelled with this superb camera-man. If so, this would further confirm that Italy had an enormous impact on early French photographers.

The contribution of an Italian calotypist, Giacomo Caneva, to this vibrant scene takes one more detour. Caneva installed himself in Rome in 1838, after training as a 'painter of perspectives' in Padua and beginning work as a daguerreotypist. Significantly, he signed himself 'painter photographer' and had a clear sense of the market, distributing his views through the printseller (later photographer) Tommaso Cuccioni,

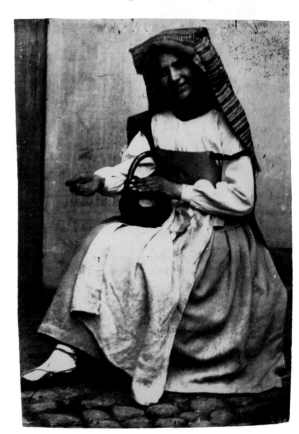

15 Giacomo Caneva, *A Girl Dressed in the Costume of the Roman Campagna*, c. 1850, albumen silver print.

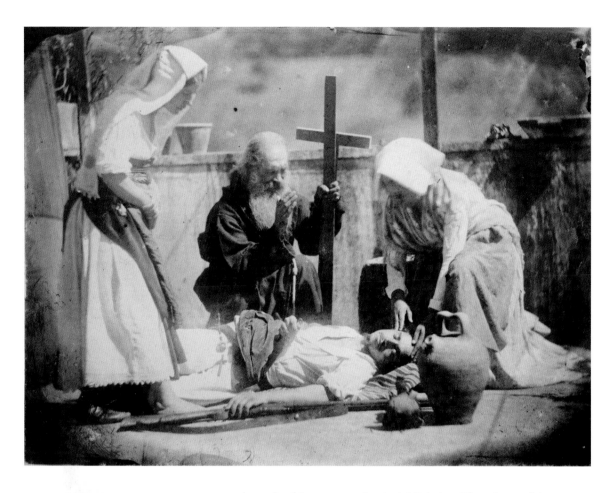

16 Giacomo Caneva, *Tableau of the Risorgimento*, c. 1850, salted paper print.

and opening his own store in via del Babuino. There is proof that Caneva sold his photographs not only to seekers of antiquity but also to painters.[20] It was common practice for artists in Rome to select models from the crowd of peasants who were stationed every day by the stairs of Trinità dei Monti. Most likely Caneva followed this practice for his photographic tableaux.

This is the case with his gentle portrait of a young girl wearing a costume from the Roman countryside and holding a basket (illus. 15); the cobblestones in the foreground suggest an outdoor portrait taken against a makeshift sheet backdrop that enhances the singularity of this figure,

removed from the popular crowd. Caneva's narrative tableaux reflect an exceptional sensibility for storytelling, predating a genre that became successful and pervasive in Victorian England. Working on the balcony of his studio, overlooking Castel Sant'Angelo, he composed theatrical *memento mori*, scenes of *caritas romana*, figures of *pifferari* (pastoral musicians from the neighbouring mountains) and subjects that hinted at current politics. It is possible that the dead figure of a Republican fighter, supported by farmers and a Capuchin monk (illus. 16) referenced Risorgimento battles occurring in Rome during these years. Caneva shared Flachéron's process and had a clear technical grasp of the medium, as demonstrated by his first published treatise on Italian photography, *Della Fotografia Trattato Pratico* (1855), where he described the aesthetic qualities of the calotype, 'its unevenness, roughness, and great range of nature's tones'.[21]

A remarkable case of a photographer-publisher of this period is the Milanese Luigi Sacchi, painter and printmaker who studied at the Academy of Fine Arts in Brera, became illustrator for the magazine *Cosmorama Pittorico* and, also, artistic director of the prestigious illustrated edition (1840) of Alessandro Manzoni's *The Bethrothed* – a historical novel with patriotic undertones. He travelled to Paris to gather artists and engravers for this important task, and learned about the new photographic invention. His first calotype experiments can be traced to 1845 (possibly the first ones by an Italian). Later, he applied Blanquart-Evrard's and Le Gray's improvements to this process.

In 1851 – the year of the *Mission Héliographique* and of another unfinished French project, Eugène Piot's *Italie Monumentale* [22] – Sacchi launched an Italian publication. Titled *Monumenti, vedute e costumi d'Italia*, it consisted of 100 images of north, central and south Italy, sold in four instalments, and distributed through the printseller and photographer Pompeo Pozzi. The completion of this group occurred between 1852 and 1855. This *oeuvre* was exceptional, not only for Sacchi's vision, but for the handcrafted and locally distributed output, which kept the cost quite low. As a literary critic wrote with praise at the time,[23] its price was half of a comparable series produced in Blanquart-Evrard's industrial *Imprimerie*. Sacchi thoroughly investigated historic buildings, refraining from any

17 Luigi Sacchi, *The Small Cloister of the Certosa, Pavia*, 1854, salted paper print.

PAVIA

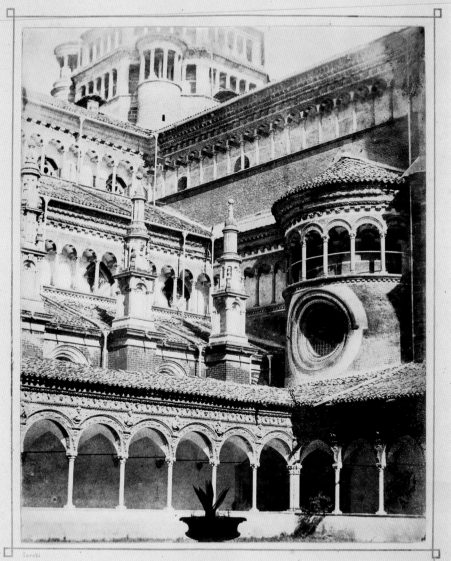

CHIOSTRO DELLA CERTOSA

Fianco della chiesa e piccolo cortile interno

picturesque tradition. An example of this approach is the series of the large complex of the Certosa of Pavia, where he studied the triple and quadruple layers of arches, towers, courtyards and corridors, choosing different perspectives, close-ups and distant views (illus. 17). Beside the monuments, he reproduced renowned local paintings and frescos (Leonardo, Raphael, Bernardino Luini) and made a few rare calotype portraits of artists in his circle.

Sacchi was moved by a civic duty, sharing the belief of other scholars of his time (for example, Pietro Estense Selvatico at the Academy of Fine Arts in Venice)[24] that photography was suitable for the diffusion of Italian art and the consequent growth of nationalist sentiments. His intention to survey Italy from north to south – from the Romanesque church of Sant'Ambrogio in Milan to the Greek temples of Agrigento in Sicily – was an ambition to visually unify this fragmented peninsula, interpreting a patriotic invitation published by the contemporary press:

It is our wish that a skilful and hard-working artist will walk through a hundred Italian cities and will reproduce a thousand monuments and costumes as if they were in a gallery. Wealthy art lovers, scholars of historical studies, archeologists, directors of museums and of Academies of Fine Arts could contribute towards such a goal in order to create a monumental illustration of the whole of Italy and thus disseminate the image of the most splendid memories of our history.[25]

One would have to wait until after 1860 for such a systematic documentation to be fully realized. None the less, Sacchi's early enterprise is noteworthy for his use of the process with keen political awareness – an awareness confirmed, a few years later, by his records of the battle sites of the War of Independence and Garibaldi's heroic hagiography.[26]

Risorgimento Mythologies

The vision of a photographic gallery of monuments and art treasures celebrated a country immersed in the past. Meanwhile, a much more contemporary Italy was in the making. An enduring process of resurgence (Risorgimento) aimed to put it back on the European map and defy the opinion of the Austrian Chancellor, Metternich, who, at the Congress of Vienna in 1815, belittled Italy as a 'geographical expression'.

Characterized by long exposures of battlefields and still portraits in the studio, Risorgimento photography from 1849 to 1870 recorded the history of Unification, which was supported by the Kingdom of Piedmont-Sardinia fighting against Spain, France, Austria and the Vatican. These photographs of military aftermaths echoed, in their empty scenarios of contemporary ruins, those of other nineteenth-century conflicts – the American Civil War, the Crimean War, the so-called 'Mutiny' in India and the later Paris Commune. But if the barricades and the theatre of death were reminders of other battles, the political views behind them defied this apparent homogeneity. In a 'country' which was divided into many regions and factions, there were neither official commissions nor mainstream distribution, and the photographers – both Italian and foreign – negotiated their position *vis-à-vis* the winners or the losers. These intricate stories demand a study of photography as a vehicle of ideology, where the pictures signify patriotism or conservatism, in relationship to the political liaisons struck by the individual authors.

Stefano Lecchi's records of the aftermath of the Roman Republic, in the summer of 1849, are a case in point. This short-lived Republic (from 8 February to 29 June 1849) represented one of many revolutionary

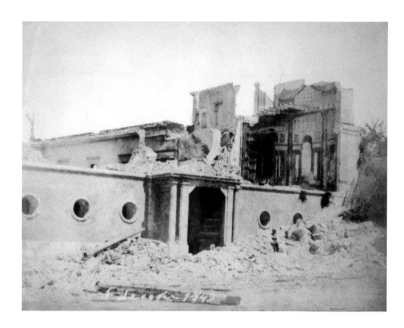

18 Stefano Lecchi, *Orangery at the Villa Borghese, Rome*, 1849, salted paper print.

hotbeds in the 1840s, with the intent of founding a democratic govern-
ment and suppressing the Pope's temporal power. The French government
intervened to re-establish political control, sending troops to fight against
the Republicans, and forcing some of these revolutionaries – Garibaldi,
Mazzini and others – into exile.

Lecchi's 41 photographs are the earliest cohesive war reportage
with the calotype. These pictures of the scars of combat inflicted on the
suburban villas nestling on the Janiculum, the Pincian Hill and elsewhere
(illus. 18), anticipate the better-known photographs taken by Fenton and
Robertson in the Crimea. Yet, unlike the photographs of those campaigns,
these images do not testify commercial assignments supported by one
central government or royal patronage. The evidence uncovered thus far
has confirmed that Lecchi's campaign was self-directed, and possibly in
favour of the Republicans. The fact that the only two existing sets of
these images belonged to members of this faction proves that they had
an underground circulation, mounted and inscribed by the revolution-
aries in remembrance of their friends and martyrs.[1] This sequence of
ruined sites connected the dots on a map where villas, bastions, gates

and churches signified battles and memorialized historical moments of sacrifice and bloodshed. The ghostly appearance of living people within these desolate landscapes (in some cases, Lecchi himself with his son) enhances the melancholic quality of these theatres of war.

These pictures of 'the new ruins of Rome' propose an alternative iconography to the known repertories of ancient monuments.[2] Indeed, when Lecchi photographed these sites, they were off the beaten track of picturesque and romantic views, only later becoming significant as shrines. This is even more remarkable if one considers that Lecchi belonged to the circles of calotypists and landscape photographers outlined in the previous chapter. In 1845 both Calvert Jones and the Revd Bridges had praised his work in their correspondence with Talbot, and it is known that Lecchi had made views of Pompeii and Rome with this process.[3] A few records of the same war zones by Caneva and Flachéron testify these photographers' ventures into a new pictorial ground where Italy was no longer just an immobile souvenir but a politically unstable terrain.

At this time, the country lacked national media. *L'Illustrazione Italiana* was founded in 1873, circulating wood-engraved illustrations that only in 1885 were replaced by photo-engravings.[4] Early war photographs were published, most frequently, as lithographs that resembled tourist views and thus lost their political immediacy. This is the case with a series of five lithographic plates titled *Ruine di Roma dopo l'assedio del 1849* ('Ruins of Rome after the Siege of 1849'), published by Michele Danesi and Carlo Soleil in Rome (both connected to the Vatican establishment) without any reference to Lecchi. Following publishing strategies adopted by Artaria and Lerebours, these were labelled 'after daguerreotype' (despite their calotype matrix), thus emphasizing their truthfulness and objectivity. The narrative addition of staffage figures tweaked the documentary evidence of Lecchi's bare documents, putting a political emphasis on the winning troops against the Republic. Such a reading was conveyed in the title, where the word 'siege' (of Rome) replaced the Republican idea of 'defence' (of the newly formed government).[5]

As one of these plates illustrates (illus. 19), the French and Papal troops are represented in the attacks by the aqueduct near Villa Pamphili (top left) and the fortified walls near St Peter's. Opposite them, the Republican

soldiers are reduced to insignificant entities, covered by a cloud of smoke ignited by the enemies, or hidden behind fortified walls. The cupola of St Peter towers in the distance, as historical reference to the importance of the Vatican (this view was obtained from a panorama in three photographs by Lecchi). On the top right the ruins of Villa Borghese (and see illus. 18) – with traces of frescos on the walls – suggest the acts of vandalism by the revolutionaries, destroying these historical treasures.

Such a war of images, in which the same event could lead to opposite interpretations and satisfy different consumers, permeated Risorgimento photography, spreading confusion between heroes and victims, romantic ruins and temporary barricades. To further complicate this history, the political coalitions shifted back and forth in support or in opposition to the insurgents, as was the case in Napoleon III's France. The Prime Minister of Piedmont, Camillo Benso, Count of Cavour (illus. 20), had worked to gain his support, promising the French Emperor territorial gains (Savoy and Nice) and even profiting by the seduction of his cousin, the Countess of Castiglione (temporarily Napoleon III's lover), as a political

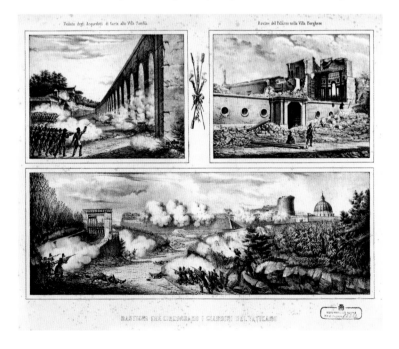

19 Michele Danesi and Carlo Soleil (attr.), three scenes of conflict and its aftermath, near the Villa Pamphili, at the Villa Borghese, and before the defensive bastion at the Vatican Gardens, in *Ruine di Roma dopo l'assedio del 1849*, lithograph.

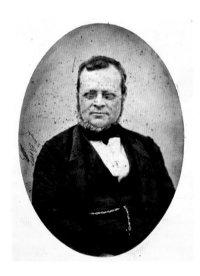

20 Louis Crette, *Camillo Benso, Count of Cavour*, c. 1855–6, salted paper print.

strategy. Napoleon III contributed to the victories against Austria in the battles of Magenta and Solferino (1859), but his alliance then switched to Austria.

Numerous French photographers – Léon-Eugène Mehedin, Louis Crette, Gustave Le Gray, Eugène Sevaistre, Pierre Petit – shaped the iconography of the Risorgimento. Crette's portrait of Cavour was taken in Nice, before he moved to Turin and became royal photographer (1860–61), confirming Franco-Italian sympathy at this early stage. Further, Le Gray's reportage of the takeover of Sicily by Garibaldi helped galvanize the mythology of this prime Risorgimento hero. Travelling on board Alexandre Dumas' schooner *Emma*, the well-known French photographer embarked on an adventure that was coloured by the writer's fascination with Garibaldi – Dumas was the editor and translator of the revolutionary's *Memoirs* [6] – and by a romantic idea of reporting on the progress of Italy's liberators. In May 1860 Garibaldi had organized a military campaign of volunteers, the so-called 'Expedition of the Thousand', departing from the north (Genoa) and landing in Sicily. His capture of Palermo was an important step towards the demise of the Bourbons' 'Kingdom of the Two Sicilies' and the proclamation of the new Italian kingdom in March 1861. As the news of Garibaldi's military success reached Dumas, he promptly decided to be a witness of such crucial events.

This passionate involvement is evident in the writer's description of his first encounter with Garibaldi in Palermo:

> Do you have a photographer with you?
> (*Dumas*) Quite simply, the leading photographer in Paris, Le Gray.
> Well then, have him shoot our ruins; Europe must know these
> things: two thousand eight hundred bombs in a single day![7]

Le Gray's albumen prints from waxed paper negatives (a process which he mastered) resulted in compelling images of Palermo as a theatre of war: an empty stage half burned and barricaded. The aesthetic sought by this photographer throughout his professional life (the sense of space, the monumental sweep of buildings, the fascination with ruins) was translated into images of a city suspended between life and death. The

35

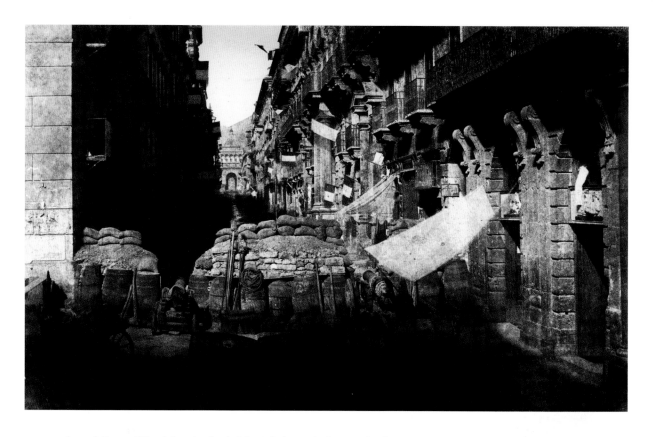

view of General Turr's barricades in Via Toledo, with the Royal Palace in the distance (then inhabited by Garibaldi), shows this fine balance (illus. 21): introduced by a defensive installation of carts, barrels, sandbags and cannons, this street illustrates a festive patriotic display of Sardinian flags waving left and right, while two blurred awnings in front suggest the fresh Mediterranean breeze comforting the insurgents. One can imagine Le Gray's excitement as a chronicler of history in the making. His plates were distributed in Paris by Eugène Colliau (a student of Le Gray) and Costet, and also printed as woodcuts in *Le Monde Illustré*. In Italy their circulation followed a similar path to Lecchi's, becoming lithographs in the *Album Storico Artistico* (1860), published in Milan by Fratelli Terzaghi.

Among Le Gray's photographs, his portrait of Garibaldi acquired an unprecedented iconic value in the French press and was widely distributed through the photographic market.[8] Its towering presence among numerous *cartes-de-visite* pasted into a personal album attests to this currency

21 Gustave Le Gray, *Barricade of General Turr in Via Toledo, Palermo*, June 1860, albumen silver print from a waxed paper negative.

(illus. 22). This posthumous sequence of portraits and narrative vignettes assembled by a French supporter highlights this icon within the mythology of Garibaldi's courage and sacrifice. To the left and right of Le Gray's *Garibaldi* (the largest portrait), Garibaldi appears in one dressed in his characteristic red shirt and in the other in bourgeois attire, while a portrait of General Türr (Garibaldi's chief aide) and one of a Prussian soldier killed in Sicily during the 'Expedition of the Thousand' enrich this historical gallery.

Three *cartes-de-visite* in this group are reminders of Garibaldi's legendary wounded leg, which is remembered to this day in songs and popular rhymes: *Garibaldi fu ferito, fu ferito ad una gamba . . .* One photograph

22 *Portraits of Garibaldi and his Generals, with Narrative Vignettes of this hero's wounded leg*, c. 1862–3, albumen silver prints (from a personal album of Risorgimento *cartes-de-visite*).

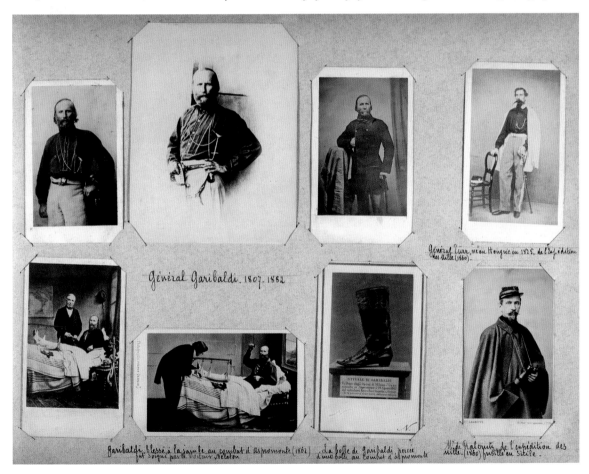

(copied in Nadar's studio) acts as evidence of his boot, pierced by a bullet on 29 August 1862, during his march through the mountains of Aspromonte. This picture appears alongside scenes of Garibaldi's recovery, where he poses for the photographer with his French surgeon, Nelaton (left) and British doctor, Partridge (right). An attentive study of the image on the left, possibly also by Pierre Varner,[9] reveals the use of different backdrops (the Italian map here is replaced with the bars of Garibaldi's prison in another photomontage), bringing further symbolic dimensions to a photograph that was actually taken outdoors.[10]

Significantly the *carte-de-visite* portrait involved the process of nation-building. It was Alphonse Bernoud, a French photographer based in Florence and Naples, who had introduced it in Italy only a few months after Disderi's patent, in 1854.[11] At once this modern visual currency contributed to create a Risorgimento pantheon of statesmen, philosophers and volunteer soldiers. The history of the numerous photographers who made this happen still needs to be written, and has a great potential for understanding Italian photography as a form of social currency and mythmaking. In the particular context of Risorgimento, the fact that this format was used as fundraising to support the revolutionary troops confirms its political scope.[12]

Garibaldi's heroic 'Thousands' became the subjects of a monumental gallery of *cartes-de-visite*, titled *Album dei Mille*, and conceived between 1863 and 1870 by Alessandro Pavia, a commercial photographer with a studio in Genoa. The project consisted of an elegantly bound volume with a grid of twelve portraits by page, tightly mounted recto and verso, and a list of 1092 soldiers inventoried with a number, name and place of origin.[13] In numerous instances Pavia had commissioned third parties to portray these soldiers, who had left together from Genoa in 1860, but had become scattered, or even died, after the Unification. The multiple authorship of this volume is also illustrated by the range of props, poses and military garb – from red shirt uniforms to the different ranks of regular armies, to casual attire – that conveyed an extra visual variety to the uniformity of each mount. The page shown here (illus. 23) belongs to King Victor Emmanuel II's personal copy, presenting a special mount decorated with the Savoy coat of arms and crown.

23 Alessandro Pavia. *Album dei Mille* (unnumbered plate), *c.* 1863–70, albumen silver prints, *cartes-de-visite*. This page shows a selection of Garibaldi's volunteers in 'The Thousand' army.

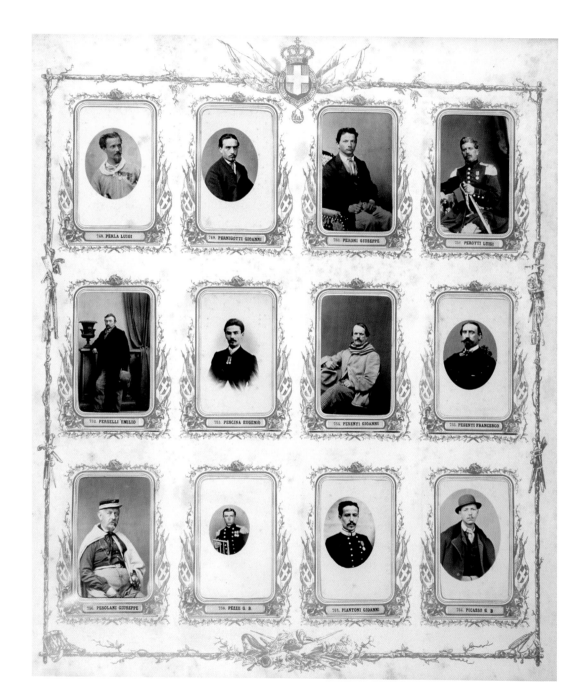

748. PERLA LUIGI

749. PERNIGOTTI GIOANNI

750. PERONI GIUSEPPE

751. PEROTTI LUIGI

752. PERSELLI EMILIO

753. PESCINA EUGENIO

754. PESENTI GIOANNI

755. PESENTI FRANCESCO

756. PESOLANI GIUSEPPE

759. PEZZE G. B.

763. PIANTONI GIOANNI

764. PICASSO G. B.

Pavia's photographic inventory of these volunteers was exceptional for the inclusion of names and faces of subalterns, commonly ignored by official histories, and for his unique interpretation of the cause. In his dedication to Garibaldi, he wrote: 'This work is far from perfection, but my political and national goal has been achieved, and that is enough, because I did not aspire to the glory of an artist, but to the dedication of a citizen, thus paying the just homage to those brave soldiers.'[14]

The cost of this large volume was very high, 460 *lire*, considering that a medium annual income at that time was around 1,500–2,000 *lire*. Pavia created a small publication for advertising: 28 pages with the complete list of the 'Thousands' and three sample photographs, for 1 *lira*; he also offered to accept payments by instalment and sold copies to Italian libraries.[15] Despite these attempts this endeavour was a financial failure. As Pavia's nationalist goal had transformed the *carte-de-visite* into high currency, the economy of this format was defeated altogether.

Pavia also portrayed the brigands – an armed political force made up of rural classes in the south, awakened as a result of the crisis in the newly unified country, and victim of social inequities that would persist throughout the twentieth century. A particular production of *cartes-de-visite* introduced these subjects to Italy's growing middle class, helping to tame the bourgeois fear of rebels and thieves. These portraits matched a type of forensic photography aligned to the social evolution of other modern states like France or England, as illustrated by Allan Sekula's political analysis: 'The invention of the modern criminal cannot be dissociated from the construction of a law-abiding body – a body that was either bourgeois or subject to the dominion of the bourgeoisie.'[16]

Portraits of these criminal 'types' were marketed by prominent studios in the south (Giuseppe Incorpora and Enrico Seffer in Palermo, illus. 24; Alphonse Bernoud in Naples) as collections of daring people, soon to be arrested or even killed by the new central government. At times these portraits were staged as gruesome criminal trophies, reassuring a dominant ideology and feeding a voyeuristic gaze. Police photography was instituted in Italy some time later,[17] so these images acted as early vehicles for social order, supporting evolutionary theories that saw southern Italians as racially inferior, and offering scientific justifications for forceful

24 Enrico Seffer, *Portrait Collection of Brigands in Sicily, c.* 1877, albumen silver prints, *cartes-de-visite.*

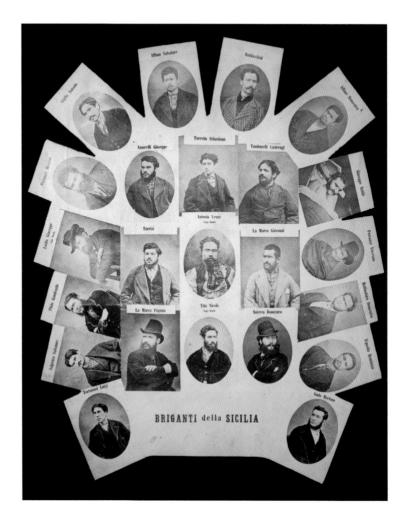

BRIGANTI della SICILIA

repression. The use of photography by the anthropologist Cesare Lombroso in his study *The Criminal Man* (1876) confirms such logic. In Lombroso's own words, 'Photography, the telegraph, and the railway, are the new instruments to neutralize the evils of civilization.'[18]

Another type of representation, romantic and colourful, borrowed early nineteenth-century pictorial codes (in particular, Bartolomeo Pinelli's commercial illustrations of peasants in the Roman countryside) and relocated the brigand 'type' in an idealized pre-industrial world.

These portraits, usually hand coloured, dressed the models in the pastoral and folkloristic costumes of Sonnino (a village south of Rome), pursuing the kind of photographic *mise-en-scène* highlighted earlier with Caneva. The brigands' fierce wives were portrayed holding handguns and rifles, and leaning on fake antique pillars. G. Agostini was one of a number of photographers based in Rome's Piazza di Spagna district, selling both views and Roman and Neapolitan characters in costume (illus. 25).

A different kind of photographic narrative illustrated the last stages of the Risorgimento, with the annexation of Venice in 1866 and the final incorporation of Rome in 1870. Rome, in particular, became a contested territory for photographers, who took stands for and against the Pope's secular power. The priest Don Antonio D'Alessandri represented such power, in the role of exclusive portrait photographer of Pius IX, and in charge of a significant atelier known as 'Fratelli D'Alessandri' (in collaboration with his brother Paolo Francesco). In November 1867 D'Alessandri recorded the aftermath of the battles in Mentana and Monterotondo, two villages on the outskirts of Rome, where Garibaldi's troops were arrested by the Papal Zouave soldiers while marching towards the Holy City. The resulting landscapes of rolling hills and peaceful farms were memorials of battles, acting as visual propaganda of the Pope's victory. For example, the Vigna Santucci in Mentana (illus. 26) was transformed into a garrison in the battle against the red-shirted sharpshooters of Garibaldi's army.

The significance of these landscapes is enhanced by D'Alessandri's contemporary distribution of *cartes-de-visite* portraits which commemorated the wounded and dead Zouaves fighting in those battles.[19] The records of their maimed bodies – supported, albeit humorously, by plump religious characters (illus. 27) – bring one more level of complexity to the

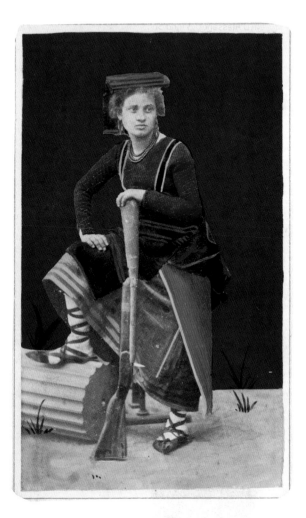

25 G. Agostini, *Wife of a Brigand Wearing the Costume of the Roman Campagna*, c. 1865, hand-painted albumen silver print, *carte-de-visite*.

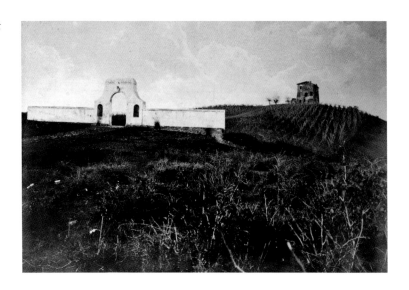

26 Fratelli D'Alessandri, *Vigna Santucci at Mentana*, 1867, albumen silver print.

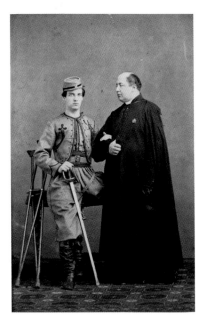

27 Fratelli D'Alessandri. *A Wounded Papal Zouave with a Priest*, c. 1868, albumen silver print, *carte-de-visite*.

gallery of illustrious statesmen and anonymous volunteers presented here, revealing the extent of the visualization of the Risorgimento.

One of the most popular scenes of this period, widely distributed as a *carte-de-visite*, was a rather clumsy visual montage of soldiers pointing their guns towards Porta Pia's fortified walls at the entrance of Rome (illus. 28). The scene chronicled the breach of these walls on 20 September 1870 as the final chapter of Italian Unification. It was the end of the Pope's temporal and political power, establishing Rome as the country's capital. The image was assembled from a record of this site attributed to Gioacchino Altobelli, a history and portrait painter, who turned to photography in 1858 (in brief association with Pompeo Molins, see illus. 32). Altobelli was known for other kinds of montages of Roman views, defined as 'moonlight effects', and he had also created a composite photograph of the ecumenical council of 18 July 1870, inserting photographic portraits onto a painted surface.[20]

With similar skill he conceived this 'action' photograph of the Porta Pia and enhanced its patriotic drama (the Italian flag in the middle-ground; the cloned soldiers, standing or falling; the retouched bullet holes). Remarkably, Altobelli was granted copyright protection on this picture, in confirmation of the value and originality of his pictorial idea.

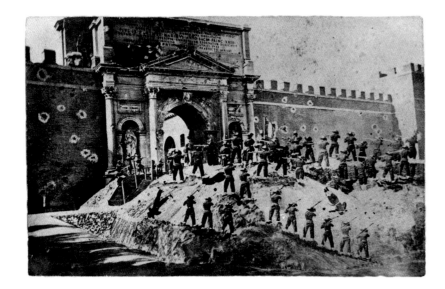

28 Gioacchino Altobelli (attr.), *The Breaching of the Porta Pia, Rome*, 21 September 1870 (photomontage), albumen silver print.

It is worth reflecting that, more than twenty years after Lecchi's early reportage, and with notable political distortions due to the translation of those photographs into lithographs, an Italian photographer, witnessing the beginning of the new government, was capable of manipulating his own record, cutting and pasting photographs for the sake of his nation's conflicting mythologies.

three

Romance of Stone and Steel

A different kind of revolution from the political Risorgimento transformed the economy and industry of Italian photography. This was the irresistible and powerful force of tourism that took over in the 1860s, which contributed to standardizing the image of the country. Its modalities were different from the aristocratic Grand Tour, as railways had replaced horse-drawn carriages, and foreign borders were progressively eradicated. By 1865 a railway trip from Milan to Florence was only eight hours long, a drastic improvement on the 40 hours it took before 1860, but also a radically new experience.[1] John Ruskin spoke nostalgically for a generation that savoured slow-pace travelling: 'A man who really loves travelling would as soon consent to pack a day of such happiness into an hour of railroad, as one who loved eating would agree . . . to concentrate his dinner into a pill.'[2]

Photography became an indispensable apparatus for the modern handbooks (John Murray, Baedeker, Guide Bleu) where descriptions were no longer accompanied by illustrations. As a visual confirmation of 'having been there', photography became a trigger for the tourist imagination that in turn created a new form of mass communication. During this period commercial ateliers rapidly grew everywhere in number – from 50 in 1856, to 150 in 1861, and five times more between 1865 and 1870. Concurrently, photographic technology had been transformed from the jewel-like daguerreotype and the atmospheric calotype to a sharp image obtained from a glass negative (covered with an emulsion of albumen since 1847; wet-collodion since 1851; and dry-collodion since 1864) and printed onto glossy albumen paper. The highly detailed image obtained

with this new process enhanced the impression of a new age. As Giacomo Caneva had sensibly pointed out in his *Trattato*, the natural landscape and the ancient monuments were perfectly suited to the paper negative, while 'a modern building, a statue, a general view, a painting, an engraving was rendered in marvellous ways on glass'.[3] Such a crystal-clear world was shiny and exuberant, producing pictures for foreign consumption and celebrating Italian industrial development.

Not surprisingly, many photographers of this generation were involved in the tourist industry. One of them, Leopoldo Alinari, was apprentice engraver to the renowned Florentine publisher of prints and guidebooks, Luigi Bardi (and his son Giuseppe), who introduced him to the new technology in the early 1850s. Backed up by Bardi, Leopoldo created a firm with his two brothers, Romualdo and Giuseppe, in 1854. From the start, their views were taken with an audience in mind. For example, the peaceful image of Florence (illus. 29) with the Arno reflecting the city, and the bridge of Santa Trinità separating this stretch of nature and culture, corresponded to the dream-like sight that British travellers could admire from the hotels des Iles Britanniques and Schneider's, listed in their John Murray guidebooks.[4] Most frequently, the early Alinari views rendered the massive volumes and tight perimeters of medieval

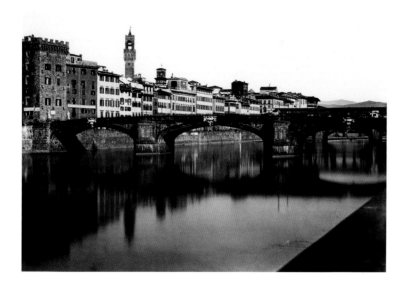

29 Fratelli Alinari, *The Ponte Santa Trinità, Florence*, 1856 (unnumbered plate from an album of views of Florence, Pisa and Siena), albumen silver print.

cities like Florence and Siena airy and spacious. This was due to their choice of central and symmetrical compositions, perfectly aligned in their parallax lines.

Clearly, the international success of Alinari was due to a combination of art and commerce in the transmission of a national visual culture. The influential French critic Ernest Lacan had highlighted this aspect, commenting thus on their work:

Fratelli Alinari must be noted not only among the most skilful photographers but also among those who have best comprehended the mission of this new art . . . They are not content with the mere

30 Fratelli Alinari, *Interior View of the Camposanto, Pisa*, 1855 (unnumbered plate from an album of views of Florence, Pisa and Siena), albumen silver print.

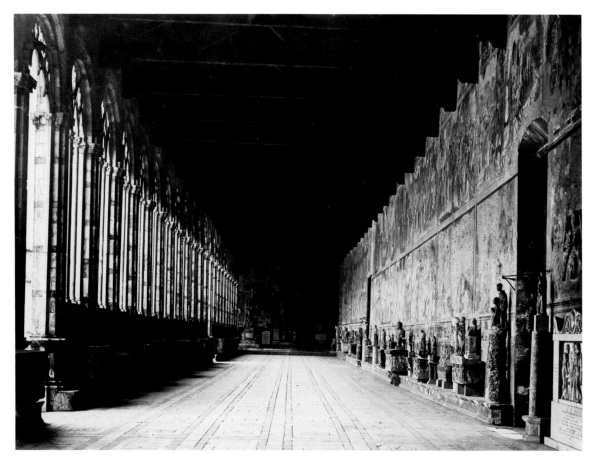

illustration of the monuments of their beautiful country but they are committed to preserve for posterity those masterpieces that time is slowly destroying.[5]

In particular, 'La Lumière' praised two architectural views taken by Alinari in very difficult and irregular light conditions, and presented, among others, at the 1855 Exposition Universelle in Paris.[6] These illustrated the Gothic Camposanto of Pisa, a semi-dark space where light was filtered through tall and narrow window tracery, bathing unevenly the diverse textures of sculptures, funerary inscriptions and frescos (illus. 30). Speculating on their use of large reflecting mirrors to balance light and shadow and thus show those painted surfaces in a state of decay, Lacan singled them out as masters of art reproduction – a speciality that became their quintessential mark, bringing them to prestigious commissions, such as the request by Queen Victoria's consort, Prince Albert, to create a monumental volume of photographic reproductions (310) of Raphael's drawings, conserved in the Galleria dell' Accademia in Venice and in the private collection of the Archduke Carl of Hapsburg in Vienna.[7]

A significant transformation took place from the earliest photographs – made between 1854 and 1856 and sold as 'Fratelli Alinari presso Luigi Bardi' – to the progressive creation of a codified Alinari 'style', achieved by a variety of anonymous operators and focused on a systematic record of Italy's artistic patrimony (in 1863 Alinari relocated to a larger studio on Via Nazionale). The firm became a national pictures factory, as a system was in place that sold views at shops in different cities and distributed photographs by mail from catalogue listings. This sales network was similar for other commercial studios. What separated Alinari from the other photographers was the ambition to make available a complete topography of the entire country.[8] Furthermore, their centre of operation, Florence, was a privileged tourist destination and had been, for a short period of time (1865–70), the capital city. In 1890 Leopoldo's son Vittorio took managerial control of the firm, bringing such a systematic classification to impressive proportions.

Florence had been designated as the site for the first national exhibition, opened by Victor Emmanuel II on 15 September 1861. This important

show was installed in the renovated spaces of a deserted railway station, just outside the city.[9] For the first time in Italian history the regional resources of industry, agriculture, art and culture were grouped together, and photography was one of them. Forty-four photographers showcased their works, and Pietro Semplicini (in charge of the 'Società Fotografica Toscana', formed in 1853), was commissioned to record the event in an official volume of 150 plates that was offered to the King. This official engagement of photography is relevant if one considers that Italy still did not have any photographic magazine, the first, *La Camera Oscura*, not appearing in Milan until 1863.

Photography became part of the pride and wonder that permeated this young nation, and this official volume attested it, following methods of marketing and representation that had been launched earlier, at the Great Exhibition in London in 1851. This volume illustrated the range of mechanical and optical instruments, agricultural products and objects of craft that represented the nation's progress. This particular image (illus. 31) is reminiscent of the grander series by Philip Henry Delamotte documenting the reconstruction on a new site of the Crystal Palace that had housed the Great Exhibition, with figures of workers (possibly, the man slouched on the pavement) and of entrepreneurs posed in front of the hall where machines were on display.

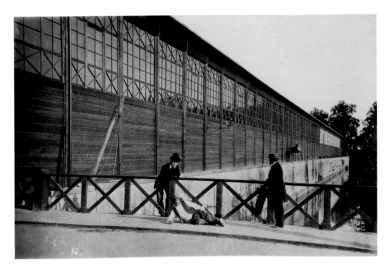

31 Pietro Semplicini, 'Exterior of the Machines' Exhibition Hall', plate 14 from the album *Esposizione Italiana del 1861*, albumen silver print.

49

Despite a few significant absentees, the catalogue of the Florence exhibition listed the 'who's who' in photography at the time. Among the views and portraits by Alinari, Brogi, Sorgato, Duroni, D'Alessandri, Suscipj and the like, the work of the Roman team Altobelli and Molins is worth a note for a particular series of pictures, taken between 1859 and 1865, that echoed the exhibition's industrial emphasis. These recorded an impressive new Roman railway (800 km long) built during the government of Pius IX. Pompeo Molins was related to the Pope's personal secretary (Cardinal Antonelli), which explains why he received the commission.

The series presented a new iconography for Rome, with the clergy and the middle class celebrating industrialization, posing against backdrops of iron technology. These photographs were primarily taken as proof of the Pope's power and independence from the rest of Italy, as in the case of this portrait, where Pius IX posed beside the new tubular and rotating railway bridge over the Tiber (illus. 32). A few Romans gathered for the official photograph on 22 October 1863, acting as a measuring scale of this impressive project – a bridge designed by the Scottish engineer Robert Stevenson, and perceived as 'the grandest work built on the railway track between Rome and Civitavecchia'.[10]

While the Vatican supported photography for propaganda and scientific research (for example the photographs of a lunar eclipse taken by Jesuit astronomer Angelo Secchi in 1851; the archaeological records of the Appian Way by Pompeo Bondini in 1853[11]), most photographers living in Rome during this period made tourist views, applying for permission to the Pope's government (*publicetur*) to produce their work commercially.[12] They produced breathtaking pictures that mirrored the magnificent dimensions of the ancient ruins, the harmony of sculptures located in churches and museums and the romance embedded within the city. Photographers such as James Anderson, Pietro Dovizielli and Robert Macpherson achieved international reputations for their outstanding grasp of Italian art and architecture.

Briton James Anderson was a painter turned photographer; he had studied art in Paris and then moved to Rome in 1838, where he belonged to the 'Caffè Greco' group of artists. His fame as a photographer grew through the 1850s, as he worked on his first catalogue (1859) and secured

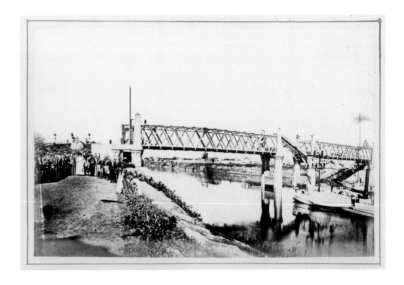

32 Giacchino Altobelli and Pompeo Molins, *The Ponte Tevere, Rome, Visited by Pope Pius XI on 22 October 1863* (unnumbered plate in *Ragguaglio delle cose operate dal Ministero del Commercio, belle arti, industria, agricoltura e lavori pubblici dall'anno 1859 al 1864*, Governo Pontificio, Rome, 1864), albumen silver print.

a dealer, the German bookseller Joseph Spithöver in Piazza di Spagna, to sell his views exclusively. Anderson's early reproductions of Roman sculptures made a strong impact at the 1855 Paris Exposition Universelle, to the point that a French critic wished for a future date when Anderson would also reproduce the works in French galleries and museums. In particular, in the case of *Michelangelo's 'Moses'* (illus. 33) – a masterful rendering of the statue bathed in light – Lacan described the exceptional skills of this artist, who 'had to fight against the main element, light, so dim in the Church of Saint Peter [in Vincoli]'.[13] Anderson's son, Domenico, carried on his work in 1877, thus continuing an enterprise that resembled Alinari's family business.

On a smaller scale, but equally effective in his renderings, Pietro Dovizielli, who had won a bronze medal at the 1855 Paris Exposition, became so well known for his studies of art and architecture that Henry Cole, Director of London's South Kensington Museum (now the Victoria and Albert Museum), chose him for a commission of views of Rome that would inspire a planned extension of the museum.[14] His approach to architecture was grand, allowing a building to sit within spacious sur-roundings, as is visible in one of his early records, an unusual frame of the tomb of Cecilia Metella, taken from the fields beyond the Appian

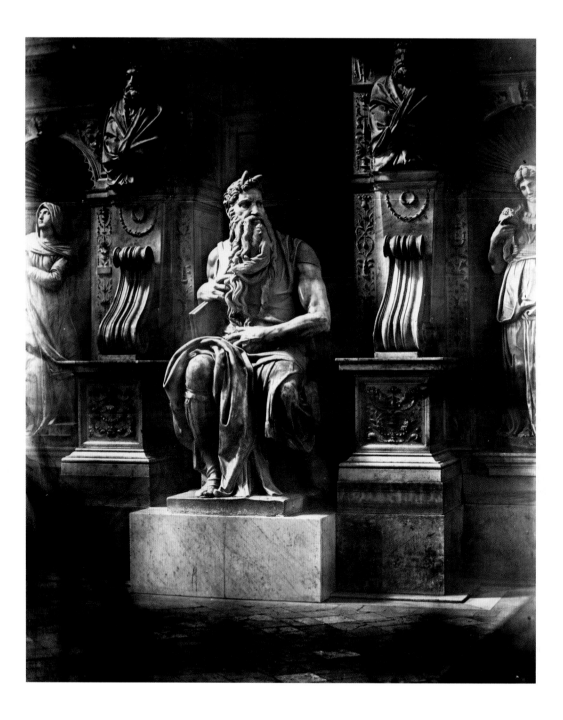

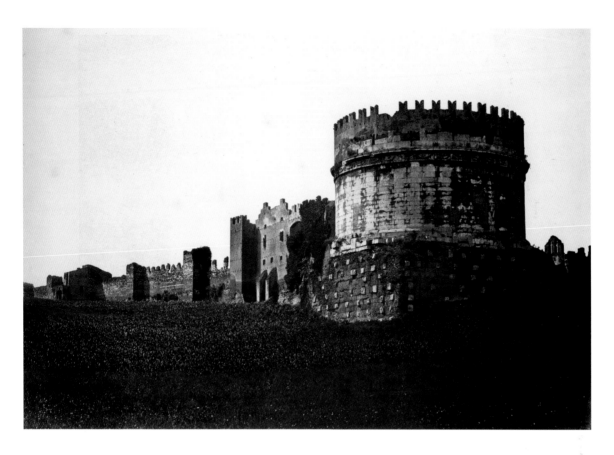

34 Pietro Dovizielli, *The Tomb of Cecilia Metella, Rome, c.* 1858, albumenized salted paper print.

33 James Anderson, *Michelangelo's 'Moses' in S. Pietro in Vincoli, Rome, c.* 1854, salted paper print.

Way (illus. 34). Dovizielli's early negatives were albumen on glass, a technology that rendered much softer tones, but was less sensitive to light than the wet-collodion.

Robert Macpherson, a Scotsman who had converted to Catholicism, was a master of the albumen on glass process. Initially a landscape painter, he had settled in Rome in 1840, becoming a photographer in 1851. His marriage to Gerardine Bate – niece of the travel writer and art historian Anna Jameson – brought him closer to the British expatriates in Rome and increased his clientele of Anglo-Saxon tourists. Unlike Anderson, Macpherson had his own shop. He liked to be perceived as an 'Artist Photographer'[15] and frequently enhanced the aura of his pictures by producing them in oval, rectangular and square formats.

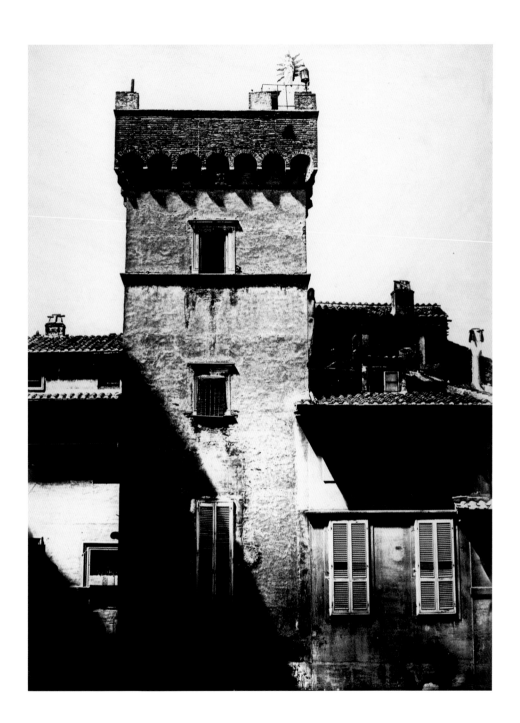

His photographs were the most expensive in the Roman market, listed as 'by far the finest' in John Murray's *Handbook for Travellers in Central Italy* in 1856[16] and exhibited at the Architectural Photographic Association, founded in London in 1857.

Hilda's Tower (illus. 35) is a proof of Macpherson's intimate knowledge of Rome and of his perception of architecture as massive sunlit presences. But this beautiful print reveals something else: that Macpherson was aware of the impact of tourism and romance on his own photography. Although listed in his catalogue as 'Hilda's Tower', this photograph actually illustrates a medieval tower situated in an out-of-the-way corner in Via Portoghesi, west of Via del Corso. The choice of this title, derived from Nathaniel Hawthorne's *The Marble Faun* (in which the character Hilda is an American copyist and painter), suggests the photographer's knowledge of this book in connection with tourism. In fact, the site had been incorporated, with reference to Hilda, in the Baedeker for Rome, and other kinds of commercial photographs were produced for the illustration of a custom-made edition of Hawthorne's novel.[17] In his choice of this odd subject (certainly not as famous as the Roman Forum or St Peter's), Macpherson confirmed his understanding of the tourist market and his will to participate in the creation of a fictional Rome.

Architectural views often functioned not only as topographical documentation but also as a vehicle for the imagination of fabulous worlds. This aspect became particularly effective in Venice, a city where photography was part of a tourist boom, with many studios reproducing art and architecture, such as Carlo Naya, Antonio Perini, Domenico Bresolin, Giuseppe Coen and Federico Ongania. The Swiss Carlo Ponti represented a particular case: he trained in Paris with the distinguished optician Robert-Aglaé Cauchoix, and settled in Venice soon after 1848, with a shop in St Mark's Square, in the proximity of the cosmopolitan Caffè Florian.[18] In 1862 he had patented an apparatus for the viewing of photographs, a table-model instrument beautifully carved in walnut by a Venetian cabinet maker (Demetrio Puppolin), called 'alethoscope' or 'megalethoscope' ('mega' because of the addition of a magnifying system). This technology enhanced the experience of canals and piazzas with effects of day and night that resembled those of Daguerre's Diorama,

35 Robert Macpherson, *Hilda's Tower, Rome*, 1871, albumen silver print.

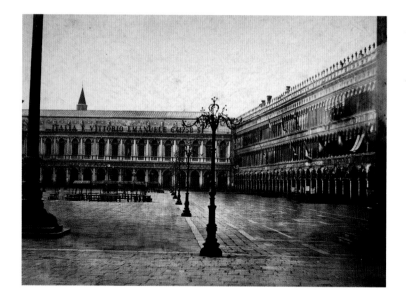

36 Carlo Ponti, *Piazza San Marco, Venice*, 1866, albumen silver print, day effect. This print was mounted for viewing with a megalethoscope. A sign on the palace indicates the annexation of Venice to Italy, with the number of votes: 'Italia e Vittorio Emanuele 641758 sì'.

but on a smaller scale. The optical trick was achieved by adding colour and narrative vignettes to the back of the albumen prints, and making tiny pinholes, invisible on a day scene but turning into lights in the dark, when the print was illuminated from the rear through a gas lamp. Each print was mounted on canvas and wood – objects that could be easily handled and viewed.

The most characteristic subject-matter consisted of the simulation of a journey along the Grand Canal at night, to this day the most typical and desirable Venetian tourist experience. The range of treatments and geographies (including Egypt) was indicative of several trends: of Ponti's knowledge of a tradition of painted views prior to photography; of his global network with commercial studios also outside Venice (from Francis Frith to Pompeo Pozzi in Milan); and of his use of this technology as a way to re-enact history. For example, the view of the empty St Mark's Square (illus. 36) was transformed into a night scene celebrating the moment when Venice was annexed to Italy in 1866 (illus. 37). The miniscule holes in the paper allowed the lampposts to shine; the Italian flags decorated the palaces on the right (where Ponti had his shop); and an elegant Venetian crowd animated this space in the fashion of a lively Canaletto *veduta*.

In a city like Venice, where photography had become a commodity, Ponti's competition with Carlo Naya (who settled here in 1857 and specialized in creating particular 'moonlight' effects) caused a serious case of copyright infringement. While Ponti had sued Naya for producing his alethoscope in 1867, Naya counter-sued Ponti for the appropriation and sale of his work – many views for Ponti's megalethoscopes were indeed by Naya. The legal matters were finally settled in 1882, with Naya's victory. This was the first of many episodes where Italian photographers claimed authorship and awareness of the market value of their art. This was even more relevant given the fact that Naya was not always the photographer of those views but, rather, the producer of images taken

37 Carlo Ponti, *Piazza San Marco, Venice*, c. 1866, albumen silver print showing colouring and punctures on the verso (night effect).

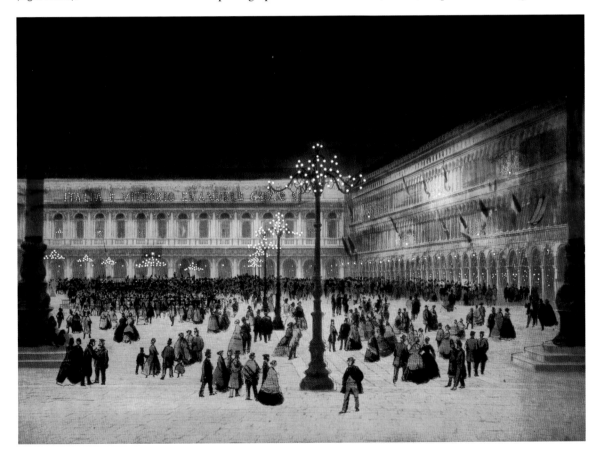

by his assistants, published in standard tourist albums and titled, most frequently, *Ricordo di Venezia*.[19]

Ponti's fantastic re-enactments included events outside Venice. A large group of these views, conserved at the George Eastman House in Rochester, New York, reflects Ponti's repertoire. For example, the Hôtel de Ville in Paris was shown ablaze during the Commune in 1871; a crowd was painted on the back of St Peter's Square to represent the Pope's benediction; and a spectacular effect was achieved for the eruption of Vesuvius (way back in AD 79), with painted flames oozing towards the sea. The violence of these colours was a cheap adaptation of the sublime rendering of the same historical scene by Joseph Wright of Derby in the late eighteenth century.

German-born Giorgio Sommer had documented an impressive (and real) contemporary eruption of Vesuvius in 1872, indicating the precise date and time for each exposure. These early photojournalism records were part of his thriving studio in Naples – offering views that comprised the sublime and the picturesque, the scientific and the populist. Sommer had practised photography in Frankfurt from a young age, and his move to Italy in 1857 – Rome first and then Naples – was clearly motivated by the growing tourist market. Naples was a popular destination, particularly since the discoveries of neighbouring Herculaneum (1738) and Pompeii (1748). In 1865 statistics reported fourteen professional studios in Naples, which became 33 in 1871.[20] The reason why so many of these were foreigners (Alphonse Bernoud, Giorgio Conrad, Robert Rive and also Wilhelm Weintraub in Salerno) was due to the lack of a national policy, and the consequent scant support for photographic publications, organizations and exhibitions. Significantly, Weintraub started a *Giornale di Fotografia* in 1868, with the stated goal of bringing up-to-date information to Italy from countries like France and Germany.[21]

Sommer knew the market. He secured distribution of his images through booksellers and dealers based in Naples (Albert Detken), Florence, Rome and Venice (Carlo Ponti) and controlled the German venues through catalogues (published in three languages). His name was always prominent, despite the fact that most photographs were taken by his assistants, who covered most Italian cities. Finally, just like Anderson,

he formed a partnership with his son, Edmondo. What distinguished Sommer from other photographic studios of this period was the wide range of his subjects – from archaeological documentation, to views of Naples and the Amalfi coast, to costume studies, taken in the street and in the studio – and his deep attraction, of German origin, to the classical roots of the South.

His coverage of Pompeii, for example, had a double edge. These views were manufactured for tourists (who could purchase them from custodians on site)[22] but were also part of a growing branch of archaeological photography, connected to politics of national preservation. It is known that Sommer assisted the scientific inquiries of archaeologist

38 Giorgio Sommer, *View of Pompeii from the Theatre*, c. 1860, albumen silver print.

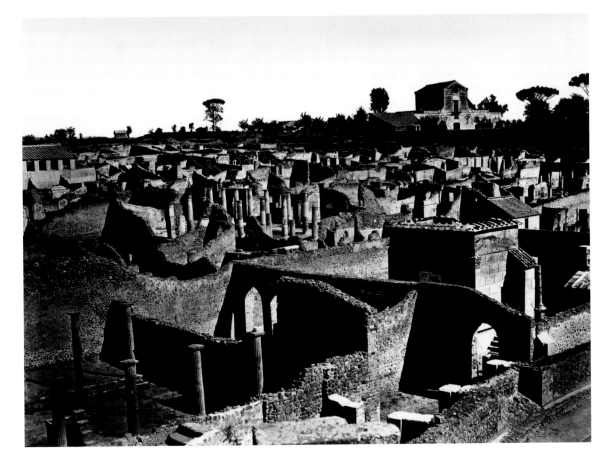

Giuseppe Fiorelli, and it is also possible that he inspired British scholar John Henry Parker to document the ruins of Pompeii. Parker had worked with other local photographers, between 1866 and 1871, towards a major publication titled *The Archaeology of Rome*. Sommer's view of Pompeii's ruined dwellings, with lights and shadows enhancing the overall sense of fragmentation would certainly resonate with a visitor's fantasy of the volcano's active power, as well as having an impact on archaeological studies of the strata and spatial relationships of these ruins. In particular, it has been noted that Sommer applied his experience of archaeology (of asymmetrical perspectives and flattened compositions) to his photography, creating a style that surpassed the picturesque formula.[23]

By 1873, with the success of his business, Sommer settled in a newly built four-storey building in the Neapolitan residential quarter of Chiaia, which became headquarters for his administrative and commercial activities. The shop on the ground floor sold not only photographs but also sculptural objects in terracotta and bronze that he produced in collaboration with his son. This additional expertise is revealing of his deep understanding of the tourist demand for souvenirs and also of his interest in three-dimensional renditions – an interest that might have been triggered by his marketing of numerous casts, realized by Fiorelli in Pompeii.

Sommer's focus on Neapolitan types and anecdotal narratives (the pickpocket, the fruit seller, the macaroni eater, women being deloused, the *lazzaroni*) was part of this context that appealed to both foreign and Italian bourgeois. As Adam Weinberg has observed, 'These photographs emphasize[d] distance between the middle and the lower classes and bolster[ed] the tourist's self-image of wealth and security. No doubt the touch of humor and the voyeuristic qualities of these images made them palatable and desirable for the tourists to obtain.'[24] Such an 'orientalist' attitude towards Italians – dirty, idle, primitive – found a whole range of subjects and attitudes that was shared by other studios in Naples. A group portrait made by Robert Rive (illus. 39) reflects the otherness of this population: forlorn street urchins clustered on a sandy beach around a young woman (possibly an older sister) photographed in the act of delousing an old lady (possibly her grandmother) who functions, simultaneously, as a

39 Robert Rive, *Nit-picking Street Urchins on the Beach, Naples*, c. 1883, albumen silver print.

40 Hippolyte Deroche and Francesco
Heyland, *The Construction of Giuseppe
Mengoni's Galleria Vittorio Emanuele II in
Milan: Vault of the Southern Wing with the
Cathedral's Spires in the Distance*, 1865–7,
albumen silver print.

comfortable pillow for the little boys. This striking picture combines many stereotypes of the South – the large family, the daily *dolce far niente*, the stark beauty of poverty – that surrender to the camera's distant gaze.

Parallel to this folkloric representation of social immobility, photographers were also alert to the signs of progress and growing urbanization that were occurring north and south after Unification. A photographer based in Naples, Achille Mauri, made a large series of photographs of railroad constructions,[25] and he also documented the building of the vast Galleria Umberto I (1887–91). Earlier on, two photographers with a studio in Milan, Hippolyte Deroche and Francesco Heyland, had recorded the construction site of the Galleria Vittorio Emanuele II (1863–77), a distinct ironwork monument of avant-garde European architecture. A photograph taken from a temporary wooden floor at the top of this gallery (illus. 40) captures the relationship between the modern arches and the distant spires of the cathedral, as a suggestion of this new secular space taking over the religious monument. This image marked the triumph of a new technology in a country that had reached, albeit with some delay, a modern identity, a bourgeois pride and a commercial exchange of goods. In its crystal-clear beauty, photography was reflecting these goals, becoming intrinsic to their fabric.

four
Amateurs and Professionals

In the late 1870s, as the market for classical tourist views and art repro-
duction was flourishing, a few commercial photographers in Rome were
making pictures that seemed out of the ordinary – almost bizarre. Their
subjects were the edges of the city, often without a clear documentary
reference – stairways, doorways, walled passages, stone houses and
courtyards. Most fascinating, the point of view and camera angle was
at times daring, at street level, or suspended in mid-air. The photograph
attributed to Gustave Eugène Chauffourier (illus. 41), featuring a man
dozing on the steps of a villa is an example of this new approach: not a
plain record of a monument but a spontaneous glance at a slice of life.
Chauffourier's aesthetic was shared by other photographers in Rome –
Carlo Baldassare Simelli and A. De Bonis – who contributed to John
Henry Parker's *The Archaeology of Rome* (1874), and provided painters
with views of a city that looked like a village.[1]

As photographic technology changed radically after 1880 with the
introduction of gelatin dry plates, these impressions became more and
more popular. No longer involved with the preparation of the negatives
and the laborious application of emulsion on the plate, photographers
were more free to browse the world. Many were amateurs – aristocrats,
novelists, painters – and did not seek commercial gain. The camera became
a notepad to record city dwellers, leisure time at the beach, games played
by friends and families, even a spontaneous smile on someone's face.
Back in the 1950s a noted critic, Lamberto Vitali, designated this new
group as 'the irregulars', praising their refreshing and immediate spon-
taneity in comparison with the stiff and formulaic views produced by 'the

regulars'.[2] Such a divide between art and topography, leisure and profession, amateur and commercial work shaped two parallel histories of photography for many years to come.

The comments of the director of a new journal, *Il Dilettante di Fotografia* (1890), Luigi Gioppi, sounded quite radical in this regard:

> The professional has not the will, the time or the money to study. He is dragged into an inevitable orbit that limits his work to mere commerce bent to the fashion of the day in his country or abroad. The amateur, instead, has free time and a baggage of advanced studies. He does not lack any money and therefore has the means to select, like a bee over flowers, the best of what he sees . . .[3]

41 Gustave Eugène Chauffourier (attr.), *Man Napping on the Steps*, c. 1870–75, albumen silver print.

The case of Count Giuseppe Primoli is paradigmatic of this new turn. An aristocrat whose family was connected to the Bonaparte dynasty, Primoli lived in Paris from 1853 to 1870, until the demise of Napoleon III's Empire. As the protégé of Matilde Bonaparte (his aunt) he was immersed in a *salon* that comprised famous French literati – Alexandre Dumas, Edmond de Goncourt, Guy de Maupassant and Théophile Gautier – who influenced his passion for literature. His friendship with Impressionist painters, Degas in particular, contributed to his understanding of the camera as an instrument of instantaneous recording. In 1870 he moved to Rome.

It was precisely the combination of reportage and storytelling that made Primoli's photography unique and engaging. Not only was he considered 'the King of the Snapshot',[4] due to his instantaneous images of horses jumping a fence, people rowing a boat and children at play, he

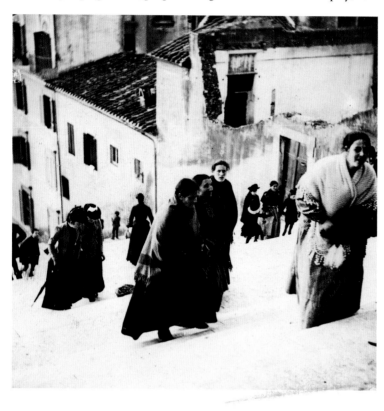

42 Giuseppe Primoli, *Women on the Steps of S. Maria Aracoeli, Rome*, December 1893, albumen silver print.

was also exceptionally capable of thinking about his images as a potential story, sequencing them onto paperboards. To this date, 318 of these remarkable paperboards are conserved in his old *palazzo* in Rome, and offer a unique source for understanding how the Count was thinking visually. A commentator of his time explained his process thus: 'The Count Primoli, when he decides to reproduce a subject, is not happy until he has exhausted it, photographed it from all sides, in all possible manners, in the most minute details. In this way, he obtains a cluster of photographs that helps him reconstruct complete events.'[5]

Primoli's events comprised the mundane, the artistic and the socially marginal: military parades, the fox hunt in the Roman Campagna, the arrival of Buffalo Bill in Rome, the theatrical demeanour of Eleonora Duse and Sarah Bernhardt and the street life of beggars and vendors, flooding into the city from the neighbouring country. Using the new model of the 'kinegraph', a small hand-held camera with a glass plate size of 8 x 9 cm and fixed focus, he captured the essence of life and the variety of human expression. Look, for example, at the daring camera angle showing the women ascending the staircase of S. Maria Aracoeli (illus. 42). The steep walk of these figures from all social ranks (elegantly dressed and draped in hand-knitted shawls) is enhanced by Primoli's diagonal line. This photograph, which was taken around the time that Etienne-Jules Marey was pursuing chronophotography, shows a similar fascination for time and motion. This picture is part of a sequence of fifteen vignettes illustrating life near the church on Christmas Eve 1893. It is also an important document that shows (to the right) the first demolition of the housing quarters by the Capitoline Hill, in order to make space for the imposing 'Vittoriano', built in honour of Victor Emmanuel II and to celebrate Rome as the capital city.

It has been noted that Primoli's social investigation was 'exempt from any folkloristic temptation',[6] and thus different from those pictures of 'types' (beggars, spaghetti eaters, etc.) produced in most Italian cities. Furthermore, his dispassionate curiosity for all aspects of Rome as a stage of modern life differentiated him from numerous other aristocrats (Prince Francesco Chigi, Marquis Giuseppe Caravita of Sirignano, Marquis of San Giuliano and two women – Maria Sophia, Queen of Naples, and Countess

Bellentani), who focused almost exclusively on their own privileged lives.[7] He truly uncovered the beauty of the banal.

If Primoli has been defined as 'the true and genius Zola-like photographer',[8] it was an Italian writer who made photographs inspired by the French novelist. Luigi Capuana, the Sicilian theorist of Italian naturalism ('*Verismo*'), practised photography as a positivist science and a personal keepsake of his home of Mineo, in the province of Catania. He started photography quite early, in 1863, building his own cameras and experimenting with spirit photography. Significantly, these beginnings were in Florence, a photography hub at this time, where Capuana was involved in reviewing plays at the theatre. Later on, his skills inspired important Sicilian authors – Giovanni Verga and Federico De Roberto – to photograph the life of those fishermen and peasants they had depicted in their novels. Capuana was also introduced to Primoli's circles, where he met and even photographed Zola.[9] His portrait (illus. 43) of Luigi Pirandello – the famous novelist and playwright from Agrigento – is not only a document of a younger writer whom Capuana had initially mentored, but also an intimate impression of this man's creative genius, rendered more accessible through a daring close-up.

43 Luigi Capuana, *Luigi Pirandello*, 1894, albumen silver print.

The relationship between photography, physiognomy and the recording of time was central for another protagonist of this period, the painter Francesco Paolo Michetti. Born to a modest family in the region of Abruzzi, he studied at the Academy of Fine Arts in Naples in the 1860s, becoming a representative of Italian *Verismo* or naturalism, converging into a visionary Symbolism. It appears that he started to take photographs in 1871, during a trip to Paris.[10] Photography became symbiotic with his art, acting not only as copy for his canvases but as an experiment

in its own right, to the point of finding autonomous expression in the 1910s, as he stopped painting. His use of cameras with multiple lenses, which were similar to Disderi's *carte-de-visite* apparatus, and adopted stereo-cameras of various sizes, was geared towards the study of movement, and focused on the instantaneous and almost secret traits of people's expressions.

Examples of the special dialogue he was able to establish with his subjects are the delicate portraits of his mother-in-law, Luisa Carmignani (illus. 44), an ageing and wrinkled woman, bundled up in her scarf, surrendering to the camera with expressions of tenderness, concern and grace. Needless to say, this intimate use of *carte-de-visite* was far from the formulaic aesthetics often associated with this format. This family photograph is part of a large archive that contains numerous studies of costumes and rituals of the poverty-stricken rural population of his region, squeezed and neglected by the urbanization and industrialization of the country. His attention to the social landscape of the South – embedded with superstition and archaic myths – was close to an anthropological study that was neither romanticized nor scientific and that found an exceptional balance with his small and large canvases. He shared this pursuit of the social with another photographer of this time, Luciano Morpurgo, who was equally inspired by the popular traditions of the Lazio and Abruzzi regions.

One of Michetti's paintings, titled 'The Daughter of Iorio', achieved recognition at the first Venice Biennale (1895), bringing him to collaborate

44 Francesco Paolo Michetti, *Zi' Luisa*, c. 1881 (contemporary print).

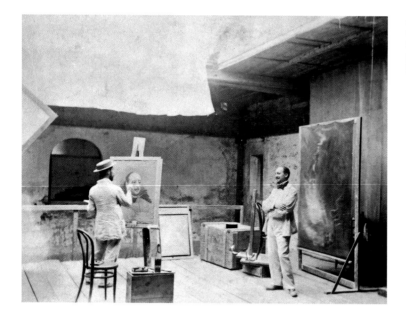

45 Mario Nunes Vais, *Michetti Sketching a Portrait of the Poet Gabriele D'Annunzio at Michetti's House at Francavilla*, c. 1890, gelatin on glass negative (contemporary print).

with the Symbolist poet Gabriele D'Annunzio on the theatrical set of an opera inspired by the same story. D'Annunzio shared Michetti's regional origins, only at a higher social rank. The two became close friends in the 1880s and '90s and the poet often followed the painter in his photographic explorations of Abruzzi's rugged landscape. D'Annunzio commented thus on Michetti's photography:

> As [Michetti] knows that, in order to achieve beauty, it is necessary to patiently linger on the real world, he has assembled a great detail of precise observations, [and] has analysed the appearance of things in all their elements in order to uncover their hidden relationships . . . In one word, he has been able to pursue nature's creation with his own means.[11]

An interesting document of this creative encounter lies in an unpublished photograph taken by a noted Florentine, Mario Nunes Vais: Michetti appears on the deck of his house in Francavilla al Mare – an old Franciscan convent, purchased in 1885 and converted into his

creative dwelling – while sketching a portrait of D'Annunzio (illus. 45), who looks at ease and cheerful by one of Michetti's canvases. This is proof of these artists' friendship and fame. Nunes Vais was, at the end of the century, the Italian equivalent of Nadar during the Second Empire: a portrait photographer of famous people during the Belle Epoque. But, unlike Nadar, he was not a commercial photographer (he did not even own a studio). In the definition of Lamberto Vitali, he was, also, 'an irregular'.[12] This image, uncovered from Nunes Vais' archive of 30,000 negatives, is a testimony of his connection to D'Annunzio (he took many portraits of him, as well as of his lover, Eleonora Duse) and of the importance of Michetti's abode in Italian culture – an open-air studio for photography, poetry and painting alike.

If Michetti was exceptional in his use of photography as artistic expression, his case was part of a larger history of collaboration between painting and photography that evolved in the last two decades of the nineteenth century. The work ranged from painters who had become photographers (Federico Faruffini), to painters who belonged to Italian Pointillism and sought realistic documentation (Giovanni Segantini, Pelizza da Volpedo), to portrait photographers who worked close to painters (Emilio Sommariva, Giovan Battista Ganzini).[13]

The story of a German aristocrat from Prussia, Baron Wilhelm von Gloeden, is an example of this creative exchange. Gloeden wished to be a painter, following an artistic education at the Weimar Academy, where he was inspired by the classicizing style of Adolf von Hildebrand and Hans von Marées. But when he moved to Sicily to recover from lung disease in 1876 he became interested in photography, receiving an apprenticeship from the local Giovanni Crupi, and, possibly, his cousin Guglielmo Plüschow, who had settled in Naples a few years earlier.[14] Gloeden's work shows a progression from social documentary pictures of Taormina to radical *tableaux vivants* that are clearly modelled on painterly compositions, such as those by Lawrence Alma-Tadema. His name is universally recognized in the histories of photography for the overt homoeroticism in many of his staged sets. In some of them one might perceive the colonizing gaze of this aristocratic Prussian, asking Sicilian peasants to pose as if they were gods or spirits from classical

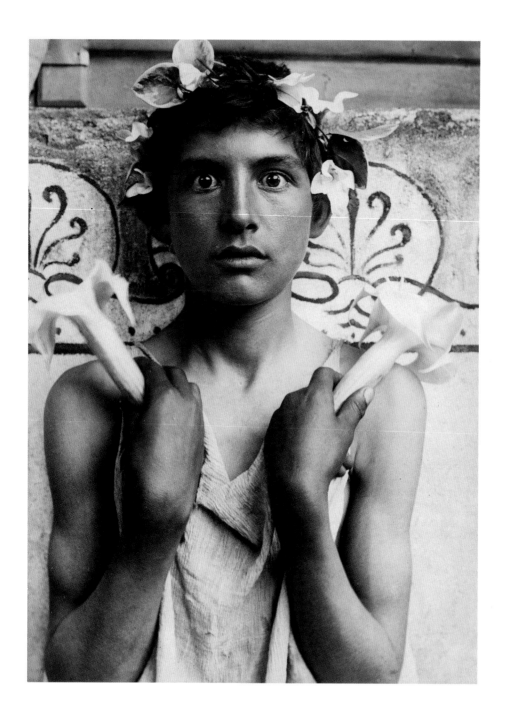

mythology (illus. 46), or to dress in the costumes worn in neighbouring Arab countries.[15] Additionally, Gloeden's nudes were densely symbolic and open to interpretation, evoking the atmosphere of a mythical and timeless Arcadia. In some cases Gloeden himself dressed up in costume, as an Arab or as Jesus Christ, working in the same vein as the American Fred Holland Day and anticipating the fantasy and theatricality of much Pictorialist photography.

Significantly, it was a meeting with Michetti at Francavilla that reinforced Gloeden's beliefs in photography. This was Michetti's feedback: 'Painting is a type of art where one can be an artist or a craftsman; on the contrary, photography is a craft, where you can prove to be an artist.'[16] Ironically this wealthy man had to apply his artistic photography to commerce as a consequence of his family's financial crash. After 1905 he made a living by producing a series of postcards from his photographs, thus rendering this mythical image of Italy more popular (incidentally, his nudes were censored and destroyed during Fascism).

Gloeden's switch from amateur to professional was symptomatic of the last two decades of this century, when photography had become common practice for 'regulars', 'irregulars' and casual snap-shooters with Kodak cameras. The need to find unity in the field had grown, together with the awareness of the ubiquity of photography in Italian society. Thus, in 1889, 50 years after Daguerre's announcement, the Società Fotografica Italiana (SFI) was founded in Florence, with Paolo Mantegazza as president and Carlo Brogi as vice-president. Mantegazza was a man of science, Director of the National Museum of Anthropology in Florence, and Professor of Anthropology; Carlo Brogi was the son of Giacomo Brogi, a successful studio in Florence contemporary with Alinari, and named official photographer of the king in 1878. Carlo Brogi was deeply involved in granting a professional and legal identity to photographers within a country still incapable of recognizing the value of this medium. His numerous papers on copyright issues found recognition, at a late date, in 1910, when the Italian government guaranteed legal protection to photographers.[17] The SFI published a monthly bulletin which became a new, important vehicle of national information. At the same time the journal *Il Dilettante di fotografia* (1890) was addressed to Kodak amateurs,

46 Wilhelm Von Gloeden,
A Boy with Two Calla Flowers,
c. 1900, albumen silver print.

while *Il Progresso fotografico* (1894) had a very technical and specialized scope, in close dialogue with the chemical industry.

Mantegazza was a typical nineteenth-century positivist who embraced photography for its modern significance. His opening speech at the SFI revealed this enthusiasm and understanding:

> Photography holds a very precious value, that of being democratic. Science is always the most faithful ally of true democracy . . . The railroad transports today at equal speed the Prince and the proletarian, and the electrical light shines in our streets above the heads of the poor and the rich. Similarly with photography, today, with little money, it is possible to preserve the features of our dearest, as it was once allowed only to wealthy men. We must bless science, which widens the horizon of the human eye and grants to everybody's hearts what was once privilege for a few. We must bless photography, which is one of the youngest and most sympathetic daughters of science.[18]

Such a democratic outlook pertained to science and art. With this enlightened spirit, Mantegazza conceived a photographic publication with Brogi junior (Giacomo) that aimed to illustrate the psychology of human expressions. His *Atlas of Expressions of Pain* (1876) included 123 photographs grouped in 27 plates, and was inspired by earlier photographic studies of human physiognomy, such as Duchenne de Boulogne's *Mécanisme de la physiognomie humaine* (1862) and Charles Darwin's *The Expressions of the Emotions in Man and Animals* (1872).

Mantegazza's focus was on the analogy between the expressions of physical pain (provoked by a variety of physical stimulations connected to taste, hearing, smell and sight) and that of sorrow (not as tangible).[19] This was a comparative study of human and racial features, which included also an African model, as in the cases shown here (illus. 47–48), where the expression of pain and disgust on both wrinkled faces was in response to the tight squeezing of these men's fingers. Mantegazza's involvement with photography continued further, in his anthropological studies of people from Lapland (photographed by Stephen Sommier) as well as India.

47 Giacomo Brogi, 'Pains of general sensibility: expression made by a grimacing man', plate II from *Atlante delle Espressioni del Dolore*, 1876, albumen silver print.

48 Giacomo Brogi, 'Pains of general sensibility: expression of a strong reaction', plate XIV from *Atlante delle Espressioni del Dolore*, 1876, albumen silver print.

Additionally, his introductory remarks to Carlo Brogi's volume *The Portrait in Photography* (1895), an essay that explained the art of private, public, celebrative and promotional portraits, confirmed Mantegazza's enthusiastic belief in photography as a democratic medium and his commitment to this important Florentine photographer.

If one looks at the overall scene of photography at the end of the century, it becomes clear that Italy had two centres: Florence and Turin. The first aimed towards a national unity, the other had a more pronounced international outlook. In 1898 the city of Turin hosted the first congress of photography and organized a national exhibition that, for the first time, kept 'artistic photography' separate from the display of cameras and commercial products. This exhibition marked the debut of Guido Rey, who became the best-known Italian Pictorialist (published in *The Studio*, in 1905, and in *Camera Work*, in 1908).[20]

Rey's passion for photography had been ignited by enthusiasm for alpine climbing, which he shared with his cousin, Vittorio Sella. Both were nephews of Quintino Sella, Minister of Finances in the new Italian government, and the founder of CAI, the Italian Alpine Club (1863). This club gathered the most enlightened social class from Turin – ministers, noblemen, professors, lawyers and businessmen – at a time when this city

was still Italy's capital. Rey belonged to this group as the son of a business-man involved in a thriving textile industry.[21] His photographs were a vehicle for stories – from his alpine sketches, dated to 1891, to a range of *tableaux vivants*, taken at his country villa, located in the hills surrounding Turin. His characters were members of his family – his nephews and sister-in-law – and the staging consisted of re-enacting pictorial dreams: the painterly world of Japanese prints, scenes of classical age and antiquities and the Flemish world of Vermeer and van Dyck. Many of these images acquired elegance through platinum printing. In particular, the accuracy of his peaceful composition of classical Rome (illus. 49) reveals a fascinating anachronism when considering this photographer's actual domestic life and the fantasy world of antique costumes, mosaics and bas-reliefs.

49 Guido Rey, *Girls with Pigeons (Classical Rome)*, c. 1897, platinum print.

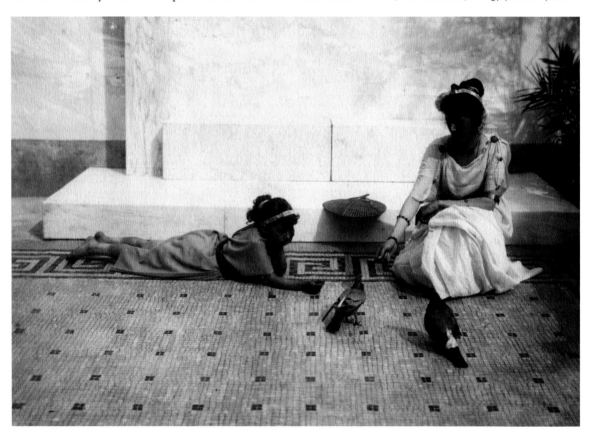

50 Vittorio Sella, *The Weisshorn and Mischabel, Summit of Castore (4,230 m). First Section of a Panoramic View*, 13 July 1888, gelatin silver print.

The spirit of Vittorio Sella's alpine photography was different from Rey's imaginary flights. As Mark Haworth-Booth has summarized, 'Sella used his large camera like a magnifying glass',[22] seeking faithful details in glaciers and geological layers. Having begun taking pictures in 1879, using wet-collodion and albumen prints, he later shifted to gelatin dry plates and to a new paper (P.O.P., or printing-out paper) that guaranteed warm hues and a long tonal range. He was nurtured in photography from a young age, as the son of Giuseppe Venanzio Sella, author of the first Italian treatise on photography, *Il Plico del Fotografo* (1855), and his family represented the new industrial nobility in Piedmont, as owners of a woollen mill in Biella. Sella's records of the Alps and faraway landscapes, among these the Caucasian mountains, Sikkim and Karakorum,

convey the excitement of mountain climbing and sublime vistas. It is no wonder that the American Ansel Adams championed his work for its impeccable skill in controlling light and exposure, and the straightforward sense of awe towards nature. One early image taken in the Alps near Monte Rosa (illus. 50) combines photographic purity of light and shadow with a painterly tradition that matches Caspar David Friedrich's *Wanderer above the Sea of Fog*, where a human figure confronts the immensity of nature.

The cultural prominence of Turin was confirmed in 1902, when photography found a special place in an international exhibition of decorative arts. This venue was significant on many levels: as the first and only international exhibition of artistic photography in Italy; as the first attempt of Italian photography to be 'modern'; as the achievement of amateurs in initiating this new aesthetics.[23] The main organizer, Count Edoardo Di Sambuy, was also President of the Società Fotografica Subalpina, an amateur society that had formed in 1899 in Turin. The design of the exhibition, installed in a special pavilion, met the goals of presenting photographs as works of art. All major European countries participated and American photography, championed by Alfred Stieglitz, was awarded a special prize by the Italian king.

51 Cesare Schiaparelli, *Sheep Pasture at Sunset*, 1900, silver bromide print.

This exhibition led to the creation of *La Fotografia artistica* (1904–17), a monthly magazine directed by the journalist and amateur photographer Annibale Cominetti, published in Italian and French and illustrated with photogravures. This elegant publication had the same life span as *Camera Work* (1903–17) but its spirit differed from Stieglitz's titanic struggle to raise photography to the height of modern art. As Paolo Costantini summarized in his study, 'the idea of modernity [was] constantly reiterated but never quite pinned down . . . in this young Italy, still young as a kid, who dreamed of metropolises but was incapable of seeing the new life of its cities'.[24] That feeling of escapism, already pointed out in Rey, permeated the work of Italian Pictorialists, most of them sharing high social rank, landed properties and industrial enterprises. The works by Bertieri, Grosso, Masoero, Pacho', Rho' Guerriero and Cesare Schiaparelli were recurrent in *La Fotografia Artistica*, presenting, most of the time, languid and sentimental meditations on pastoral landscapes. Schiaparelli's image of sheep at sunset (illus. 51) is a trademark of this production: a highly crafted view taken with backlight, and a lovely composition of a subject that is timeless and reassuring. His particular craft, or trick, consisted of adding artificial skies with clouds, combining two negatives.

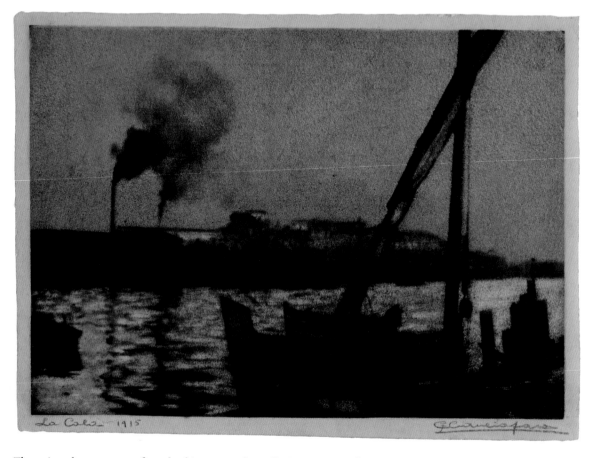

La Cala - 1915

The painterly treatment of rural subjects was also a distinctive trait of
Domenico Peretti Griva, a lawyer from Turin who mastered the gum
bichromate, as well as the bromoil transfer process, well into the late
1940s. The delicate impression of a woman bent over, working in a field
of corn (illus. 52), is a clear reference to Millet's pious farmers, at the edge
of a world in transition, immersed in the rituals of agriculture.

The recent discovery of a large archive of photographs produced by a
noble amateur in Sicily, Filippo Cianciàfara Tasca di Cutò, proves that the
techniques and subjects of artistic photography were common knowledge
for this social constituency. Cianciàfara, a cousin of the Sicilian writer
Giuseppe Tomasi di Lampedusa, author of *The Leopard*, had started

experimenting with artistic photography in 1915, using a range of processes from gum-bichromate to resinotype (illus. 54), aristotype and carbon print.[25] A series of local marinas taken near his hometown of Messina is particularly striking for the masterful rendering of reflections in the water. In *La Cala* (illus. 53) the familiar world dissolves into a sinister image reminiscent of Whistler's *Nocturnes*. The peaceful fishing boats in the foreground appear threatened by tall industrial smokestacks, whose dark fumes are reflected in the calm water. It is possible to retrace this bleak scene to the photographer's own sense of loss (his parents had been killed in a terrible earthquake in Messina in 1908), but it is also tempting to see this view in the context of the effects of the First World War, the loss of peaceful retreats, and the symbolic use of photography to convey a growing existential unease.

54 Filippo Cianciàfara Tasca di Cutò, *Controvento*, 1932, resinotype.

Italian Modernities

A major figure of this period, Anton Giulio Bragaglia, took a position in the critical debate on art and photography. In 1912 he published an interview in *La Fotografia artistica*, where he identified the cultural delay of Italian artists and intellectuals (Biondi, Sartorio, Venturi, Bonaventura) in ascribing to photography those intangible qualities of passion and inspiration that were easily credited to painting and sculpture. Bragaglia was the son of a pioneer in the Italian film industry, the manager of the Cines Company based in Rome, and from a young age he was fascinated by moving images. This early exposure led to his first photographs of para-psychological phenomena[1] and subsequent experiments in 'photodynamism', a word he invented that conveyed his photographic revolution, breaking away from pictorial conventions and showing the abstraction of movement. Bragaglia's new images were published in *La Fotografia artistica* and appeared radically different from the romantic and nostalgic works seen in this journal.[2] They represented an avant-garde entering the new century.

In 1911 Bragaglia wrote a treatise, *Fotodinamismo Futurista*, that explained this groundbreaking aesthetic, starting with a polemical note in the preface: 'It is a pleasure to observe that my brother Arturo and I are not *photographers* and could not be further from that profession.'[3] With such a disclaimer he drew a line between his experimental work and any accepted notion of photography. He argued that his pictures were no longer realistic (he criticized 'the pedestrian photographic reproduction of the immobile reality, stopped instantaneously') nor pictorialist (as he criticized 'the overly mummified "artistic photographs" where the

55 Anton Giulio Bragaglia, *The Typist*, 1911, gelatin silver print. This image is unusual in that published versions of 'The Typist' do not reveal the 'Sun' company's name.

monkey imitation of Old Masters is evident').[4] Their non-descriptive quality, obtained in camera, elevated them to contemporary art, in touch with the vibrancy of modern life.

The image of the trajectory of human hands bouncing on the keyboard of a machine manufactured by the Sun Typewriter Company (based in New York) is an example of this new writing with light, where the camera records the interval of a gesture. *The Typist* (illus. 55) was obtained by leaving the lens open during exposure, showing a ghost-like trace almost dematerialized through its movement. The resemblance of this aesthetic to Etienne-Jules Marey's chronophotography – highly influential on Futurist painters Giacomo Balla and Luigi Russolo and published

in photographic journals like *Il Dilettante di Fotografia*[5] – reflected similar investigations but different results. While Marey's analytical study of a body's kinetic phases showed a progressive sequence of fragments, Bragaglia delineated movement as a continuous synthesis.

With these new pictures Bragaglia engaged with the complexities of Italian culture, which seemed to resist, more forcefully than that of other countries, the idea of photography as artistic expression. It is remarkable that the heart of this discussion would continue to haunt, and ultimately defeat, him. Due mostly to the antagonism of the artist Umberto Boccioni, Bragaglia, author of *Fotodinamica Futurista* (1912), was alienated from the Futurist movement in 1913, the year he turned to theatre and film. He went on to open an art gallery (Casa d'Arte Bragaglia) in 1918; meanwhile his brother Arturo continued to work in photography through the 1920s and '30s.

Following these rough beginnings, a new wave of works emerged in 1930, as the *Manifesto della fotografia futurista* was officially signed by Tato (pseudonym of Guglielmo Sansoni) and Filippo Tommaso Marinetti (the founder of the Futurist movement). The *Manifesto* launched a wide range of visual explorations that also assimilated ideas from Surrealism and Dada: camera and darkroom manipulations, multiple exposures, montage, collage and theatrical set-ups. This new group of Futurists had backgrounds in photography (Wanda Wulz and Enrico Pedrotti from Trieste; Filippo Masoero, Rome; Mario Castagneri, Milan; Vittorino Gramaglia, Turin; Giulio Parisio, Naples), while others brought to photography expertise from painting, architecture, theatre and graphic design (among them Fortunato Depero, Vinicio Paladini, Ivo Pannaggi, Franco Grignani, Bruno Munari and Riccardo Ricas).

Tato's portrait of the Futurist poet G. A. Fanelli (illus. 56) is paradigmatic of this new phase when montage and superimposition of various objects replaced Bragaglia's 'photodynamism' of an individual gesture. Tato explained this effect as 'transparency of opaque bodies',[6] conceiving a new graphic complexity and dream-like effect through multiple exposures. In this case the poet's face (seen in profile and frontally) was layered onto photographs of books that seemed to float over his head. These volumes were revealing of Fanelli's art (Enrico Cavacchioli's collection of Futurist

verses, *Cavalcando il sole*) and ideology (Rousseau's *Emile,* and a book on natural history by Giovanni Mace). Tato's new research in the simultaneity and transparency of bodies, together with his notion of the 'disguising of objects' (inanimate objects assuming anthropomorphic shapes) was an indication that photography was pushing its boundaries into the narrative of the unconscious.

56 Tato (Guglielmo Sansoni), *The Poet G. A. Fanelli,* 1930, gelatin silver print.

57 Mario Castagneri, *Man with Arm Raised in Fascist Salute, with Superimposed Cross, Circle and Spray of Flowers*, c. 1930, gelatin silver print,

As Marinetti's Futurism teamed up with Mussolini's Fascism in the 1920s and 1930s, portrait photographers like Mario Castagneri employed similar strategies of montage and multiple exposure to filter the Fascist ideology. Castagneri, once a Pictorialist, now embraced Futurism and became a close friend of the painter and designer Fortunato Depero. This superimposition of a muscular male body making a Fascist salute, with a symbolic cross and a bunch of flowers, in perfect parallel line with the young man's arm (illus. 57), is characteristic of his Futurist photography that associated portraits with symbols of their life (other examples include Depero and the modern skyscrapers of New York, and Marinetti with Fascist insignia). This image is evocative of human sacrifice, state religion and the creative possibility of bringing together human and superhuman elements.

Significantly, Castagneri had also portrayed the artistic entourage of Margherita Sarfatti, the famous mistress of Mussolini, art critic and supporter of *Novecento* – a new artistic movement that impacted on other artists in the 1930s and '40s in its celebration of a monumental

58 Marcello Nizzoli, 'Photomontage with Mussolini as a Pilot', published in *La Rivista Illustrata del Popolo d'Italia* (November 1935), p. 32.

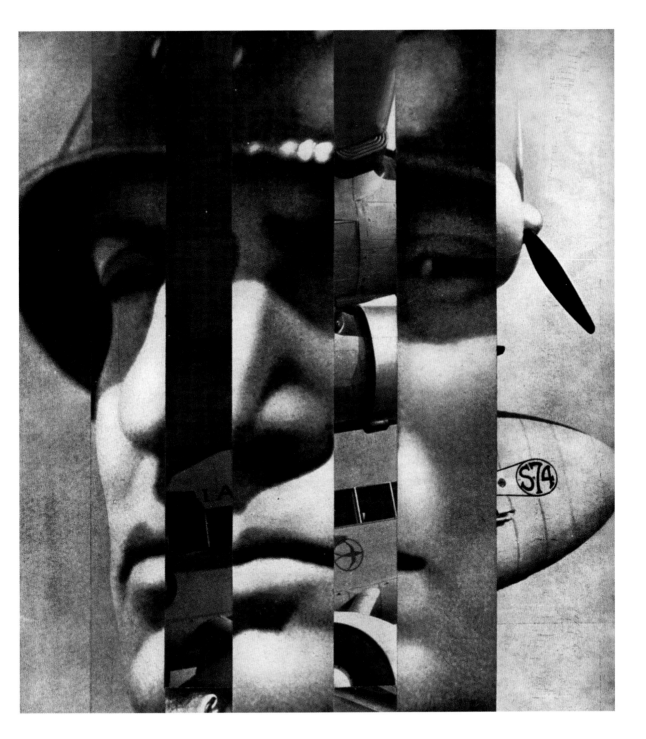

Italian art of pure and classical forms. One of these artists, the photographer Elio Luxardo in Rome, enhanced the representation of male strength and female beauty, pushing forward those elements noted in Castagneri's works.

Inevitably, during this period the points of convergence between avant-garde art and politics became numerous and at times contradictory, prompting historians of art and culture to speak of 'Fascist modernism'.[7] Artists used photography to illustrate the mythologies of the regime, borrowing from Futurism, Russian Constructivism and the Bauhaus (which had been repressed by the Nazis in 1933). In numerous and exciting ways photography participated in a new dialogue with architecture, graphic design and publicity.

The case of Marcello Nizzoli – a painter, designer and architect – is paradigmatic of the creative exuberance of this decade. His photomontage of Mussolini (illus. 58) exemplifies one of his typical strategies: the slicing of the photograph in folded pleats, revealing surprising effects when viewed from the extreme left or right. Published in *La Rivista Illustrata del Popolo d'Italia*, a pictorial magazine founded by Il Duce and directed by Arnaldo Mussolini (Il Duce's brother), this image used the common Fascist trope of Mussolini the air pilot as symbolic of his leadership of the new government and military. Parts of the S74 airliner, recently designed by the company Savoia-Marchetti for Ala Littoria,[8] intersected Il Duce's features as emblems of speed and efficiency in the modern empire.

Images of aeroplanes were numerous in the 1930s, reflecting the Futurist thrill of flying and the Fascist utopia of conquest. Filippo Masoero, who had been appointed director of photography and cinematography in Italo Balbo's Ministry of Air, performed aero-photography, leaving the camera shutter open during his spectacular aerobatics over the historic scenarios of Italian cities. The aesthetics of his photographs resembled the work of aero-painters, who had signed a *Manifesto dell'aeropittura futurista* in 1929, and perceived the aeroplane as the ideal observatory for a dynamic view of the world.[9]

The work of Bruno Munari, a member of the Milanese Futurist group since 1926, was also key to the shift from painting to photography and

graph design, with a clear understanding of Futurist and Bauhaus strategies.[10] The cover he created with his partner Riccardo Ricas for *L'Ala d'Italia* ('National Periodical of Fascist Aviation') announcing the spectacular exhibition Mostra dell'Aeronautica (1934) installed in Giovanni Muzio's Palazzo dell'Arte in Milan, is a case in point (illus. 59). A rough aeroplane cut-out was filled with photographs selected from the catalogue of the first Milan Triennale of 1933, illustrating the triumph of

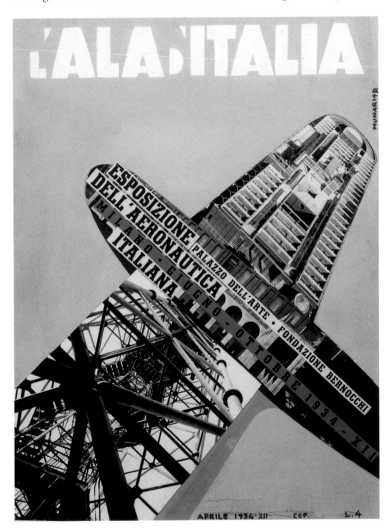

59 Bruno Munari and Riccardo Ricas, *Esposizione dell'aeronautica italiana*, tempera and photocollage, *L'Ala d'Italia*, (April 1934).

new Italian architecture: inside the left wing, Gio Ponti's newly built Torre Littoria, an impressive steel construction with a lighthouse and a café on top, was presented at a daring angle from below; in the right wing was an interior view of Muzio's Palazzo dell' Arte, photographed from the tower; while the fuselage combined the text of the announcement with a frontal view of this building.

This montage captured the spirit of the exhibition, a celebratory feast of Italian aerial achievements from Leonardo da Vinci's machines to Balbo's Atlantic crossings in the early 1930s. The exhibition was meant to be experienced as a 'construction' rather than 'illustration', where 'the realism of the document [was] sacrificed to the overall installation, going beyond the dualism of form and content, ornament and structure'.[11] Similarly, Munari and Ricas appropriated photographs for a new meaning that expressed modernity and power. It is significant that Munari was also a participating artist in this exhibition, teaming up with the architect Giuseppe Pagano in the 'Sala d'Icaro' and contributing cosmic wall paintings of aeroplanes and flocks of seagulls, while Marcello Nizzoli collaborated with the architect Edoardo Persico in the installation of photographs of heroes and martyrs of flight in the 'Sala delle Medaglie d'Oro'.

The Aeronautica exhibition, together with the Mostra della Rivoluzione Fascista (1932), celebrating the tenth anniversary of Mussolini's 'March on Rome', confirmed the role of photography in political propaganda. During this period the Istituto LUCE published the book *L'Italia Fascista in Cammino* (illus. 60), an impressive compilation of 516 photographs presented in montaged clusters with multilingual captions, on the subjects of physical youth, fertility, education, industrial and military power. The montage illustrated here is an example of the combinations of perspectives and scale deployed to create an overall dynamic effect.

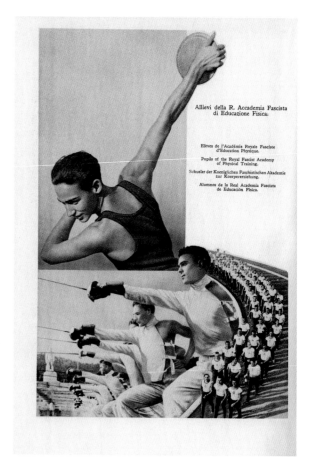

60 'Royal Fascist Academy of Physical Training', from *L'Italia Fascista in Cammino* (Rome, 1932), p. 82.

But it was in the domain of advertising where photography and graphic arts thrived as experimental forms. In particular, Bauhaus functionalism and experiments with photography and typography impacted the work produced for Italian industry, including Olivetti, Pirelli, Fiat, Dalmine and Breda. One of the focal points for graphic artists of this period became the Studio Boggeri, founded in Milan in 1933 by photographer and designer Antonio Boggeri. The group included fellow countrymen like Nizzoli, Munari and Erberto Carboni, as well as Bauhaus exiles like Xanti Schawinsky and Max Huber. The magazine *Campo Grafico* (1933–39), also inspired by Boggeri and directed by Attilio Rossi, revealed the maturity of this group in the understanding of photography as visual communication.

In particular, the work of Luigi Veronesi – painter, photographer and graphic designer, author of numerous covers of *Campo Grafico* – indicates his emulation of László Moholy-Nagy. Veronesi created numerous photograms, both in black and white and in colour, throughout his long career and he fully grasped the meaning of photography as abstraction, employed towards the creation of visual puns. *'Del Fotomontaggio'* (illus. 61) is an example of his and Pallavera's appropriation of found imagery within a visual essay. A machine-gun on a tripod is aimed at a panicking crowd; and there is a cutout of a man lying down as if dead. This narrative vignette is combined with a cosmic illustration of the globe and its constellations, connected by a dynamic red line reminiscent of Russian Suprematism. Veronesi's accompanying text explains his purpose:

Photomontage is the unique expression of modern illustration. A book, a magazine, a newspaper that aims to be part of the contemporary spiritual climate must rely on photography and on the dynamic creation of photomontage which is imposed by the artist . . . Photomontage is not a basic sampling of photographs with more or less documentary pretence, as one often sees; rather, it is foremost a pictorial composition . . . In this way it is possible to achieve an imaginative ensemble where the story of an event, or of an object, is not merely conveyed with the objectivity of photography, but with the atmosphere and life newly created.[12]

VERONE/I - PALLAVERA - 1934

The magazine *Campo Grafico* dedicated ample discussion to photography, following, for the most part, the lesson of the Bauhaus. In particular, Antonio Boggeri articulated his grasp of photography as a modern language of pure objectivity – 'something precise and concrete, which can be defined as a model of architecture'.[13] In 1929 he wrote a lengthy commentary on the impact of this 'New Vision' in Italy, observing that cinematography, aerial photography and the language of publicity had contributed to the invention of close-ups, non-perspectives and abstraction – strategies that reflected the works of Renger-Patzsch, Rodchenko, Moholy-Nagy and Weston, exhibited at 'Film und Foto' in Stuttgart in 1929. This essay was published in *Luci e Ombre*, a special annual publication (1923–34) of *Il Corriere Fotografico* which was directed in Turin by Stefano Bricarelli, Achille Bologna and Carlo Baravalle, three lawyers and amateur photographers, commonly called by historians the three 'B's.

Boggeri singled out Bricarelli's 'Helicoidal Ramp at the Fiat Factory' (illus. 62) as exemplary of this new photography – an image that captured the functional beauty of the secular vaults of car production. This photograph was also symbolic of recent innovations at Fiat, where the famous Lingotto car factory had opened in 1923, and where the first assembly line was set up. As *Luci e Ombre* stood for a group of professionals and amateurs who aimed to pursue a new idea of photography, their debate found an ideal context in Turin as a propulsive centre of growing internationalism and successful industries.

Italo Bertoglio – a civil engineer and amateur photographer between the 1910s and the 1940s – surveyed a variety of industrial machinery and electrical power plants, producing a body of work that was quite daring in the choices and the framing of his new subjects. For example, his close-up view of an electrical coil transformed this colossal metallic structure (illus. 63) into modern architecture, harmoniously bent over two workers. Such metamorphosis from metal to stone, from coil to arch, was a reminder of similarly striking camera transformations achieved by Renger-Patzsch in *Die Welt is Schön*, while the presence of workers, perfectly integrated within this mechanical gear, seemed to echo Margaret Bourke-White's sense of awe when looking at mechanical structures.

61 Luigi Veronesi and Franco Pallavera, 'Del Fotomontaggio', *Campo Grafico. Rivista di Estetica e di Tecnica Grafica*, vol. II (December 1934), p. 280. The crowd scene was appropriated from *Il Quadrante* (February 1934).

62 Stefano Bricarelli, *Helicoidal Ramp at the* FIAT *Factory, Turin*, 1927, gelatin silver print.

As noted in the discussion on photomontage, Italian photographic modernism often mirrored Fascist symbolism. A range of authors in *Luci e Ombre* (Bertoglio, Cesare Giulio, Vincenzo Balocchi, Riccardo Moncalvo, Bruno Stefani, Mario Bellavista, Giulio Parisio) had represented this regime's insignia, buildings and crowds, and many of them had also contributed impressive pictures to *La Rivista Illustrata del Popolo Italiano*. Bellavista, in particular, had been eloquent about the significance of photography within modern life, listing these new symbols: 'Smoky industrial furnaces, fast transatlantic ships, aeroplanes, machines, noisy

engines, the glorious armies of Mussolini, young athletes, collective reunions, daring architecture pointing towards the sky like a scream of victory . . . '.[14]

Mario Gabinio's radical image of Mussolini's Torre Littoria (1933–34) in Turin (illus. 64) illustrated such a 'scream', enhancing the height of this twenty-storey structure with a radical perspective that looked similar to Rodchenko's tilted views of Russian apartment blocks. The image was part of Gabinio's documentation of new buildings and urban planning in Turin in the 1920s and '30s. From early nostalgic surveys of declining

63 Italo Bertoglio, *Short Circuit*, 1934, gelatin silver print.

neighbourhooods, Gabino's work changed into dynamic images of
Turin's new architecture.

As noted in the earlier discussion on temporary installations and
photomontage, architects and photographers of this generation collabo-
rated closely on a definition of modernity. For example, in 1932 Gio Ponti
(founder of *Domus*) had stated that 'photographic distortion is our same
reality; it is for the most part, even, our knowledge, and therefore our

64 Mario Gabinio, *Torre Littoria, Turin,*
1934, gelatin silver print.

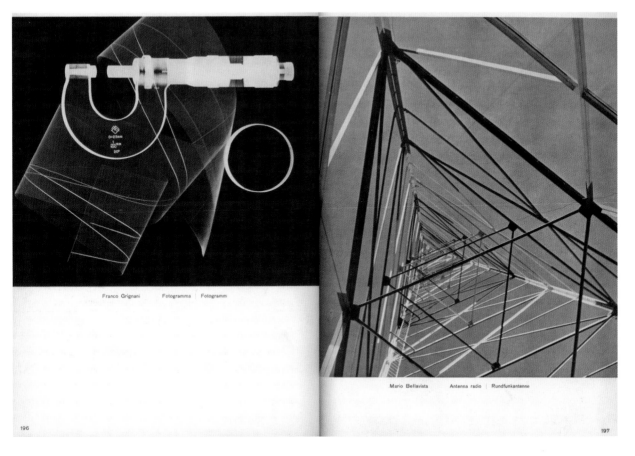

65 Franco Grignani, *Photogram*; Mario Bellavista, *Radio Antenna*; unnumbered page spread from *Fotografia: Prima rassegna dell'attivita' fotografica in Italia*, special issue of *Domus* (1943).

judgment'.[15] Edoardo Persico (co-director with Giuseppe Pagano of *Casabella*) had commented on the artistic autonomy of Atget in choosing subjects like mannequins in store windows and operating with no artistic frills, only accordingly to his camera's optics.[16]

This creative dialogue between photography, architecture and graphic design culminated in a special issue of *Domus* (published 18 February 1943, a few months before the coup that ousted the Fascists), and titled *Fotografia. Prima rassegna dell'attività fotografica in Italia*. Defined by historians as a 'manifesto' of photographic modernism,[17] this was a bilingual portfolio (in Italian and German) and a summary of new photography, with 171 images by 114 authors, a graphic layout

by Albe Steiner and essays by Ermanno Scopinich, Alfredo Ornano and Federico Patellani. The range of photographers selected by Scopinich showed an impressive breadth and abolished the distinction between professionals and amateurs. There were architects (Sissa, Pagano, Peressutti, Mollino), designers (Boggeri, Munari, Steiner, Veronesi, Nizzoli, Grignani), film directors (Comencini, Lattuada), photojournalists (Patellani), amateurs (Cavalli, Vender, Finazzi, Leiss) and professionals (Balocchi, Arturo Bragaglia, Luxardo, Ornano, Sommariva, Bellavista). These diverse contingencies engaged with social documentary, publicity, realism and abstraction, in an exciting pursuit of experimental images. The double-spread with Franco Grignani's *Photogram* and Bellavista's *Radio Antenna* (illus. 65) was a further confirmation that Moholy-Nagy was a decisive influence for the Italian modernists.

In his introduction Scopinich commented on the photographers' civil duty towards a national and cultural progress, which was unconventional but open to a wide range of creative expressions. As he said:

> Let photography become a spontaneous art, without prejudice or imposition; let the photographer interpret with his own sensibility, nature and society; explore, with his own intelligence, the real and the imaginary; let him go beyond the threshold of the real. Furthermore, Surrealism and abstract vision can be reproduced photographically . . . we do not limit, *a priori*, the possibility of photographing thoughts and dreams.[18]

The photographic theories of two architects included in this issue were proofs of the potential described by Scopinich. Carlo Mollino, based in Turin, used photography in a directorial mode, propping his interior design as a dream-like stage. In particular, between 1937 and 1943 he made a series of 'set portraits' of women that were part of this décor, some grouped together later by Scopinich in a little book titled *Ritratti Ambientati*.[19] *The Devil in the Glass* (illus. 66) was one of them: Mollino had transformed the crystal case of his newly designed interior of Miller House (1936) into a magic treasure trove filled by the enchanting face of a woman in the act of gazing at a range of objects. From left to

right, the visible objects were a small wooden mannequin (carved by Mollino's artist friend, Italo Cremona), a plastercast of two clasped hands (used by Max Ernst in a collage), two crystal glasses and the hint of a shell (on the far right). This installation and game of reflections revealed Mollino's inclination towards Surrealism, as confirmed by his theoretical essay on photography, *Il Messaggio della Camera Oscura* (written in 1943 and published six years later). This extraordinary

66 Carlo Mollino, *The Devil in the Glass*, 1939, gelatin silver print with fine pencil and watercolour retouching.

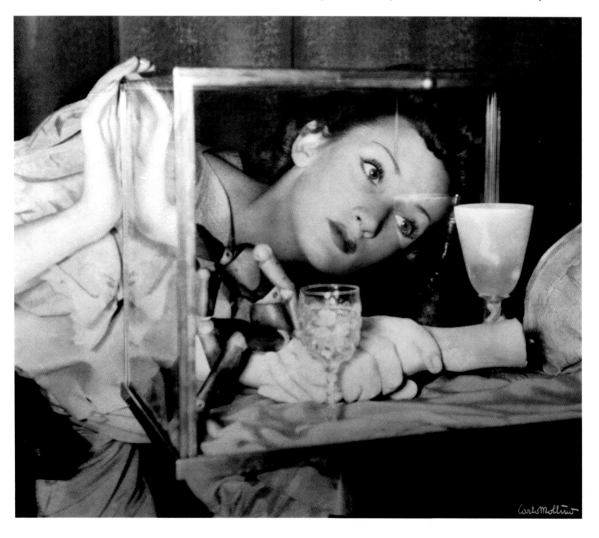

volume surveyed the history of photography, champ-
ioning the work of Alvarez Bravo and Man Ray for
their unique capacity to 'transfigure reality . . . [and
portray] all the fables of creative fantasy, free from all
restrictions'.[20] Clearly, Mollino aimed to reach those
goals in his own eclectic approach.

With a different focus, Giuseppe Pagano revisited
vernacular architecture as a new vocabulary to build
on the present. His detail of a local house on the
island of Ischia off Naples (illus. 67) is an example of
his visual revolution: the striking viewpoint, light
and texture render the house as an intersection of
planes in touch with the language of Bauhaus func-
tionalism. This image was part of a large archive of
photographs of vernacular buildings that Pagano
assembled, with his Rolleiflex, in preparation for the
1936 Triennial of Architecture in Milan. Significantly,
the need to provide visual material for this display
had prompted him to become a photographer.
Several factors at work in Pagano's operation would
mark Italian visual culture from then to the end of
the twentieth century: the search for an unknown
Italy and the consequent necessity to find a modern
vocabulary that conveyed the experience of seeing
things anew; the rebellion against the codified image of a monumental
country, Alinari-style, built along traditional schemas established in
the Renaissance; and the integration of the marginal dwelling into a
modernist predicament.

Pagano proudly described himself as a 'hunter of images' approach-
ing a country 'not yet discovered . . . shaped by vernacular and heroic
horizons, built with strange contrasts, like revelations with modern
echoes, courageous misery and dignified manners',[21] and his words
signalled the kinds of journeys and imagery that would be sought after
by postwar photographers, drawn to regional narratives and to unknown
and often neglected landscapes.

68 Federico Patellani, *New Cassino*, 1945.

67 Giuseppe Pagano, *House at Ischia*,
c. 1935, published in *Fotografia: Prima
rassegna dell'attivita' fotografica in
Italia*, special issue of *Domus* (1943).

six

Postwar Narratives

The critical examination of what constituted 'modern photography' included, in the special edition of *Domus* of 1943, the subject of photojournalism. An essay by Federico Patellani, titled 'the new formula journalist', explained the importance of a new kind of photographer involved in the creation of picture-essays – no longer stories sparsely accompanied by images, but cohesive 'photo-texts'.[1] Patellani's contribution to the growing industry of illustrated magazines began with *Tempo*, which was modelled after *Life* and *Signal*; directed by Alberto Mondadori between 1939 and 1943, and closed for the remainder of the war, *Tempo* was relaunched in 1946 under the direction of Arturo Tofanelli (significantly many reports of the war destruction in Italy did not appear in the Italian press).

Patellani's covers and picture-essays demonstrated a great command of images and text, as in the case of the story of Carbonia (illus. 69), a coal mining town in Sardinia, built during Mussolini's dictatorship and about to close down. This remarkable portrait of workers with stark, chiselled faces, anxious about the future, was sequenced with smaller vignettes, graphically composed by Bruno Munari, *Tempo*'s art director.[2] Both text and captions were written by the photographer, in reference to the end of this industry and the misery of this community.

Patellani surveyed a country under reconstruction, reporting on the scars of war (illus. 68), the 1948 election for the new Republic, and a renewed erotic appearance. Often his portraits of models conveyed a distinctive *made in Italy* style that resembled fashion shots – as in the case of the vibrant and solar Miss Lombardia posing in a 'Lucky Strike'

bikini top that revealed the obvious traces of American colonialism on her smooth Mediterranean skin (illus. 70).

His formulation of a new photojournalism touched on the genre of photography, broadly discussed – and yet debateable – as 'neorealist'.[3] Among these were: a recurring tension between form and content (simply put, the beautiful and the useful picture) and the ambition to shape a modern image of the country. Several points are important: first and foremost, the look of these pictures as they were printed and consumed within a magazine layout; second, the dialogue that was opened up with other fields of Italian culture like anthropology, literature and film; third, the schism between professionals and amateurs and the ongoing tension concerning the inclusion of photography within the realm of art. These points are critical for

69 Federico Patellani, 'Il Dramma di Carbonia,' *Tempo* (5 February 1950).

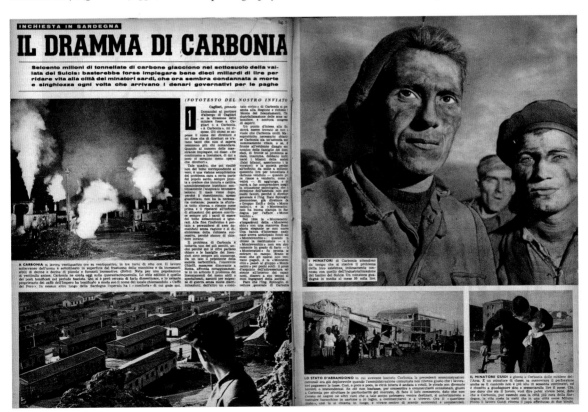

The cover shows text including:

A. XI - N. 39 - Milano. 24 Sett. 1949

TEMPO

Che ne pensate di Miss Lombardia?

70 LIRE

AUSTRIA Scellini . . .	4.50
BELGIO Fr. belgi . . .	12.25
BRASILE Cruzeiros . .	5
EGITTO Piastre . .	6
FRANCIA Franchi	40
GRECIA Dracme . .	2600
MALTA Scellini . .	1
SVEZIA Corone	1
SVIZZERA Franchi .	1
TURCHIA Piastre . .	70

LE 30 BELLE DI S. REMO
Servizio esclusivo a pagg. 34-36

70 Federico Patellani, cover of *Tempo* (24 September 1949).

the understanding of postwar photography as multi-layered in its applications and goals.

The publication of *Tempo* started a new wave of news weeklies that looked very different from the early covers of *L'Illustrazione Italiana* (founded in 1873) and *La Domenica del Corriere* (first issued in 1899).[4] The first significant attempt to include full-page photography in journalism

had been achieved by the literary magazine *Omnibus* (1937–9), published by Rizzoli and edited by Leo Longanesi, but suppressed very rapidly under Fascism. Milan became a catalyst for illustrated periodicals after the Second World War as its industry started to flourish, and advertising followed. *Oggi* (1945), *L'Europeo* (1945), *Epoca* (1950), *Le Ore* (1953), *Gente* (1957), *Panorama* (1962) were based there, while *Il Mondo* (1949–66) and *L'Espresso* (1955) were in Rome. Italian intellectuals and journalists like Mazzocchi and Debenedetti became their key orchestrators. Concurrently, photo-agencies improved their distribution (among these were Publifoto run by Vincenzo Carrese, Tullio Farabola's agency). Comic books and *fotoromanzi* like *Grand'Hotel*, *Bolero Film* and *Sogno* became very popular in spreading gossip and love stories as a form of escape from postwar realities, and fashion magazines like *Bellezza*, *Novita'* and *Grazia* increased their output.[5]

71 Mario De Biasi, *Pavia*, 1949, gelatin silver print.

A news-stand recorded by Mario De Biasi in Pavia, a town near Milan, shows the popularity of illustrated covers, contributing to shaping the feeling of a national community (illus. 71). Significantly, in 1953, De Biasi became an important player in the world of printed media, as the first in-house staff photographer employed by *Epoca* – a glossy news-weekly with a circulation of 500,000 copies by 1955.[6] His record of an old and sombre newspaper seller tucked in her dark booth shows the magazines hanging in the light, featuring dreamy and anxious women's faces; like banners of a modern imaginary, these covers promise an easy grasp of the latest news and scandals. This photograph describes what Patellani had enthusiastically remarked in his essay regarding popular access to the news through photographs. It speaks of 'a hunger for images'[7] in a country where illiteracy was still very high (13 per cent of those over six years old) and RAI television did not exist (broadcasting dates from 1954).

The interest in storytelling with photographs informed the experimental work of many photographers and intellectuals of this generation. In particular, the work of Elio Vittorini, an anti-Fascist Sicilian writer who settled in Milan in 1939, stood out for the political and discursive understanding of photographs in a narrative sequence. His wide-ranging commitment to visual culture began in the 1930s, when he introduced American literature and photography into the country, as a powerful alternative to the monolithic and nationalistic messages of Fascism. His anthology *Americana* (1942) was illustrated with photographs by Brady, Stieglitz, Hine and a selection from Walker Evans's *American Photographs*.

Furthermore, Vittorini regarded his short-lived periodical *Il Politecnico* (1945–7) as the first attempt to deploy photography as autonomous story (works by Bourke White, Bishop and Weegee were selected from *Life* and *Look*). His emphasis was not on the aesthetic value of individual pictures, but on their graphic ensemble. As he observed:

> It was through the sequence of photographs, and the glare that one picture could transmit onto another, that I could create narrative sentences . . . This new reality, mirrored by the sequence of photographs, was no longer passive or fragmentary, but unified, dynamic, transformable, as if it held the promise of renewal.[8]

His ideas were radical at the time. The layout of picture-essays (*fotoracconti*) presented on *Il Politecnico* as newsreel strips (illus. 72) was also unusual, and sealed a collaboration between Vittorini, the photographer Luigi Crocenzi and the graphic designer Albe Steiner. For example, the story 'Andiamo in Processione', published between January and March 1947, was based on a religious procession in central Italy (possibly Crocenzi's hometown of Fermo), and allowed images to prevail over the text, like a montage. The repeating image of two women with a child (first strip, second strip and epilogue) worked like the voice of a storyteller, and the sequence described the grim reality of the small community, marked by signs of religion, poverty, civic pride and social unrest.

72 Luigi Crocenzi, 'Andiamo in processione,' *Il Politecnico*, 35 (January–March 1947). This image shows the whole *fotoracconto*, which was mounted by Crocenzi for exhibition.

With similar expressive aims, Vittorini asked Crocenzi to contribute photographs for his novel *Conversation in Sicily*, first published in 1941, and again, with photographs, in 1953. He treated his text like a film script, more or less operating as a film director – choosing locations, deciding his subjects and conducting a *mise-en-scène* for some episodes. The photographer's role was actually diminished by the writer's over-bearing control in the selection and layout of photographs; nonetheless, this collaboration had an impact on Crocenzi's subsequent work. Soon after, in 1954, he started a Centre for Photographic Culture (CCF) in Fermo, with the goal of improving photographic education. In his pro-gramme the photo-book was considered a vehicle of communication

that could disclose stories of the everyday (which he called *Storie Italiane*), and contribute to visual literacy. His plan was to popularize this form of photo-book and thus lower the costs of production. His reference to the successful distribution of crime-books, *fotoromanzi* and cartoons indicated his knowledge of what appealed to the public, and his intention to bend those visual strategies towards a more sophisticated product.

73 Page of *fotoromanzo* 'Nel fondo del cuore' written by Francesco Reda, photographs by Elio Luxardo, *Sogno*, 1/17 (31 August 1947).

A glance at the numerous layouts of such popular magazines clearly indicates what Crocenzi had in mind. For example, a passionate episode of love and hate, with a young Gina Lollobrigida performing for the camera of the glamorous Elio Luxardo (illus. 73) illustrates Crocenzi's important observations: 'These stories must reflect the deepest human feelings, wide and popular, like the feeling of justice, of love, of family, of the right to live, of freedom, with absolute sincerity, conveyed with fantasy and poetry.'[9] Crocenzi's interest in creating photographic scripts was also inspired by his direct knowledge of filmmaking, which he had studied in Rome, at the *Centro Sperimentale di Cinematografia*, producing a short documentary on fishermen in 1948. Given this background, it is no surprise that the screenwriter Cesare Zavattini supported Crocenzi's ideals and photographic populism. In 1958 he put out a call for photographers, asking them to capture the microcosms of Italian lives – at work, at play or hanging out in the market. 'Photographers . . . you will open up to us our peninsula like a book and we will leaf through it, metre by metre, face by face . . .'.[10] The collaboration of Zavattini with American photographer and filmmaker Paul Strand for *Un Paese* (1955) fulfilled this dream of a photo-book as a mirror of everyday life in a small village (Zavattini's own village), adding a patina of internationalism to Crocenzi's regional projects.

These episodes are telling of a photographic culture inspired by neorealist themes while striving to impose its own artistic language. Throughout the 1950s the dialogue between film and photography became ideologically complex, despite the shared themes. Here is an example: between 1954 and 1956, social documentary photo-essays were launched by Guido Aristarco, noted left-wing film critic and editor of *Cinema Nuovo*, and Zavattini, along the model of 'a day in the life of . . .'.[11] These visual essays were opportunities for upcoming photographers to show their work, but their pictures were also instrumental in their support of political action. As they represented the misery and despair known from earlier neo-realist films (for example, *Shoeshine* and *Bicycle Thief*), they stirred up the readers, showing that this country still needed socially engaged films and social reform – reform that appeared to be moving far too slowly under the Christian Democrat government that had been in power since 1948.

Among these *fotodocumentari*, Chiara Samugheo's reportage on the poverty of children in Naples (illus. 74), with text by Domenico Rea, was a direct confrontation of the brutality of starved populations, with a social cry to rescue these citizens. This spirit of harsh accusation – so striking in this portrait of a screaming mother – was emphasized in the layout, where words and pictures contributed to tell a story of shame about this 'Italy'. This project introduced the young woman photographer, who had been inspired by Patellani's photojournalism and would continue to work, very successfully, for illustrated magazines like *Tempo*, *Epoca* and *Paris Match*.

The case of Enzo Sellerio, a Sicilian photographer, writer and publisher, who began his career in 1952, became paradigmatic of Aristarco's use of the medium for a particular message. The publication of 'Borgo di Dio' on 25 June 1955 consisted of a selection of photographs taken in a small village not far from Palermo, Partinico, undergoing social work. The story conveyed was much bleaker than the one sought out by Sellerio – a young photographer interested in a form of lyrical reportage, inspired by the early work of Cartier-Bresson. One would have to wait until 1961 for his work to reveal a sensibility unencumbered by ideology, when the Swiss magazine *Du* commissioned Sellerio to interpret the city of Palermo. The spontaneous shot (illus. 75) of two children crossing a street, carrying chairs on their heads, is not a populist statement but a sympathetic encounter between the photographer and the playful energy of his region. As he wrote, 'I have not allowed myself to be drawn into the Sicilian tragedy: I loathe the sight of violence. Such a disfigurement of my island's features finds no place in my photographs, which are not a compendium of things Sicilian, rather a harvest of personal experiences.'[12]

Sellerio's position is significant here as, indeed, throughout the 1940s and '50s, the Italian South was a vehicle for postwar trauma,

74 Chiara Samugheo, 'I bambini di Napoli,' *Cinema Nuovo*, 63:3 (25 July 1955).

75 Enzo Sellerio, *Palermo*, 1960, gelatin silver print. This image was published in the Zurich-based *Du* (July 1961), in a special report titled *Palermo: Porträt einer Stadt*.

poverty and savagery. A mythology of primitivism was enhanced by the literature of Carlo Levi, who, in 1945, had described the town of Tricarico as a place out of this world, where Catholicism had not even arrived (the title of his novel was, in fact, *Christ Stopped at Eboli*). The photographic documents of Tino Petrelli in Africo, Calabria (published in *L'Europeo* in 1948) described inhuman conditions: people living with pigs and a high level of illiteracy. The following decade, in 1959, *L'Espresso* retraced these issues in a photo-essay titled, quite overtly, 'Africa at home', with photographs by Sellerio, Bavagnoli and Pinna.[13]

These projects confirmed a universalizing approach to a generalized category of social shame and romantic purity called 'the People of the South'. Typologies were created (the fisherman, the street-hawker, the barber in his shop, the widow in dark clothes) that followed similar modalities to prewar American Farm Security Administration projects involving photography,[14] while reminiscent of scenes previously shot by neo-realist directors. The Sicilian fishermen posing for Alfredo Camisa in 1955 (illus. 76) convey the impression of a harsh and yet uncontaminated region. Their faces and hands wrinkled by sun and work, their Sicilian hats throwing shade on their eyes, recall the beautiful and tragic characters from Luchino Visconti's *La Terra Trema* (1948), and the tonal and

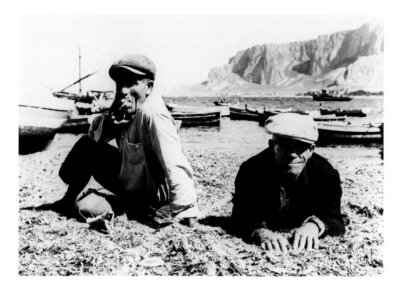

76 Alfredo Camisa, *Fishermen in Sicily*, 1955, gelatin silver print.

77 Nino Migliori, 'The Barber's Boy', from the series *Gente del Sud*, 1956, gelatin silver print.

compositional effects enhance the poetic substance of this document. At this time, Camisa was a chemical engineer working in Milan, pursuing a subjective realism imbued with a fine sensibility for chiaroscuro, and a cultural curiosity concerning a world that was different from his own.[15]

The work of Bolognese Nino Migliori shared these issues while also experimenting with photographic abstraction. In the realm of social documentary, Migliori elaborated two portfolios: 'People of Emilia' (1950–59) and 'People of the South' (1956) – that represented a traditional society bound to the land, to family and to ritual. At times, the calm of these people's gestures is reminiscent of Paul Strand's portraits. It is also possible to detect, in the portrait of a sleeping boy in a barber's shop (illus. 77), surrounded by distressed furniture, peeling walls and the clutter of the hairdressing trade, a reference to Walker Evans's *Negro*

Barber Shop Interior shot in Atlanta and shown in a state of chaos and decay, suggesting a comparable cultural distance to that experienced by Migliori.

It was a different kind of attention towards this 'other' Italy that prompted Neapolitan anthropologist Ernesto De Martino to work with photographers Arturo Zavattini, Ando Gilardi and Franco Pinna, gathering a visual archive for a new practice of visual anthropology (illus. 79). Pinna was born in Sardinia, an island characterized by rural traditions,[16] and had been active in the Communist Party while living in Rome. In his numerous photographs for De Martino (three journeys to Lucania, in 1952, 1956, 1959; one to Puglia, in 1959) he captured, with anti-sentimental style, the essence of these lives, the poetic meaning of their gestures and the presence of the irrational within their ritual.

The novelty of De Martino's work consisted, primarily, in a new approach to the South that revisited Carlo Levi's gloomy prediction. De Martino's comprehensive study investigated the meaning of the 'archaic' as an obscure and yet still active force within Western civilization that ought to be recognized and reframed historically. In his view the South represented not a source of shame but of discovery. Pinna's monumental portrait of a local *strega* (illus. 78), with an impressive wrinkled body covered in black rags, set against the bare and rocky land of Colubraro (Matera), reflects what De Martino called 'the obscure side of the soul'[17] – an uncanny presence and a source of fresh cultural awareness.

What is also interesting in relation to the questions of representation raised in this chapter, is that Pinna collected personal information about this woman, uncovering her name (Maddalena La Rocca) and the tragic life of a widow who had lost all her four sons. Pinna's belief in the narrative power of photography (as he said, 'photography is meaningless until you find a story'[18]) made him a great photojournalist, collaborating with *Paese Sera*, *L'Espresso* and the Communist

79 (*opposite*): Ando Gilardi, Ernesto de Martino (centre), Emilio Servadio, Romano Calisi, and woman interviewed listen to a recording of a story about magic (gelatin silver print, 1957). The interview was part of research conducted in Lucania between 18 May and 4 June 1957, and published in De Martino's book *Sud e Magia*.

78 Franco Pinna, *Maddalena La Rocca. Colubraro, Basilicata*, 13–15 October 1952, gelatin silver print. The photographer's manuscript notes: 'Maddalena La Rocca, the village's old witch, now disgraced (. . .) She has never seen a train, nor the sea; she does not remember her date of birth and she would like to see the Pope.'

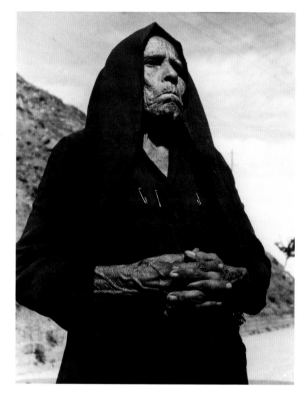

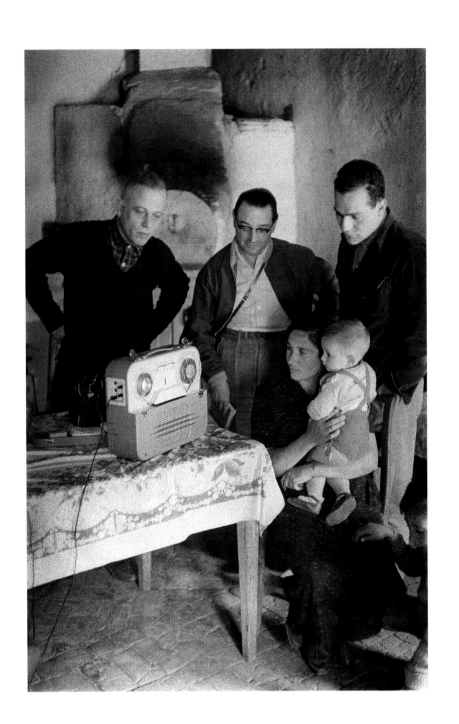

magazines *Noi Donne* and *Vie Nuove*. Among his reportages, an image taken during the regional elections in Sicily (illus. 80), is a perceptive record of a world trapped in religious hegemony (the sign above the lintel reads: 'Those who vote Communist vote against God') and gracefully posing within a primitive dwelling. In its directness and ironic tone, this image summarizes the contradictions many Italian photographers faced at the time, torn as they were between compassion and ideology.

Pinna, who had also practised documentary film, worked on Fellini's set for the preparation of *Juliet of the Spirits* (1964), confirming the intricate connections between still photography, photojournalism, the press and the Italian film industry. His film-set photography intersected with Tazio Secchiaroli's extraordinary interpretation of Fellini's cinema (the two had already crossed paths in Rome in 1952, as blitz-photographers).[19] Secchiaroli was part of the growing industry of tourism and cinema,

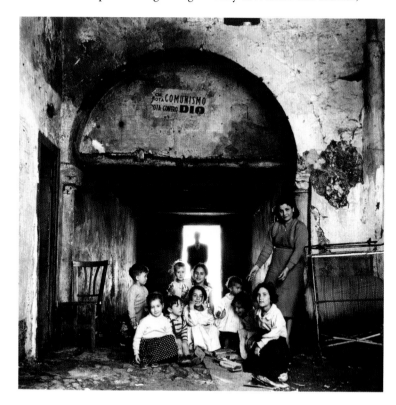

80 Franco Pinna, *Palermo*, 1955, gelatin silver print. This photograph records the visit of the Communist deputy Colajanni – possibly the figure standing by the threshold of this dwelling, in the poor quarters of Palermo.

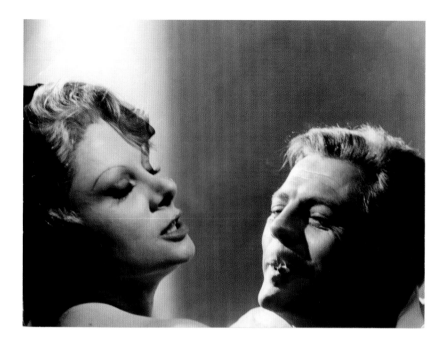

where reality acted as a source of fantasies. His background was in photo-journalism and his mentor was Adolfo Porry-Pastorel, the first significant news photographer between the wars, who had demonstrated a shrewd and somewhat reckless attitude in the capture of historical moments. Secchiaroli pursued the scandals of the well-to-do and bourgeoisie, and his attitude and subject-matter inspired Fellini's *La Dolce Vita* (1960), a film about the eroticism and alienation of Rome's high society, which centered on Via Veneto as the new hang-out of the exotic and chic. The word *paparazzo* was created for the movie, and Fellini drew inspiration from photographers like Secchiaroli – watching them at work, listening to their stories and even using their photographs as a visual canvas for his cinema. Concurrently, Secchiaroli captured the performances of Fellini's sets (illus. 81), like a hunter of emotions made for the screen.

During the postwar years, when photographers became increasingly more involved in the distribution of news and entertainment, a different kind of amateur, disengaged from anything remotely commercial, sought new forums for discussion and exhibition. Giuseppe Cavalli, a lawyer

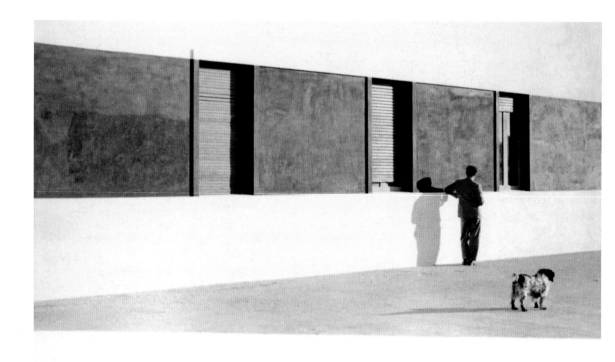

82 Giuseppe Cavalli, *Two Appointments*, 1950–52, gelatin silver print.

originally from Puglia, assumed the most radical position in favour of the autonomy of art photography. In 1947 he took intellectual leadership of the group La Bussola, and published a manifesto in the magazine *Ferrania: A Monthly Journal of Photography, Film and Visual Arts*. His group was composed of Mario Finazzi, Federico Vender, Ferruccio Leiss and Luigi Veronesi. 'It is necessary', Cavalli wrote, 'to dissociate photography with any artistic pretence from the deadly track of documentary chronicle' since 'in art the subject-matter is of no importance'.[20] These statements were clearly inspired by Benedetto Croce's idealistic aesthetics, aiming to connect the realism of photography with the intuition of the subject.

Cavalli was immersed in the art world of his time. His twin brother, Emanuele, belonged to the 'School of Rome', a group of painters who gravitated towards a metaphysical classicism (Fausto Pirandello, Corrado Cagli and Giuseppi Capogrossi were among them). He had absorbed the lesson of *Luci e Ombre* and was familiar with the formalist aesthetics of Giuseppe Vannucci-Zauli and Alex Franchini Stappo, photographers in Florence who had written *Introduzione per un'estetica fotografica* (1943). Cavalli's portraits, landscapes, seascapes and still-lifes were anti-narrative, at times even surreal. The idea for these pictures preceded the work, recalling Edward Weston's pre-visualization. Photographed against a bleached Mediterranean sunshine, Cavalli's figures and objects reflected acts of contemplation – intimate, delicate, ironic, painterly and mysterious. This picture of a man leaning against a wall with shuttered windows, standing still, like his dog (illus. 82), was the result of a long, patient session, in which the photographer's son Daniele had collaborated with Cavalli to convey this impression of stillness and expectation. The study of geometries and grey tones rendered this ordinary site into an enigmatic composition that echoed De Chirico's paintings, transforming the real into the metaphysical.

The artists of La Bussola shared Cavalli's painterly abstractions, using strategies like solarization (Finazzi), night light effects (Leiss), photograms (Veronesi) and high-key tones (Vender). The sunlight shapes the curves of Vender's nude, transforming flesh into marble (illus. 83). The sitter resembles a neoclassical statue, evoking Canova's refined elegance, and transcending, in its white-on-white texture, the eroticism and physical presence of an actual woman. Curiously, the small plaster or ceramic bust in the background appears to be the same prop that is in one of Cavalli's photographs, a clue to these photographers' aesthetic collaboration.

A different kind of lyricism moved Pietro Donzelli to photograph the landscapes and shacks surrounding the Po river delta – sites he had experienced as a soldier in April 1945, and again, in 1951, after a violent flood. Throughout the 1950s he visited this area periodically, seeking objects and atmospheres that could bring back memories of his earlier encounters. His glance at a man sleeping in the shade of two wagons

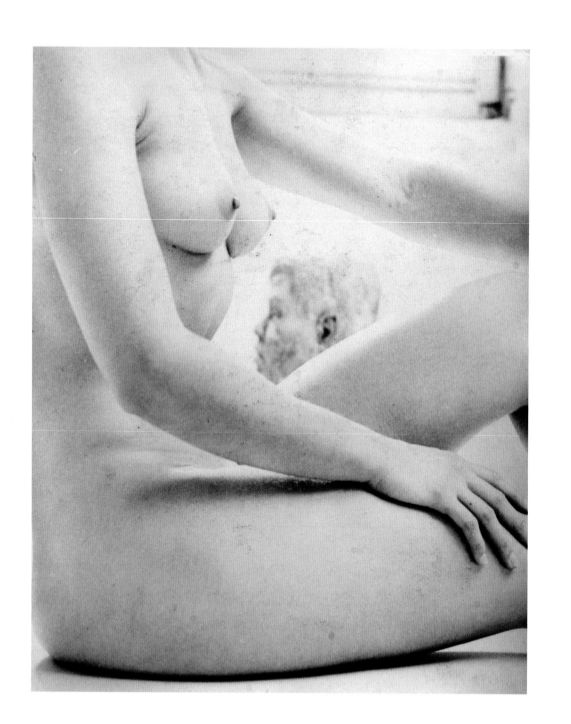

84 Pietro Donzelli, *Ferragosto*, 1954, gelatin silver print. (The word *Ferragosto* refers to the mid-August holiday that has been celebrated in Italy since Roman times.)

83 Federico Vender, *Nude*, c. 1947, gelatin silver print.

on a sunny day in mid-August renders this place habitable and familiar (illus. 84). Donzelli's photographs, taken with a Rolleiflex, were reminiscent of Alberto Lattuada's series 'Occhio Quadrato' (1941), an early suggestion of neo-realist photography, with images of town outskirts and flea markets.[21] Donzelli was also a photography impresario. In 1950 he had formed the 'Unione Fotografica Milanese' with the particular goal of divulging foreign photography in Italy, and also of taking Italian photography abroad; he was collaborator of *Ferrania*, and for a period directed the Italian edition of *Popular Photography*.[22]

A flurry of activity in the 1950s generated critical writing (by Turroni, Racanicchi, Zannier), photographic magazines (*Fotografia*,

Diorama, Ferrania, Popular Photography), groups and associations. In 1948 the Federazione Italiana Associazioni Fotografiche (FIAF) had been formed in Turin, supporting exhibitions and forums; in 1955 Italo Zannier created the Gruppo Friulano per una Nuova Fotografia, which focused on social aspects, with Toni Del Tin, Roiter (illus. 85), Bevilacqua, Beltrame and Borghesan. The 'Circolo Fotografico Milanese', started in 1930, evolved into more committed work in the postwar years. This situation was far from cohesive, but it revealed an increasing effort by Italian photographers to obtain creative autonomy.

A different kind of publication, the weekly magazine *Il Mondo*, directed by Mario Pannunzio (1949–66), offered a great opportunity for publication to amateurs and professionals alike (Sellerio, De Biasi, Scianna and others). They all saw these pages as a way to showcase their work, despite the fact that no photographers were acknowledged by name before 1959, and that the circulation of the magazine was much smaller than the other news weeklies, 15,000 to 20,000 copies only. Unlike the picture-essay magazines examined earlier, *Il Mondo* was comparable to a picture gallery, where Pannunzio operated as a 'collector of images',[23] selecting photographs from individual portfolios which had the power of metaphor and anecdote *vis-à-vis* discussions about public opinion and current fashions. This magazine pursued a photographic aesthetic that privileged street scenes and odd, ironic or bizarre encounters in both town and country.

Piergiorgio Branzi's photographs were frequently showcased in these pages, due to their unusual character of magic realism – a quality that Pannunzio sought throughout. One picture (illus. 86) looks somewhat absurd in its illustration of a poor street in Naples: a wedding-dress hangs on the exterior wall of a butcher's shop, next to a glass display case within which pig's trotters dangle. From behind the case the butcher suspiciously stares through the glass at the photographer. The caption chosen by *Il Mondo*, referring to the removal of a stain, adds a narrative ambiguity to this photograph, inviting us to see this immaculate garment against the bloody dirt of the store nearby (an erotic allusion, perhaps). The gown has the kind of surreal presence one sees in Atget's shop windows, where objects appear animated.

85 Fulvio Roiter, *On the road Gela-Niscemi, Sicily*, 1953. Roiter joined the Venetian group La Gondola in 1949 and the Gruppo Friulano per una Nuova Fotografia in 1955. His trip to Sicily in 1953 was a turning-point in his career.

The early work of an internationally recognized photo-journalist, Gianni Berengo Gardin, was highly regarded by this magazine. His collaboration began in 1954, and more than a third of the photographs published in *Il Mondo* were by him.[24] His rare capacity for capturing simultaneous actions and objects within the same frame positioned

86 Piergiorgio Branzi, *Dress: Stain Removed, Naples*, 1955. This image appeared in *Il Mondo* (3 May 1960), gelatin silver print.

87 Gianni Berengo Gardin, *Celebration of Santa Maria della Salute, Venice*, 1963. This image was published in *Il Mondo*.

him as an excellent candidate for that street life Pannunzio was after. Besides, he was championed by Henri Cartier-Bresson, who ranked the picture of the Venetian *vaporetto* (illus. 88) among the 80 most important photographs ever taken. The co-presence of gazes and of frames within a frame makes it an exceptional in-camera montage of different spaces and human figures, reminiscent of Velasquez's illusions, and suggestive of this photographer's multiple artistic influences: the French school of reportage (Doisneau, Boubat, Ronis), the group of Venetian photographers called 'La Gondola' (see chapter Seven) and Eugene Smith's powerful renditions of black and white. At the end of the 1950s this new kind of reportage seemed to reconcile

social documentary with the photographer's subjective exploration of the world, thus putting an end to the dispute about form and content that had divided many postwar image-makers.

88 Gianni Berengo Gardin, *Vaporetto, Venice*, 1960, gelatin silver print.

seven

The Margin of the Frame

In 1957 the Unione Fotografica Milanese was invited to present a small group show at the George Eastman House, in Rochester, New York, titled *Contemporary Italian Photography*. Showcasing 26 photographers, this was the first ever presentation of Italian photography in the United States.[1] A landscape photograph by Mario Giacomelli (illus. 89) stood out as a new kind of image where abstraction prevailed over description. The dense texture of tall tobacco plants blocked the view of a steep velvety hill, where patches of cultivated land formed a collage of light and dark geometries. On top of the hill the bright dot of a house was the only sign of human existence. This was one of Giacomelli's first landscape photographs: a celebration of his land, a reminder of his passion for painting and a powerful indication of his existential dialogue with nature. He would comment : 'For me the photographic film is like a printing plate, a lithograph, where images and emotions become stratified.'[2]

Giacomelli has been perceived throughout his career as the great romantic and solitary genius of Italian photography. His pictures have contributed to a new definition of the social document and to a new sensibility for abstraction. No doubt he was the most successful Italian photographer abroad in the 1970s and 1980s. In 1968 and 1979 he received solo exhibitions curated by Nathan Lyons; he entered the canon of photographic masters established by John Szarkowski, in his *Looking at Photographs* (1973; see illus. 1); in 1975 he was included in an exhibition at the Victoria & Albert Museum titled *The Land*, organized by Bill Brandt and Mark Haworth-Booth.[3] His story, though, was uncharacteristic for someone so famous.

Giacomelli was born in Senigallia in the Marche region. He lost his father at the age of nine, and though initially trained as a painter (influenced by Alberto Burri), he worked for a living as a typographer in the Marche and was first encouraged in photography by Giuseppe Cavalli, who lived in the same town. His subjects ranged from the land (photographed from hilltops and even from a small aeroplane) to close-ups of human suffering, bloody slaughterhouses, masked self-portraits, shots of farmers at work and priests by turns dancing, laughing, or having a smoke in their courtyards. His photographs interpreted poetry and literature, paying homage to the Romantic era poet Giacomo Leopardi (a native of the region) among others and the post-war existentialist Eugenio Montale, as well as foreign authors (Jorge Luis Borges and Edgar Lee Masters). Ten years after his death in 2000, these pictures still have a powerful resonance for their unique transformation of regional landscapes into a symbolic pattern of scars and wrinkles.

In the 1950s Paolo Monti was also developing an abstract and expressionist photography that was influenced by the German Otto Steinert, by American photographers such as Aaron Siskind, Minor White and Eugene Smith, and by Art Informel painters. Monti's personality and upbringing were radically different from Giacomelli's, despite some similarities in their aesthetics. A graduate of Milan's Business School, he began a successful career in industrial management and moved to Venice in 1940. This city shaped his early photography through its dense layers, its dark alleys, peeling walls and overall sense of decadence (illus. 90). He was fascinated with the vernacular houses of the lagoon (Burano, Pellestrina, Chioggia), the surprising relationships between canals and small courtyards, the beauty and sensuality of Venetian stones, trod upon for centuries, and the graffiti on the walls.[4] In Venice he became friends with Ferruccio Leiss, whose night scenes inspired him to search for an intimate and non-monumental city.

At the end of 1947 Monti formed an amateur photo group called 'La Gondola', less dogmatic than 'La Bussola', but similarly committed to supporting photography as artistic expression.[5] He moved back to Milan in 1953 and became a professional photographer, working with publishing houses, architects and artists. In 1954 he became a professor of photography

89 Mario Giacomelli, *Tobacco*, c. 1957, gelatin silver print.

90 Paolo Monti, *Pellestrina, Venice*, 1950, gelatin silver print.

at the Scuola Umanitaria, the first academic institution in Italy to offer real courses in this field. In his creative work he became a sort of archivist of decline, recording urban peripheries, war rubble and torn posters found on walls. Throughout the 1960s and '70s he contributed to the first major architectural and environmental census of Italy's historic centres (Bologna was the first, in 1966), establishing a new dialogue with public municipalities and a civic commitment towards historic preservation. His modernity, Valtorta has noted, 'lie[s] in the capacity to elevate photography, going beyond the critical limitations formulated by amateurs. These were trapped by the duality of formalism and realism . . . Monti, instead, pursued photography as a project, and as a form of experience of the real.'[6]

In the late 1950s and '60s the city of Milan had become the capital of publishing, fashion, design and chemical and heavy industry, thus

employing an increasing number of photographers in the creation of publicity images. The photographic output during these decades was heterogeneous, ranging from work for magazines and corporations (for example, Olivetti, Breda, Italsider, Innocenti, Alfa Romeo, Pirelli, Agip) to freelance reporting and social documentary. Cesare Colombo, a key player during these years,[7] was a fine connoisseur of the city and a photographer committed to the field professionally. His creative engagement prompted him to promote young authors (Mario Finocchiaro, Gualtiero Castagnola, Carlo Cosulich, Ernesto Fantozzi) who were drawn to Milan's burgeoning social life. Colombo's perception of Milan from the 1950s to today is quite distinctive for its personal rendering, like a series of snapshots, of the light of the city, people at work, growing consumerism, the

91 Cesare Colombo, *By the Old Overpass of Isola Garibaldi, Milan: Proof for a Portrait*, 1961, gelatin silver print.

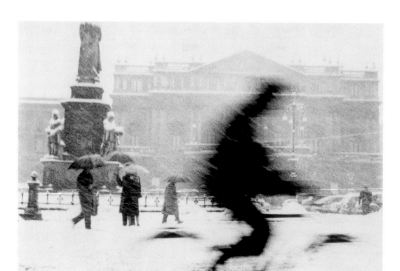

92 Mario Carrieri, *Piazza Scala, Milan*, 1957–8, gelatin silver print.

world of fashion, the alienation of the working class and the local passers-by, caught in the middle of errands. In some cases his photographs and those of his contemporaries are reminiscent of William Klein, whose book on New York was published in Italian in 1956. *By the Old Overpass* (illus. 91) conveys the spirit of an intimate encounter with the city. It is part of a small series of five, where the same sitter – a colleague from work – posed by a squalid overpass, as in a casual fashion shot.[8] This is a study of human gazes and emotions (the voyeuristic eyes of the old man on his bicycle, her fearful and wary look) that translates the urban experience of a grey evening into something quite theatrical. No longer a neo-realist chronicle, this urban portrait conveys the cosmopolitan alienation of Antonioni's films and of Calvino's stories (such as *Smog*, 1965), describing, in similar terms, the social ambiguities of flourishing Italian cities.

Similarly, Mario Carrieri's impressions, many of which were published in an exceptional book titled *Milano, Italia* (1959), filtered the multiple facets of a vibrant metropolis living between glamour and horror (illus. 92). The choice of high contrasts and grainy textures transmitted an almost painterly quality to his photographs, reminiscent of Abstract Expressionism, and transformed these urban documents into

something uniquely existential. As he wrote, 'I wanted to produce, rather than reproduce a city'.[9]

More deeply immersed in the social texture of years of great turmoil culminating in 1968, the documents by Lisetta Carmi and Carla Cerati are noteworthy not only because they are created by women but also because they are striking investigations of the human condition. Carmi focused on the working class by the Genoa harbour and, in particular, on a series about transvestites in the Jewish quarter of that city. Cerati, involved in social reportage since the early 1960s, became interested in

93 Carla Cerati, *Parma*, 1968, gelatin silver print. This photograph was published in *Morire di classe* (1969).

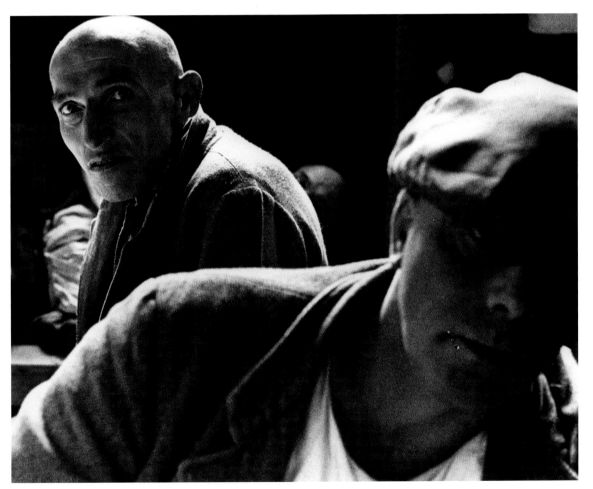

supporting the ideas of an Italian psychiatrist, Franco Basaglia, on the abolition of asylums. Her photographs surveyed a variety of Italian asylums, highlighting the conditions of imprisonment and isolation in which the mentally ill were abandoned. Cerati's work, together with Gianni Berengo Gardin's reportage on those segregated institutions, were published in an important book, *Morire di classe: la condizione manicomiale* (1969), with a text by Basaglia. The direct confrontation of her camera with otherworldly faces and bodies (illus. 93) reveals a creative inspiration drawn from Richard Avedon's portraiture and a gutsy, personal determination to uncover 'a violated humanity . . . a sense of lacerating, unbearable suffering, and a smell of constant and apparently irredeemable misery'.[10]

The brief but intense career of Ugo Mulas, from the mid-1950s to his premature death in 1972, was also nourished by the artistic milieu of Milan, where he began investigating its social landscape. His early work recorded the bohemian circle of Caffè Giamaica, with young artists like Manzoni, Paolini, Pomodoro, Fabro and Kounellis, who later become famous worldwide. These pictures, together with his impressions of hazy peripheries, people sleeping on the benches of a desolate central station and ghostly workers walking in a snowy winter night, were hints of urban conditions, resembling Robert Frank's sketchy portraits of American society. The snapshot look of most of his photographs reflected, from the start, a conceptual analysis of time as duration, with a preference for the ordinary rather than the extraordinary.[11]

In the late 1950s Mulas became involved in fashion and advertising photography, producing some groundbreaking works. He was among the first photographers in Italy (together with Alfa Castaldi and Oliviero Toscani) who took models outside the studio, hence integrating fashion design with street life.[12] For example, his colour series of a new *prêt-a-porter* collection located male and female sitters in proximity with Gio Ponti's Pirelli Tower (illus. 94), thus connecting modern casualwear to the symbol of a new industrial Milan (the building was just being completed in 1958). It is tempting to read Mulas' fashion photograph against Colombo's enactment of fashion *By the Old Overpass* (illus. 91), where the latter's model was not a professional, but a friend and colleague

94 Ugo Mulas, *Milan*, 1960, c-print.

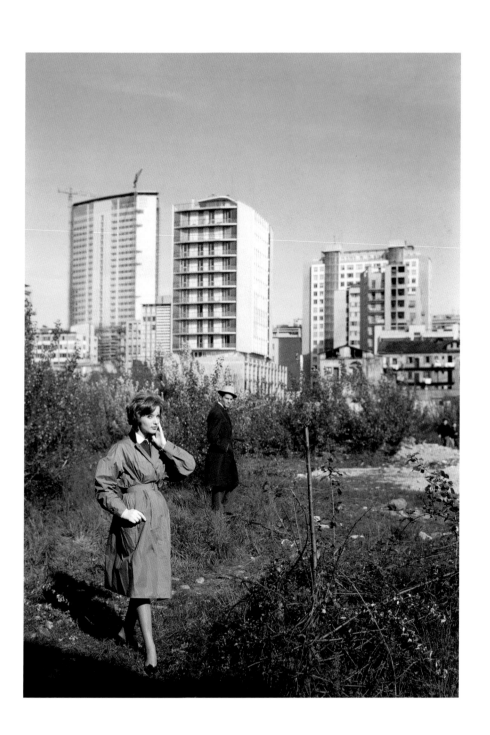

95 Ugo Mulas, 'The End. To Marcel Duchamp', Verifications, 1972, gelatin silver print.

posing within a non-monumental Milan. In both cases these modern women seem to negotiate their gender roles within a cityscape in flux.

Mulas's experience of glamour passed through contemporary art, starting with his first inclusion at the 1954 Venice Biennale, and finding an important closure with his publication *New York: The New Art Scene* (1967), a document of his full immersion in the American art world of Jasper Johns, Robert Rauschenberg, Barnett Newman, John Cage and the like. His portraits of artists also denote a sense of temporal duration, achieved through a sequence of pictures that recorded their gestures,

work, laughs, body language and the décor of their studios. The case of Marcel Duchamp remains paradigmatic of this series. The photographer described it thus: 'I wanted to bring him to a terrain that was most undefined and timeless, where I could visualize the ambiguity of his non-action.'[13] A similar exploration of time as 'non-action' was visible in Mulas's multiple records of Giorgio Strehler's Piccolo Teatro di Milano – a study of the traces of time upon theatrical sets. The last body of work, titled *Verifications* (1970–72), became a theoretical summary of his work within the numerous branches of photography. As he wrote,

> In 1970 I began taking photographs whose subject-matter was photography itself, a sort of analysis of the operations of photography aimed at identifying its basic elements and their intrinsic significance . . . I have called this series of photos *Verifications* because they were meant to clarify the meaning of those operations I have been repeating for years, hundred of times a day, without ever stopping to consider their inherent value and always seeing only their utilitarian side.[14]

This series represents a theorem in fourteen images on the making of photographs: light, frame, time, lens, enlargement, caption and focus. Mulas retraced the history of photography (Nièpce, Herschel, Talbot, Alinari, Man Ray, Robert Frank, Friedlander, the conceptual artists Davide Moscioni and Kounellis) to verify his own practice. His homage to Duchamp (illus. 95), the last image in the series, put a special emphasis on photography as a Ready-made. He recycled the first *Verification*, the homage to Nièpce, obtained by contact printing segments of unexposed negative film-strips and holding them under a glass, but, in this case, he smashed the glass with a hammer. This final act, which recalls Duchamp's gesture in *The Large Glass*, also hints at the possibility of destroying photography's illusion – an illusion that could only be held together by the glass.

Mulas's *Verifications* represented a radical shift from postwar chronicle to a form of meta-photography. The series responded to linguistic explorations that had developed through the 1960s, such as Umberto

Eco's *Opera Aperta* (1962), and the introduction of semiotics; Antonioni's film *Blow-up* (1966), a reflection on photography as language; and Germano Celant's formulation of Arte Povera (1967), a movement that rebelled against conventional art and institutions. At this time photography was deployed by numerous conceptual artists (Pistoletto, Ontani, Paladino, Paolini, Penone, Guerzoni, Parmiggiani, Altamira) while many photographers took the image apart, peeling off its layers and exploring the nature of its message (Mulas, Vaccari, Patella, Bruno Di Bello, Gioli, Tagliaferro, Ciam, Vimercati, Cresci). Additionally, female artists like Marcella Campagnano and Paola Mattioli used conceptual and performance art to comment on gender and representation. Marcella Campagnano, in particular, re-enacted fashion photography on herself, building an ironic sequence about female fictions and inventions.[15]

Oliviero Toscani's inventive and provocative analysis of fashion as a 'system' – in the Barthesian sense – began during this time and drew from similar conceptual aims. His work as a fashion photographer, started in the late 1960s, broke away from all conventions of this genre and reached its climax in the controversial campaign for United Colors of Benetton, and *Colors* magazine (1984–2000). Toscani's interest in the effects of media and the artistic possibilities of manipulating them impacted his Benetton advertising, commenting on race, sex and religion with very provoking juxtapositions. In particular, in the final phase of this work, he created 'pseudo-documentary' advertising[16] – transforming iconic news photographs like Franco Zecchin's record of the mafia's bloodshed in Sicily (illus. 96), and channelling them into the advertising of Benetton clothing. This reflection on photography as an agent of meaning fits the overall discussion of this chapter, where artists move away from a previous documentary tradition

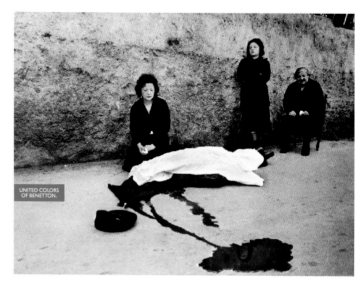

96 Oliviero Toscani, Advertisement created for United Colors of Benetton, 1980s. A computer manipulation, with colour added, of Franco Zecchin's photograph *The Wife and Daughters of Benedetto Grado at the Scene of his Murder, Palermo*, 12 November 1983.

(significantly, Toscani's father, Fedele, was a successful photojournalist working with Carrese's Publifoto agency).

The citation of earlier works has also informed Paolo Gioli's unorthodox photography since the mid-1970s. In revisiting the basic principles of camera optics, Gioli paid homage to proto-photographers (Nièpce, Julia Margaret Cameron, Marey, Eakins, Poitevin), with an approach that appeared more intuitive compared to other conceptual photographers of this period. His pictures – taken with miniscule handcrafted cameras – rendered an optical immediacy, almost a 'zero degree', that found a matching directness in the Polaroid film, called, ironically, 'the Large Positive'. For example, his homage to Hippolyte Bayard (illus. 97) was rendered as a Polaroid transfer of his self-portrait as a drowned man, obtained with a large pinhole camera (50 x 60 cm). This is the artist's explanation of his homage: 'The surface for my body's imprint and light exposure is a surface certainly much more sensitive than that Bayard prepared for his own image of a suicide, but with an incredibly similar outcome: that of a direct positive.'[17]

Valtorta has drawn an important connection between Gioli's creative explorations, based on the human figure, sometimes with reference to Renaissance paintings, and the artistic climate of the 1970s, when artists and theorists were taking critical positions with regard to the photographic industry. Franco Vaccari, an important author, contributed to this debate in his *Fotografia e inconscio tecnologico* (1979), a work that has only been translated into French, despite its international significance in relationship to the theories of Walter Benjamin, Siegfried Kracauer, Pierre Bourdieu and Wilhelm Flusser. As he wrote:

> Beginning at the end of the Sixties, I turned to the concept of 'technological unconscious' in order to explain a series of aesthetic interventions that I was performing during this time. It was common, then, to question one's own artistic relationship with the camera as there was a generalized awareness that this apparatus might limit the horizon of experience. Basically, one regarded with suspicion the spontaneous use of the camera, because one felt that spontaneity could also hide a high level of conditioning.[18]

97 Paolo Gioli, *The Drowned Man
(Homage to Hyppolyte Bayard)*, 1981,
Polaroid Polacolor transferred onto
drawing paper.

Since 1969 Vaccari has created photographic installations in which the event and the experience of the event, or the event and its photograph, became connected through a mechanical feedback.[19] These installations – which he defined, and numbered progressively, as 'exhibitions in real time' – also made reference to Body Art, Land Art and Arte Povera. The photograph acted as a trace of a 'technological unconscious' – where the artist, the audience and the mechanical apparatus collaborated. The 1972 Venice Biennale remains paradigmatic of these photographic performances, with the installation of a Photomat, encouraging visitors to have their portrait taken, whereupon those very simple and very direct photographs were displayed on the gallery walls.

Vaccari used 'mail-art' in another project dedicated to the fifteenth-century poet Ludovico Ariosto. He made a performance by walking to the sites imagined by Ariosto with his Polaroid camera, then pasting his snapshots onto tourist postcards (illus. 98). He then mailed these collages to the modern art museum in Ferrara, forming a real-time project in which travel, photography and exhibition became linked through the Italian mail service. In more recent years he has integrated photography, film, video and webcam recordings in interventions in public spaces that recall Dan Graham, Hans Haacke and Ilya Kabakov, among others.

98 Franco Vaccari, *Esposizione in Tempo Reale #8: Omaggio all'Ariosto*, Palazzo dei Diamanti, Ferrara, 22 May 1974, Lambda print, 1995.

The work of Mario Cresci is another example. His photographs from the late 1960s to the present must be seen not as representations of the outside world, but as events that occur in and around photography. Cresci's education at the University of Venice (1963–7) informed this approach. In particular, the courses in industrial design, directed by Luigi Veronesi and Italo Zannier, put him in touch with Bauhaus theories of perception. He applied these lessons to installation art, graphic design, urbanism, anthropology and political statements.[20]

In 1968 he created a long banner of photographs printed on Kodalith film in response to anti-militarist protests in Rome; in 1969 he put together an installation of a thousand transparent cylinder boxes, each containing scraps of film (illus. 99) shot in Rome, Milan and Paris. The piece was presented at Lanfranco Colombo's Il Diaframma, a gallery that opened in Milan in 1967 as the first European venue dedicated solely to the exhibition of photography. On the walls were no pictures, only a large transparent strip that reflected gallery visitors. The floor was littered with plastic containers holding photographs, which resembled objects of mass-consumerism. The piece made reference to Piero Manzoni's installation (the famously controversial cans of *Artist's Shit*, 1960), highlighting the role of photographs as objects of exchange and breaking boundaries between the gallery and the public space.

In 1968 Cresci settled in the town of Tricarico, in the Italian South, immersing himself in the life and art of the community, and constructing a completely new vision of this world. Tricarico was, in fact, the site of De Martino and Pinna's explorations in the 1950s. Among the numerous projects he pursued during these years, the series of 30 'Portraits in Real Time' (1967–73) resulted in anthropological essays on day-to-day and domestic objects. Cresci sequenced three temporal and spatial events, moving from an interior space to a group portrait, and from the portrait taken with his camera to the photographs found in these people's personal albums (illus. 100). By staging each family's portrait 'in real

99 Mario Cresci, *Prototype for the Installation 'Environment' at the Galleria Il Diaframma*, Milan, 1969, gelatin silver print.

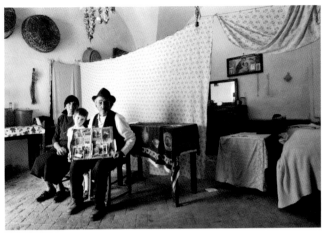

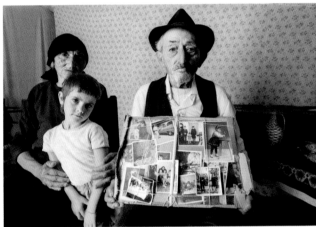

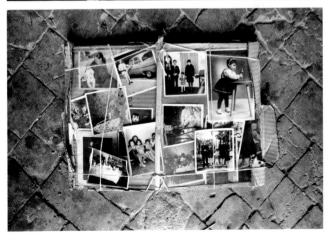

100 Mario Cresci, Untitled, from the series
Portraits in Real Time, Tricarico, 1972,
gelatin silver print.

time', he put together a conceptual sequence that transformed documentary photographs into fragile and personal relics.

Photography, memory and a new perception of place shaped Luigi Ghirri's programmatic investigation of the Italian landscape beyond what was known and stereotypical. Between 1970 and 1992 (the year of his premature death), Ghirri articulated by means of both images and superb essays his idea of photography as a map of familiar sites that could be revisited and transformed into symbols, visual puns and moments of enchantment.[21] His knowledge of conceptual art shaped his colour photographs, which looked like snapshots (as suggested in the title of his first book, *Kodachrome*, 1978), but which elicited new levels of complexity. As he noted,

> What fascinated me most about conceptual works was the possibility of surprise within the everyday . . . something like Freud's definition of humour. I think I learned from conceptual art the possibility of departing from the simplest things, from the obvious, in order to see them in a new light.[22]

101 Luigi Ghirri, *Chartres*, 1977, C-print. This image was published in *Kodachrome* (1970–78), with an essay by Ghirri. As he wrote: 'Reality is transforming into an oversize photograph where a certain kind of photomontage is already in act: that of reality itself.'

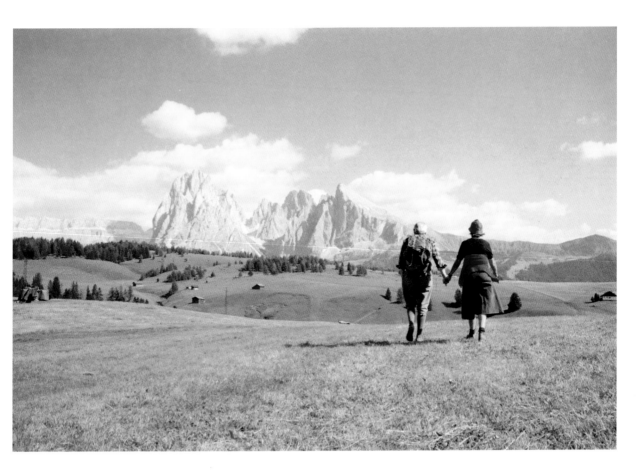

102 Luigi Ghirri, *Alpe di Siusi, Bolzano*, 1979, from *Topografia-Iconografia* (included in *Viaggio in Italia*, 1984), c-print.

These discoveries were applied to a redefinition of Italian cities and to travels through Europe, where he sought the odd and off-scale, always questioning photography as visual language. His work drew inspiration from Walker Evans, and was frequently compared to his contemporaries in the United States – Eggleston, Shore – who pursued the popular and mundane.[23]

Ghirri was also interested in questioning the significance of cultural emblems. For example, his photograph of a couple holding hands in the Alpe di Siusi, Dolomites (illus. 102), is evocative of the type of family snap that one finds commonly in Italian albums (in terms of their attraction, the mountains at Siusi are comparable to the Lake District and Yosemite) and yet this image is new, within that genre, for its ambiguous look between the real and the artificial, the record of a place and its symbol,

experience and myth, 'topography and iconography', which is the title of the series this image belongs to.

Ghirri was not the first, nor the only one, to reflect on a possible image of Italy beyond the conventional. Other important photographers in the 1970s and '80s were Franco Fontana (illus. 103), who developed a new vision of the landscape, but much more formalist than Ghirri, and Roberto Salbitani, an attentive observer of the increasing consumerism within the new urban environment. Ghirri was exceptional, though, for his intimate understanding of the meaning of landscape and also for his capacity to bring photographers to work together, as a research group, towards a new kind of vision. He strove to turn the traditional perception of Italy's monuments, Alinari-style, into a new way of seeing. His book and exhibition project, *Viaggio in Italia* (1984), summarized these ideas, with twenty authors providing a fresh look at daily life in shops, cafés and

train stations, at bus stops, in piazzas, outside factories and inside museums. The title of the project made reference to the traditional Grand Tour. As Arturo Carlo Quintavalle remarked in the introduction, it proposed a new type of tour:

> The issue was to confront the landscape as a site ignored, marginal and excluded, in a research of a peripheral Italy – ambiguous, fake, double – of a country which has been excluded and yet, the only country we comprehend, live in – the only one in direct relationship with our disassociate existence.[24]

A few examples from this book reveal Ghirri's creative dialogue with the individual photographers. Some of them belonged to his generation – Guidi, Cresci, Jodice, Ventura – while others were at the beginning of their careers – Barbieri, Basilico, Fossati, Castella. At times, the photographer's vision merges with Ghirri's – as in the case of Vittore Fossati's deadpan illustration of the absurdly refined landscaping around an industrial shed (illus. 104), which recalls Ghirri's series 'Colazione sull'erba' (1972–4), an ironic exploration of green décor in suburban zones.

104 Vittore Fossati, *Novi Ligure, Alessandria*, 1979, chromogenic colour print (included in *Viaggio in Italia*, 1984).

From the mid-1960s to the present, Mimmo Jodice's views of Naples gave non-stereotypal renderings of the underground of a Mediterranean city, which he described as 'The porous matter of Naples, a city that is noisy, colourful, but also surreal and quiet, made up of underground sites, hidden grottos, cloisters, which are different from the public spaces of the street, images that are very far from the commonplace.'[25] The corrugated screen sheathing a wall and protruding pillar (illus. 105) reflects ironically the idea of Italy as living museum, so dear to Ghirri, while also suggesting Jodice's early involvement with Pop art, Conceptual art and Arte Povera.

Guido Guidi's early series of little shacks near his place in Cesena (illus. 106) is a tender and witty statement about a pilgrimage around his

105 Mimmo Jodice, *Naples*, 1980, gelatin silver print (included in *Viaggio in Italia*, 1984).

106 Guido Guidi, *Villa Fossa, Cesena*, 1972, gelatin silver print (included in *Viaggio in Italia*, 1984).

own back yard, almost an homage to Walker Evans's vernacular homes (Guidi mentioned the influence on him of Szarkowski's exhibition catalogue of 1971 on Evans).[26] Soon after this early work Guidi moved into colour photography, using a large-format camera. With a background in architecture (he studied at the University of Venice), he has focused on the experience of cataloguing objects through time. This thread is still visible today in his renderings of architects' undertakings (in particular, Carlo Scarpa and Mies van der Rohe) as well as of marginal industrial buildings (illus. 112). If *Viaggio in Italia* excerpted particular images from each author in order to make a point, the thematic coherence of the project succeeded in giving a new sense of unity to Italian photographers, each one involved in personal examinations of local contexts.

eight

Alienation and Belonging

The feeling of inhabiting a place, so critical to Ghirri and the photographers discussed earlier, has been the main source of inspiration in the past twenty years. The depth of this quest has touched on a range of approaches from analogue to digital, focusing on urban topography and social landscape, but also delving into the memories of a personal past. The theme of landscape, central to this country's artistic tradition, has become the basis for many photographers' exploration of a place with shifting identities in its topography and social structure, growing from the economic boom of the 1970s into a post-industrial and multicultural era. This exploration has also instigated a new dialogue between public institutions and photographers, entrusting them with the civic mission of revealing remote sites in need of restoration. Gabriele Basilico, with a background in architecture and years of political activism, has moved in and out of public commissions in his investigation of industrial landscapes and urban margins. His early (1978–80) architectural views of factories on the outskirts of Milan, treated like monumental structures and immersed in a crystal-clear light,[1] drew inspiration from Bernd and Hilla Becher's obsessive classification of industrial buildings. His depopulated city views were included in *Viaggio in Italia*, and he was also selected as the only Italian photographer by the 'Mission Photographique de la DATAR' (1984–8), a French government initiative involved with environmental planning in relation to economic development. This commission opened up his vision – distant and yet involved – of the urban infrastructure and global disintegration, defined by contemporary planners as the 'scattered city'.[2] As Basilico explained,

I like to look at worn-out sites, particularly where I can see traces emerge of industrial civilization. I do not observe them with the spirit of the industrial archaeologist, nor with nostalgia, but with the consciousness that these suffering sites are a reality we have to live with, that they condition us – like a patrimony of life and culture, a past and present with which our future will have to deal.[3]

His enigmatic view of part of Genoa's harbour (illus. 107) records the grotesque post-war encroachments in Genoa that have even included

107 Gabriele Basilico, *Genoa*, 1985 (from the series *Porti di mare*), gelatin silver print.

the separation of the city from its harbour; the only human presence in this photograph is a solitary stroller. The global condition of urban anonymity and alienation was explored in the exhibition La Ciutat Fantasma, organized in Barcelona in 1985, which included photographs of empty and surreal cities by Basilico and two other Italians: Giovanni Chiaramonte and Olivo Barbieri.[4]

The experience of estrangement has been central to Olivo Barbieri, one of the few Italian photographers who have visited distant places, who learned to see his homeland via the perspective gained as a result of his travels. His photographs are influenced by painters like Giorgio de Chirico, photographers like Josef Sudek and Pop artists like Andy Warhol. He has employed a variety of strategies, from artificial light to out-of-focus exposures, to suggest the bizarre, hyper-real and uncanny essence of the world. As he said, 'When I began the series of photographs on the subject of artificial light, I wanted to use the representational potential of the camera to find out whether the metaphysical squares that de Chirico painted were pure invention or whether they existed somewhere.'[5] For example, in one of his artificial light photographs, the purple-sky twilight enhances the surreal impression of a fountain

108 Olivo Barbieri, *Milan*, 1989, C-print.

in the Triennale's Parco Sempione (illus. 108), designed by de Chirico,[6] where two sculptures are half-immersed in the shallow water, and seem to surface into the world as the night encroaches upon the city.

The preference given to artificial light as an aesthetics of estrangement was followed by out-of-focus camera shots and, most recently, *Site Specific* – a series of photographs (from Jordan to California) taken from a helicopter, using a medium-format camera and the so-called 'tilt-shift' lens, allowing a shift of focus, altering scale and proportion. This recent body of work pays homage to Ghirri's *In Scala* (1977–8), in which a miniature Italy, with models of a Leaning Tower and St Peter's basilica, is toured by apparently giant visitors. It is also a response to those contemporary

109 Olivo Barbieri, *Site Specific Roma–04*, c-print.

153

110 Walter Niedermayr, *TAV 22/2004*, cotton pigment print, mounted on Alu-Dipond.

photographers such as Thomas Demand and James Casebere who have fabricated temporary environments to be photographed. In contrast, Barbieri, who has turned real architecture into a model, flies above the ruins of Pompeii, the desert of Amman, Manhattan's skyscrapers, the artificial layouts of Las Vegas and Los Angeles and Shanghai's mayhem. In contrast to topographical aerial views, these photographs render an ambiguous world, which is also reflective of post 9/11 uncertainty and disorientation. Barbieri's treatment of Rome's monuments confirms the irony and ambiguity *vis-à-vis* the past: the Colosseum (illus. 109) resembles a spaceship parked on a ground teeming with tourists, while the Pantheon appears like a UFO ready to take off.

A similar sense of instability is conveyed by Walter Niedermayr's multi-panel compositions of tourist infrastructures in the Alps (his native sites) as well as of beach scenes and urban sprawls. Through their subtle shifts, incongruities and conflicting perspectives, these panoramic sequences suggest the impossibility of existentially inhabiting areas that have been artificially altered. This impressive close-up of a colossal structure lying in the open space of the plains of the River Po (illus. 110) belongs to a project documenting the construction of the Modena flyover, an elevated section of the new fast-speed train line (*TAV, treno alta velocita*) between Bologna and Milan. The structure consists of an 'omega'-type

girder, built on site and representing a new technology.[7] Niedermayr's panoramic approach brings out the transient nature of this piece of engineering, with a fascination for its gigantic structure inscribed in the landscape, seeming to annihilate local residents and workers.

This series is the result of a commission by Linea di Confine per la Fotografia Contemporanea, a public organization funded since 1989 by the town of Rubiera (near Parma and Modena, in central Italy) with the goal of exploring transitional areas. The theories of French anthropologist Marc Augé, defining contemporary 'non-places' as sites of hypermodernity, have impacted some of these commissions, considering the fact that this region has gone through drastic transformations of its social landscape, shifting from an agricultural economy to one that is part of the post-industrial global market. The challenge in these areas is that of retracing signs of local culture within the contemporary scene.

The work of William Guerrieri fits these criteria, with its scrutiny of depopulated institutional infrastructures – hospital waiting rooms, corridors, schoolrooms, sports halls (illus. 111) – integrated, in some of his sequences, with archival photographs of people who might once have lived in these places.[8] Guerrieri's work on public spaces pays tribute to

111 William Guerrieri, *Outpatients' Clinic*, 1991 (from the series *Public Spaces*, 1991–5), chromogenic colour print.

Ghirri's interrogation of what is real and what is artificial – one wonders, in some cases, if these are models, and if the signs on the walls are just stickers. None the less, the spirit of these pictures is less fantastic than Ghirri's playful observations. If the literary reference for Ghirri was Borges' labyrinth, for Guerrieri it is, rather, Foucault's panopticon.

Linea di Confine is a project-based group, coordinated by photographers (William Guerrieri and Guido Guidi), architects and town planners, and involving foreign photographers – mostly men, and mostly focused on landscape, like Lewis Baltz, Frank Gohlke, Stephen

112 Guido Guidi, *La Martesana, via De Notaris, Milan*, 1991, chromogenic colour print (commissioned by Archivio dello Spazio, Milan).

Shore, Robert Adams, John Davies and Michael Schmid. In its beginnings the group received important critical directions from historian Paolo Costantini (who died young in 1997), who was also responsible for an influential exhibition, 'Nuovo paesaggio Americano: Dialectical Landscapes' (1987), that introduced the work of 'The New Topographics' to Italians.[9] Furthermore, the pragmatic spirit of workshops, exhibitions and publications generated by Linea di Confine is characteristic of a region, Emilia Romagna, that has shown an exceptional institutional commitment to photography since the late 1960s.

On a much larger scale, the province of Milan has supported an ambitious project titled Archivio dello Spazio (1987–97). This remains 'the longest, most articulated and cogent work publicly commissioned ever carried out in Italy'.[10] As a result, noteworthy for this country, a collection and a museum of contemporary photography was launched in 2004, formed within the historic building of Villa Ghirlanda in the suburbs of Milan. Roberta Valtorta became its artistic director. Significantly, Villa Ghirlanda was one of the landmarks of the commission (photographed

by Mimmo Jodice); it was transformed into a repository and exhibition centre, thus testifying to the strong connection between photography, landscape and institution in Italian culture. The scope of Archivio dello Spazio (also inspired by the French DATAR) was to inventorize architectural landmarks and environmental assets within the most industrialized parts of Italy, covering almost 200 municipalities, involving 58 photographers in seven successive campaigns and producing around 8,000 photographs. The resulting images ranged from the industrial archaeology of pre-war factories to secular and religious buildings scattered throughout the countryside and long forgotten. Significantly, this archive became a source for the study not only of a patrimony that ought to be restored but also of Italian landscape photography at the close of the century.

Some photographers in this group have already been mentioned for their involvement with social reportage (Berengo Gardin, Colombo, Merisio, Nicolini); or for their association with Ghirri (Guidi, Jodice, Basilico, Ventura, Garzia, Barbieri, Fossati); others have pursued their own investigation of landscape (Radino, Tatge, Gentili, Agostini, Campigotto). There are also documentary photographers who work

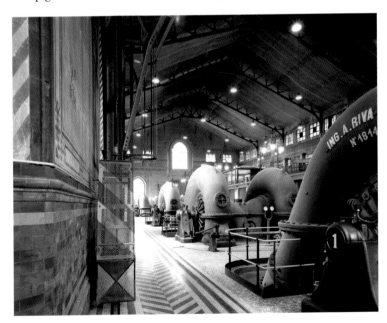

113 Francesco Radino, *Esterle Electric Powerplant, Cornate d'Adda*, 1994, chromogenic colour print (commissioned by Archivio dello Spazio, Milan).

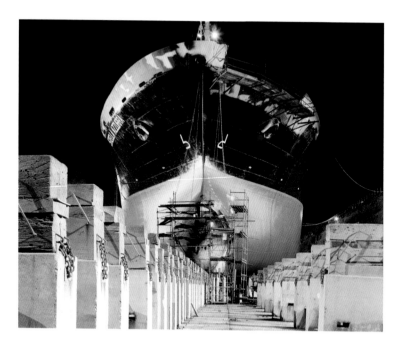

114 Luca Campigotto, *Venice Arsenal*, 1999, inkjet print on Archival Hahnemuehle paper from negative film.

for cultural institutions (Vlahov, Baldassari); those who are involved in teaching and curating (Cresci, Bossaglia, Abati, Marangoni, Chiaramonte, Guerrieri, Pozzi); architects (Battistella, Rosselli, Brunetti); experimental photographers (Ballo Charmet, Niedermayr, Delucca, De Pietri), and of course a new generation of younger practioners.

A few examples from this large archive attest the creative impulse behind the commission. Guidi's *film-noir* rendition of a small factory at night (illus. 112), along a canal between Milan and the Adda river, is the result of a flash of the headlights of his Renault against the gate, attempting to capture the ghost-like features of this building.[11] Francesco Radino's impressive view of an immaculate, and yet still functioning, electric power plant (illus. 113) is a homage to the architectural past of this region, where the industry is harmoniously integrated with poly-chrome stones that suggest the museum-like presence of a power plant. Radino's wide-angle view enhances the colossal features of the generators that appear like sculptures on display under a spectacular vault (the sense of metamorphosis is characteristic of Radino's architectural views).

Another prolific author (and fine writer) from this group, Luca Campigotto, has been involved in a variety of public commissions, where he has rendered striking architectural views, both in black and white and in colour, and frequently in artificial light. *Venice Arsenal* (illus. 114) is from a commission he received from Venice, prior to the restoration of the Arsenale, the heart of Venice's maritime industry since the twelfth century. The titanic hull of the ship is symbolic of the victorious fleets built over the centuries at the Arsenale, its imposing and seductive beauty rich with historic memory. The interest in photography as a relic of the past has informed Campigotto's visions of architectural remnants, ranging from Rome to Venice to a variety of foreign countries.

One goal of these public commissions has been to include Italian photography in international discussions on documentary practices, probing the role of the photographer as author, and that of landscape as mirror of culture. The exhibition project Milano Senza Confini, organized by Villa Ghirlanda (1998–2000), involved both Italian (Basilico, Castella, Gioli, Guidi, Jodice) and foreign (Struth, Fischli and Weiss, Paul Graham) photographers, who applied their vision to a city that was becoming

115 Vincenzo Castella, *Malpensa, Milan*, 2003, Diasec, Lambda Ciba-Ilfochrome print.

increasingly fragmented and suffering from suburban spread. Vincenzo Castella (who made a youthful appearance in *Viaggio in Italia*), looked at Milan through the grid that he recently applied to other cities (Naples, Verona, Turin, Amsterdam, Jerusalem and Ramallah), choosing a high, distant view, and suggesting the accumulation of 'layers' in the modern metropolis. His digital alterations of an analogue negative modify the depth of the image and its colours. As a result, this city series presents a homogeneous look at urban infrastructures – bus-stops, airports, city blocks – characterized by similar painterly hues. Malpensa airport

116 Massimo Vitali, *Under the Volcano, Catania*, 2003, c-print with Diasec mount.

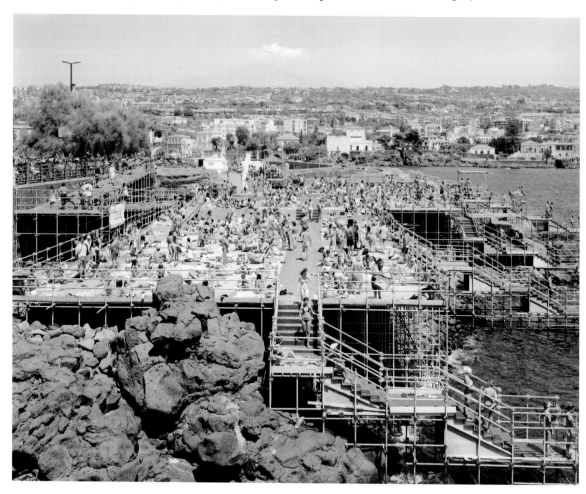

(illus. 115) brings a new visual commentary to post-modern reflections on airports as global sites, expressed by contemporary artists like Martha Rosler and Andreas Gursky: with his bright digital manipulations, Castella enhances the daily transactions at the airport, a setting busy with lilliputian workers, shuttle buses and emergency vehicles. In this way, paradoxically, the site is rendered less soulless and impersonal.[12]

The internationally recognized Massimo Vitali pursues his ongoing research on landscape and mass-culture, which includes issues related to the built environment (who shapes it, and why). The sight of a 'solarium' installed near Mt Etna in *Under the Volcano, Catania* (the volcano is visible in the distance and its power present in the black rock in the foreground) is characteristic of his interest in creating an inventory of leisure where nature and culture meet (illus. 116). Luc Sante has commented perceptively on the affinity of this photography with that of the Bechers:

> Vitali's neutral gaze, his quasi-scientific detachment, his precise rules
> – he makes a point of shooting from an elevation, on the periphery

of his subject – all call to mind the great German documenters of the end of industry, Bernd and Hilla Becher. Vitali approaches mass leisure the way the Bechers approach water towers and pitheads: with a kind of entomological collector's passion that may appear cold because it is so rigorous.[13]

With a background in photojournalism and filmmaking, Vitali works within a strictly analogue tradition, using a large-format camera and non-digital enlargement, and presenting his photographs like sculptural objects or mural-size prints, carefully planned, creative statements about the conformism of the Italian masses.

At present, the sense of belonging to a place and being able to describe its topography has evolved into an interest in social landscape and the fragments of new social dynamics.[14] The younger artists involved in these poetics are numerous, presenting the largest body of women's work discussed so far (Cristina Zamagni, Roberta Orio, Paola De Pietri, Marina Ballo Charmet, Alessandra Spranzi, Paola Di Bello, Luisa Lambri, Alessandra Tesi) as well as Francesco Jodice, Tancredi Mangano, Marco Signorini, Marco Calò and Fabio Boni.

Paola De Pietri's exploration of identity and human relationships has produced a recent series titled 'Io parto' (I am leaving), a commission from the museum of Villa Ghirlanda that consisted of photographing pregnant women (illus. 117) close to the day of delivery, posing in the middle of the streets and squares of Cinisello Balsamo (the small town where the museum is located). It is significant that this work was exhibited not only in the museum galleries but in the town's public spaces too, thus sealing an important dialogue between institution and community.

Marina Ballo Charmet is interested in photography and video art as a way of understanding perception. A practising psychotherapist in Milan, she frames the world, from landscape to human figure, in a way that appears casual and distracted. Far from spectacular, her pictures of city

119 Paola Di Bello, *Concrete Island*, 2001, from the project *Homeless Home* (1996–2001), c-print mounted on aluminium.

163

margins and edges are convincing studies of vision and experience, as in the case of an untitled example from the *Background Noise* series (illus. 118), part of a group of buildings seen from below, from the imagined perspective of a child. In their informal simplicity, these daring views recollect Rodchenko's Constructivist visions, and his belief in the snapshot as a new way of seeing.

With a similar interest in camera perceptions, Paola Di Bello has examined the socially discarded. Her project 'Homeless Home' comprises two series in which she has focused on the visual impact of abandoned things and people. *Concrete Island* is one of those in the project in which dumped furniture is photographed from each object's 'point of view' as if it were still functional (illus. 119). *They risk very strict punishments*, from the other series, is one of the documents of homeless people sleeping on pavements and in railway stations (in Milan), presenting these records with a 90 degree rotation, thus giving them a vertical – and less passive – dignity. As she wrote, 'The upsetting or overturning of the images becomes for me a way to go beyond preconceived visions, conventional and taken for granted. The transformation of the point of view determines a visual surprise which returns to set up a "full" reading of these phenomena.'[15]

Francesco Jodice, who works in photography, film and video, has studied the connections between social dynamics and the transformation of the urban landscape. His book and exhibition project *What We Want* stands out as an atlas of human behaviour in twenty metropolises. As he writes, 'People have become more conscious of the fact that the environment in which we live is at our own disposal. This recent condition has sharpened our ability to 'perform' and transform spaces, effectively creating a landscape that exists as a projection of our desires.'[16] His records of these

120 Francesco Jodice, *What We Want, Pisa, R12,* C-print.

'performances' vary from urban latitudes to analyzing the décor in people's houses and messages left on walls. The portrait of a multi-ethnic family in Pisa indicates a new social dimension: modern Italy is no longer purely a Western construct (illus. 120).

Tancredi Mangano has also confronted the discarded within the project of a public commission, *Ex Fabrica*, focused on abandoned areas north of Milan, once fully industrialized. In place of productive sheds with factory workers, these zones have become the precarious homes of Roma communities, transitional societies and the unwanted. Mangano has visited these temporary shelters and camouflaged camps, giving value to these people on the margins of society. His fascination with the cinema of Bergman and Kieslowski permeates *Ex Fabrica*, where the humble and insignificant can appear extraordinary, even magical, despite the actual social misery they represent (illus. 121).

Through symbols and metaphors, contemporary photographers are constructing a new sense of belonging, anchoring their meanings to objects invisible to most. Traces of personal memories are part of this history, as for Moira Ricci, who has mined her family photo-archive to find images of her recently deceased mother (illus. 122). It is inevitable to think of Roland Barthes' own quest for the 'true photograph' of his

121 Tancredi Mangano, *Inhabitants*, 2003–5, C-print.

own mother. But Ricci's investigation goes further, as she retrieves Italy's fashions and décors from faded snapshots of the 1970s and '80s, and digitally inserts a portrait of herself wearing the dress and hairstyle of a moment either before she was born or was not present. The photographic reality of *20.12.53–10.08.04: Zio Auro, zia Claudia e mamma* is that Ricci would have been close to the age of the baby depicted, but in the digital alteration, with Ricci added behind the father-mother-baby group, she is the age of the young mother, seen blowing out the candles. In her consistent attempts to regain her mother by literally entering these snapshots, she reflects on 'photography as a way to meet in an illusion'.[17] Her operation is conceptually subtle as she investigates memory and the need for connection.

Paolo Ventura, who lives in New York, has staged his Italian past in a true 'directorial mode'.[18] Drawing from his grandmother's stories about the last years of the Second World War, he created a series titled *War Souvenir* (2005), in which he photographed tabletop constructions with figurines and painted backdrops that re-enact moments in the war years and the invasion of Italy. His most recent series, *Winter Stories* (2007), pursues similar strategies, and creates a world that is rich with fantasies and evocations. The title works as a metaphor of a man's final stage of life, and the photographs are like fictional flashbacks. In particular, 'The Photographer', showing a soldier sitting in front of a painted backdrop, beside a large-format camera on a tripod (illus. 123), is reminiscent of itinerant photographers who captured the features of families and soldiers during the war years. In his reflection on photography and memory, Ventura looks at the fictional nature of this process, repeating itself over and over, as the past of waving Italian flags is reconstructed from afar.

122 Moira Ricci, *20.12.53–10.08.04: Zio Auro, zia Claudia e mamma*, 2004–9, Lambda print on aluminium.

Distance, estrangement and memory are inextricable elements for all these authors in search of new symbols and ways of seeing. Radically different in its strategies, the work of Silvio Wolf also pursues a reflection on photographic memory. His series *Horizons* (illus. 124) is an investigation into photography as a chemical support incurring physical transformation. This artist, involved in experiments on light, space and the phenomenology of perception, has worked with the traces mechanically originated on scraps of photographic film leaders, automatically self-exposed to light while loading the camera. Wolf enhances the abstract and almost

123 Paolo Ventura, 'The Photographer', from the series *Winter Stories #37*, 2007, digital C-print.

painterly qualities of these frames by cutting off the traction holes and printing film fragments as large digital c-prints. The resultant image – from white to black to coloured stripes – represents the shift from a total lack of information (the dark area, non-exposed to light) to the film that has caught light, forming a random colour pattern written by light. These operations are reminiscent of conceptual works of the 1970s (for example by Mulas, Vaccari, Gioli, Penone), while also embracing the explorations of artists like Jan Dibbets, Georges Rousse, Robert Irwin and James Turrell.

Horizons lives in-between the alchemy of the pre-digital world and the perception of contemporary information overload. Reflecting on these thresholds, Wolf envisions a photograph that appears before a picture of an object, an image whose attractive configurations and hues depend exclusively on the analogical properties of the film and the length of exposure. His conclusion that these might be 'the last possible photographs to be taken'[19] in a world that has been fully mapped and represented seems to bring this story full circle, confirming the struggle of photography in Italy to find a new language, overcoming the redundancy of what has been represented and narrated, and challenging a codified knowledge of what has been imagined.

If this was, from the start, the challenge of photography in Italy – that of repetition of iconic and formulaic views, at the risk of obliterating the modern and dynamic transformations of a country in the making – this history of photography has sought to show that it was met successfully, and that knowledge of this place defied simple description, producing, in fact, pictures of great historical complexity and unorthodox beauty.

References

Introduction

1 To this day there is only one history of Italian photography, Italo Zannier, *Storia della fotografia italiana* (Bari, 1986). In the past twenty years numerous publications have come out dealing with regional histories; others are exhibition catalogues on the work of individual authors, or histories of the daguerreotype, calotype, postwar photography; and portfolios of contemporary projects.

2 Enrico Castelnuovo and Carlo Ginzburg, 'Centro e periferia', in *Storia dell'arte Italiana*, vol. I (Turin, 1979), pp. 283–352.

one: Modern Pictures of an Ancient World

1 See Paolo Costantini and Italo Zannier, eds, *Cultura fotografica in Italia: Antologia di testi sulla fotografia 1839–1949* (Milan, 1985).

2 Maria Francesca Bonetti and Monica Maffioli, eds, *L'Italia d'Argento 1839–1859: Storia del dagherrotipo in Italia*, exh. cat., Sala d'Arme di Palazzo Vecchio, Florence, and Palazzo Fontana di Trevi, Rome (Florence, 2003).

3 Ibid., p. 248.

4 See Christine Boyer, 'La Mission Heliographique: Architectural Photography, Collective Memory and the Patrimony of France, 1851', in Joan M. Schwartz and James R. Ryan, eds, *Picturing Place: Photography and the Geographical Imagination* (London and New York, 2002), pp. 21–54.

5 Lindsey Stewart, 'In Perfect Order: Antiquity in the Daguerreotype of Joseph-Philibert Girault de Prangey', in Claire L. Lyons, ed., *Antiquity and Photography: Early Views of Ancient Mediterranean Sites* (Los Angeles, 2005), p. 71. See also Grant Romer's notes on De Prangey in Christie's London catalogue, Tuesday, 18 May 2004.

6 Jean Clegg and Paul Tucker, *Ruskin and Tuscany* (Sheffield and London, 1992), p. 48.

7 See Paolo Costantini and Italo Zannier, *I dagherrotipi della collezione Ruskin* (Venice and Florence, 1986), p. 14.

8 See Paolo Arrigoni, *Gli 'Artaria di Milano'; contributo alla storia editoriale cittadina dell'Ottocento* (Milan, 1952).

9 See Donatella Falchetti's study of Artaria in *L'Italia d'Argento* (Florence, 2003), pp. 185–7, and Monica Maffioli, *Il Belvedere: Fotografi e architetti nell'Italia dell'Ottocento* (Turin, 1996), pp. 105–6.

10 Roger Taylor, 'In Search of Verisimilitude', in Neil Cossons, ed., *Making of the Modern World: Milestones of Science and Technology* (London, 1992). My thanks to Roger Taylor for sharing his study of Ellis's manuscript notes, which are conserved at the National Media Museum, Bradford.

11 See a daguerreotype view of Florence, attributed to him, in *L'Italia d'Argento*, p. 233.

12 The translation of *Some Accounts of Photogenic Drawings* was by Gaetano Lomazzi (Milan, 1839). Talbot's formula was succinctly described in an article in the *Gazzetta privilegiata di Milano* (8 March 1839). The calotype process was explained in a translation (by Turinese Carlo Jest) of Marc-Antoine Gaudin's *Trattato pratico di fotografia* (1845). See Maria Francesca Bonetti, 'Talbot et l'introduction du calotype en Italie', *Eloge du negatif*, exh. cat., Petit Palais, Paris, and Museo Alinari, Florence (Paris, 2010), pp. 24–35.

13 Graham Smith, 'Talbot and Amici: Early Paper Photography in Florence', *History of Photography*, XV/3 (Fall 1991), p. 191. See also Graham Smith, 'Talbot and Botany: The Bertoloni Album', *History of Photography*, XVII/1 (Spring 1993), pp. 33–48.

14 This is how Talbot defined himself in his Introduction to *The Pencil of Nature*.

15 See Larry Schaaf, 'Calotype and Commerce', in Hans P. Kraus Jr, ed., *Sun Pictures. Catalogue Five. The Reverend Calvert R. Jones* (New York, 1990), p. 44. On the history of British calotypists in Italy, see Robert E. Lassam and Michael Gray, *The Romantic Era. La calotipia in Italia* (Florence, 1988); Roger Taylor, *Impressed by Light: British Photographs from Paper Negatives, 1840–1860*, exh. cat., Metropolitan Museum of Art (New York, 2007), pp. 104–17.

16 Taylor, *Impressed by Light*, p. 109.

17 Richard W. Thomas, 'Photography in Rome', *Art Journal*, May 1852, p. 159. See Anne Cartier-Bresson, 'Il metodo romano: tra ricerca e adattamento', in Anne Cartier-Bresson and Anita Margiotta, eds, *Roma 1850. Il Circolo dei pittori fotografi del Caffè Greco* (Milan, 2004), p. 22.

18 See Alberto Prandi, 'The Roman Process', in Maria Francesca Bonetti, ed., *Roma 1840–1870: La fotografia, il collezionista e lo storico. Fotografie della collezione Orsola e Filippo Maggia* (Rome, 2008), pp. 17–18.

19 See Sylvie Aubenas, *Gustave Le Gray 1820–1884*, exh. cat., Bibliotheque Nationale, Paris, and J. Paul Getty Museum, Los Angeles (Los Angeles, 2002), p. 303. I wish to thank Hans P. Kraus Jr for showing me a few of the images of the Temple of Paestum with this title.

20 For a biography on Caneva, see Bonetti, *Roma 1840–1870*, p. 198. In the last few years Caneva's photographs have been offered at auction from collections belonging to painters like the Spanish Bernardino Montanés and the Villa Medici pensioner, Edmond Lebel. See also Maria Francesca Bonetti, 'Costumi della campagna romana: la fotografia di "genere" e i suoi modelli', in Roberta Tucci, ed., *I 'suoni' della Campagna Romana* (Catanzaro, 2003), pp. 203–9.

21 Giacomo Caneva, *Della Fotografia Trattato pratico* (Rome, 1855),

reprinted by Alinari (Florence, 1985), p. 11.

22 See Tiziana Serena, 'La Venise de Piot', in Claire Barbillion and Gennaro Toscano, eds, *Venise en France: Du romantisme au symbolisme, Actes Ecole du Louvre* (Paris, 2006), pp. 289–305.

23 The critic was Mongeri – cited in Marina Miraglia, *Alle origini della fotografia. Luigi Sacchi lucigrafo a Milano 1805–1861* (Milan, 1996), p. 139.

24 See Paolo Costantini, 'Pietro Selvatico: fotografia e cultura artistica alla metà dell'Ottocento', *Fotologia*, III (July 1985), pp. 55–67.

25 Miraglia, *Alle origini della fotografia*, p. 139.

26 See Miraglia, *Alle origini della fotografia*, p. 24; Roberto Cassanelli, ed., *Luigi Sacchi. Un artista dell'Ottocento nell'Europa dei fotografi* (Turin, 1998), p. 40.

two: Risorgimento Mythologies

1 They were Agostino Bertani and Alessandro Calandrelli. See Maria Pia Critelli, ed., *Stefano Lecchi: Un fotografo e la Repubblica Romana del 1849* (Rome, 2001).

2 Ibid., p. 24.

3 Robert E. Lassam and Michael Gray, *The Romantic Era: La calotipia in Italia* (Florence, 1988), pp. 15, 21; Critelli, *Stefano Lecchi*, p. 23; Silvia Paoli, 'Veduta e reportage', in Critelli, *Stefano Lecchi*, p. 47.

4 See Cesare Colombo, *Italy: One Hundred Years of Photography* (Florence, 1988), p. 15; Marina Miraglia, 'I luoghi dell'epopea garibaldina: reportage bellico e "veduta" nella fotografia dell'Ottocento', in *Garibaldi: Arte e Storia* (Florence, 1982), p. 277.

5 Marina Miraglia, 'Come Simonide di Ceo', in Critelli, *Stefano Lecchi*, p. 16. Illustration 18 in *Photography and Italy* was uncovered during research on the Risorgimento, thus adding a new plate to the four already published by Miraglia, in *Garibaldi*, p. 300.

6 See Sylvie Aubenas, *Gustave Le Gray 1820–1884*, exh. cat., Bibliothèque Nationale, Paris, and J. Paul Getty Museum, Los Angeles (Los Angeles, 2002), p. 163.

7 Ibid., p. 169.

8 The portrait was reproduced in *Le Monde Illustré* on 21 July 1860. See ibid., p. 171.

9 See Maria Antonella Fusco and Salvatore Abita, *Garibaldi nell' iconografia dei tempi* (Milan, 1982), p. 126. Pierre Varner was a photographer working with Doctor Nelaton.

10 Wladimiro Settimelli, ed., *Garibaldi: L'album fotografico* (Florence, 1982). See page 56, where this montage is framed with the bloody tissue from Garibaldi's wound, confirming the use of this image as a relic.

11 See Ugo Di Pace, 'La fotografia', in Raffaello Causa and Giuseppe Galasso, eds, *Brigantaggio lealismo repressione nel Mezzogiorno 1860–1870* (Naples, 1984), p. 51.

12 See Silvia Paoli, 'Le origini della fotografia a Milano: vedute e ritratti dell'epopea risorgimentale', in *Milano pareva deserta . . . 1848–1859: l'invenzione della patria* (Milan, 1999), p. 182: 'Alessandro Duroni sells portraits of Mazzini, Garibaldi, D'Azeglio and Cavour and distributes the profits for funding of the Expedition of the Thousands'.

13 Marco Pizzo, *L'Album dei Mille di Alessandro Pavia* (Rome, 2004). The total number of portraits was 846, as many volunteers had died in battle.

14 Ibid., p. 25.

15 This research has identified three copies located at the Museo del Risorgimento in Rome, one copy at the Biblioteca Reale in Turin and miscellaneous pages and cartes-de-visite at the Collezione Bertarelli in Milan. My thanks to Marco Antonetto for his help in determining the value of this volume in 1860.

16 Allan Sekula, 'The Body and the Archive', in Richard Bolton, ed., *The Contest of Meaning. Critical Histories of Photography* (Cambridge, MA, 1992), p. 350. See also Di Pace, 'La fotografia', pp. 51–9.

17 Police photography becomes institutionalized in Italy at the end of the nineteenth century. In particular, Umberto Ellero was Director of the School of Police in Rome, founded in 1909, and wrote an important book on the subject, *La fotografia nelle funzioni di polizia e processuali* (Milan, 1908). See Italo Zannier, *Storia della fotografia italiana* (Bari, 1986), p. 175; Ando Gilardi, *Wanted! Storia, tecnica ed estetica della fotografia criminale, segnaletica e giudiziaria* (Milan, 2003).

18 Cited in Paolo Morello, *Briganti: Fotografia e malavita nella Sicilia dell'Ottocento* (Palermo, 1999), p. 30.

19 Piero Becchetti, *Roma nelle fotografie dei fratelli D'Alessandri, 1858–1930* (Rome, 1996), p. 143.

20 Marina Miraglia, Daniela Palazzoli and Italo Zannier, eds, *Fotografia italiana dell'Ottocento* (Florence and Venice, 1979), p. 139.

three: Romance of Stone and Steel

1 Luigi Tomassini, 'Vedere Firenze nell'Ottocento', in Michele Falzone Del Barbarò, Monica Maffioli and Emanuela Sesti, eds, *Alle origini della fotografia: un itinerario toscano 1839–1880*, exh. cat., Palazzo Vecchio, Florence (Florence, 1989), p. 13.

2 John Ruskin, *Modern Painters*, cited in John Buzard, *The Beaten Track: European Tourism, Literature, and the Ways to 'Culture' 1800–1918* (Oxford, 1993), p. 35.

3 Giacomo Caneva, *Della Fotografia: Trattato pratico* (Rome, 1855), reprinted by Alinari (Florence, 1985), p. 11.

4 Graham Smith, 'Calvert Jones in Florence', *History of Photography*, XX/1 (Spring 1996), p. 4.

5 Lacan, cited in Arturo Carlo Quintavalle, *Gli Alinari* (Florence, 2003), p. 116.

6 Ibid., pp. 104–5.

7 Arturo Carlo Quintavalle and Monica Maffioli, eds, *Fratelli Alinari Fotografi in Firenze: 150 anni che illustrarono il mondo 1851–2002* (Florence, 2003), p. 30.

8 See Luigi Tomassini, 'L'Italia nei cataloghi Alinari dell'Ottocento', in Quintavalle and Maffioli, eds, *Fratelli Alinari*, pp. 147–215.

9 See Piero Becchetti, 'La fotografia alla prima Esposizione Italiana di Firenze del 1861', in Del Barbarò, Maffioli and Sesti, eds, *Alle origini della fotografia*, pp. 83–102.

10 See *Ragguaglio delle cose operate dal Ministero del Commercio, belle arti, industria, agricoltura e lavori pubblici dall'anno 1859 al 1864* (Rome, 1864), p. 267. I was able to consult a copy of this rare book at the Canadian Center for Architecture in Montreal.

11 Laura Gasparini, 'Padre Angelo Secchi e l'applicazione della fotografia nelle osservazioni astronomiche', *Fotologia* (Spring–Summer 1990), pp. 34–47; Maria Antonella Pelizzari, 'Pompeo Bondini: *Della Via Appia* (1853)', *History of Photography*, XX/1 (Spring 1996), pp. 12–23.

12 The history of the *publicetur*, or the authorizing of the Pope's Government to publish photographs (with obvious cases of censorship), remains unclear because few photographs have been found, to this date, with this indication. I wish to thank Maria Francesca Bonetti for this information.

13 See Quintavalle, *Gli Alinari*, p. 109. Anderson was born Isaac Atkinson in Cumberland and changed his name to William Nugent Dunbar when he first settled in Rome in 1838. For speculations regarding his change of identity see Helmut Gernsheim, 'James Anderson 1813–77', *Fotologia*, VI (1986), pp. 17–23.

14 See Martin Barnes and Christopher Whitehead, 'The "Suggestiveness" of Roman Architecture: Henry Cole and Pietro Dovizielli's Photographic Survey of 1859', *Architectural History*, XLI (September 1998), pp. 192–207.

15 See Marjorie Munsterberg, 'A Biographical Sketch of Robert Macpherson', *Art Bulletin*, LXVIII/1 (March 1986), p. 150. See also Alistair Crawford, 'Robert Macpherson 1814–1872', *Papers of the British School at Rome*, LXVII (1999), p. 362.

16 See Andrew Szegedy-Maszak, 'Roman Views', in *Six Exposures. Essays in Celebration of the Harrison D. Horblit Collection of Early Photography*, ed. Anne Anninger (Cambridge, MA, 1999), p.93.

17 See my 'Retracing the Outlines of Rome: Intertextuality and Imaginative Geographies in Nineteenth-Century Photographs', in Joan M. Schwartz and James R. Ryan, eds, *Picturing Place: Photography and the Geographical Imagination* (London and New York, 2002), pp. 67–72.

18 See Paolo Costantini and Italo Zannier, *Venezia nella fotografia dell'Ottocento* (Venice, 1986), p. 37; see also S. F. Spira, *The History of Photography as seen through the Spira Collection* (New York, 2001), p. 53.

19 Constantini and Zannier, *Venezia nella fotografia*, p. 37.

20 Daniela Del Pesco and Mariantonietta Picone Petrusa, *Immagine e città: Napoli nelle collezioni Alinari e nei fotografi napoletani fra Ottocento e Novecento* (Naples, 1981), p. 71.

21 See Italo Zannier, *Leggere la fotografia. Le riviste specializzate in Italia (1863–1990)* (Rome, 1993), pp. 22–3.

22 Adam D. Weinberg, *The Photographs of Giorgio Sommer* (Rochester, 1981), p. 43.

23 See Brigitte Desrochers, 'Giorgio Sommer's Photographs of Pompeii', *History of Photography*, 27, no. 2 (Summer, 2003), pp. 111–29.

24 Weinberg, *Photographs of Giorgio Sommer*, p. 38.

25 See Del Pesco and Petrusa, *Immagine e città*, p. 106.

four: Amateurs and Professionals

1 Bruce W. Lundberg and John Pinto, eds, *Steps off the Beaten Path: Nineteenth-Century Photographs of Rome and its Environs* (Milan, 2007), p. 11. In the 1870s Chauffourier acquired Simelli and De Bonis' negatives, rendering the attribution of these pictures quite difficult. For biographical information on Chauffourier see also Lucia Cavazzi, 'G. E. Chauffourier e il fondo omonimo nell'archivio fotografico Comunale', *Bollettino dei Musei Comunali di Roma*, I–IV (1977), pp. 89–100.

2 Lamberto Vitali, 'La fotografia italiana dell'Ottocento', in Peter Pollack, *Storia della fotografia dalle origini a oggi* (Milan, 1961), pp. 258–80.

3 Luigi Gioppi, *Bullettino della Societa' Fotografica Italiana* (1894), cited in Daniela Del Pesco and Mariantonietta Picone Petrusa, *Immagine e città: Napoli nelle collezioni Alinari e nei fotografi napoletani fra Ottocento e Novecento* (Naples, 1981), pp. 94–5.

4 Article in *La Tribuna Illustrata*, 22 February 1891 (pp. 117–18), reprinted in Pietro Becchetti and Carlo Pietrangeli, *Roma fra storia e cronaca nelle fotografie di Giuseppe Primoli* (Rome, 1981), pp. 20–21. For biographical information see also Lamberto Vitali, *Un fotografo fin de siècle: Il conte Primoli* (Turin, 1968), publishing Primoli's photographs accompanied by pages of his diary.

5 *La Tribuna Illustrata*, p. 117. See www.fondazioneprimoli.it/ (accessed February 2010) for a complete view of Primoli's archive.

6 Daniela Palazzoli, *Giuseppe Primoli* (Milan, 1979), p. 14. This scholar is the only one who has studied Primoli's paperboards.

7 See E. P. Amendola, *Uno sguardo privato, memorie fotografiche di Francesco Chigi* (Turin, 1978); Marina Miraglia, ed., *Filippo Rocci e la fotografia pittorica: Ritratto di gentiluomo con camera*, exh. cat., Calcografia, Rome (Rome, 1987); Francesco Faeta and Marina Miraglia, *Sguardo e memoria: Alfonso Lombardi Satriani e la fotografia signorile nella Calabria del primo Novecento* (Milan and Rome, 1988); Diego Mormorio, ed., *Diario fotografico del Marchese di San Giuliano* (Palermo, 1984).

8 Carlo Bertelli, 'La fedeltà inconstante', *Storia d'Italia*, Annali 2

(Turin, 1979), p. 101.

9 See Vincenzo Mirisola and Michele Di Dio, *Sicilia 800: Fotografi e Grand Tour* (Palermo, 2002); Wladimiro Settimelli, *Giovanni Verga, specchio e realtà: 84 foto inedite dello scrittore siciliano, accompagnate da una scelta antologica* (Rome, 1976). See also Marina Miraglia, 'Note per una storia della fotografia italiana (1839–1911)', in *Storia dell'arte italiana*, II/2 (Turin, 1981), pp. 494–5.

10 Marina Miraglia, *Francesco Paolo Michetti fotografo* (Turin, 1975), p. 12.

11 Marina Miraglia, 'Michetti tra pittura e fotografia', in Claudio Strinati, ed., *Francesco Paolo Michetti: Il Cenacolo delle arti: tra fotografia e decorazione* (Naples, 1999), p. 15. D'Annunzio was a guest of Michetti at Francavilla, where he wrote *Il piacere* and *Il trionfo della morte* (dedicated to Michetti).

12 Carlo Bertelli, ed., *Mario Nunes Vais fotografo*, exh. cat., Palazzo Vecchio, Florence (Florence, 1974); see also Maria Teresa Contini, *Gli italiani nelle fotografie di Mario Nunes Vais*, exh. cat., Palazzo Venezia, Rome (Rome, 1978).

13 See Silvia Bordini, 'Aspetti del rapporto pittura fotografia nel secondo Ottocento', in Enrico Castelnuovo, ed., *La pittura in Italia: L'Ottocento*, II (Milan, 1991), pp. 581–602; Giovanna Ginex, 'Fotografia e pittura nel laboratorio divisionista', in Gabriella Belli and Franco Rella, eds, *L'età del Divisionismo* (Milan, 1990), pp. 232–41.

14 Marina Miraglia, 'Guglielmo Plüschow alla ricerca del bello ideale', *AFT*, VII (1988), pp. 62–7.

15 See Francesco Faeta, 'Wilhelm von Gloeden: per una lettura antropologica delle immagini', *Fotologia*, 9 (May 1988), pp. 88–104.

16 Cited in Italo Mussa, *Wilhelm von Gloeden Photograph* (Munich, 1979), p. 13.

17 Donatella Valente, 'Carlo Brogi: l'impegno polemico di un professionista', *Fotologia*, 5 (1986), pp. 24–35. See also Elvira Puorto, *Fotografia tra arte e storia: Il 'Bullettino della Società Fotografica Italiana' (1889–1914)* (Naples, 1996).

18 Cited in Luigi Tomassini, 'Le origini della Società Fotografica Italiana e lo sviluppo della fotografia in Italia: Appunti e problemi', *AFT*, I/1 (May 1985), p. 48.

19 Paolo Chiozzi, 'Fotografia e antropologia nell'opera di Paolo Mantegazza (1831–1910)', *AFT*, III/6 (December 1987), pp. 56–61.

20 Marina Miraglia, Daniela Palazzoli and Italo Zannier, eds, *Fotografia pittorica 1889–1911*, exh. cat., Ala Napoleonica, Venice, and Palazzo Pitti, Florence (Venice and Florence, 1979), pp. 12–13.

21 See Angelo Schwarz et al., *Guido Rey: Dall'Alpinismo alla letteratura e ritorno*, exh. cat., Museo della Montagna, Turin (Turin, 1986), p. 14.

22 Mark Haworth-Booth, *Frozen in Time: The Mountain Photography of Vittorio Sella*, exh. cat., Estorick Collection, London (Rome, 2008), p. 14.

23 See Paolo Costantini, 'L'Esposizione internazionale di fotografia artistica', in Rossana Bossaglia and Marco Rosci, eds, *Torino 1902: Le arti decorative internazionali del nuovo secolo* (Milan, 1994), pp. 95–175.

24 Paolo Costantini, *La Fotografia Artistica, 1904–1917: Visione italiana e modernità* (Turin, 1990), p. ix.

25 Dario Reteuna, *L'occhio del Gattopardo: Filippo Cianciàfara Tasca di Cutò e la fotografia d'arte in Sicilia* (Messina, 2008).

five: Italian Modernities

1 See Pierre Apraxine, ed., *The Perfect Medium: Photography and the Occult*, exh. cat., Metropolitan Museum of Art, New York (New Haven, CT, and London, 2004), p. 13; Marta Braun, 'Fantasmes des vivants et des morts: Anton Giulio Bragaglia et la figuration de l'invisible', *Etudes Photographiques*, I (November 1996), pp. 40–55.

2 Bragaglia's work was published in *La Fotografia artistica* in 1913. See Paolo Costantini, *La Fotografia Artistica, 1904–1917. Visione italiana e modernità* (Turin, 1990), pp. 182–8.

3 Antonella Vigliani Bragaglia, ed., *Anton Giulio Bragaglia: Fotodinamismo Futurista* (Turin, 1970), p.10.

4 Ibid., p. 40.

5 'La cronofotografia', *Il Dilettante di Fotografia*, III (1892), pp. 260–65. See Marta Braun, *Picturing Time: The Work of Etienne-Jules Marey (1830–1904)* (Chicago and London, 1992), p. 296.

6 Guglielmo Sansoni, *Tato raccontato da Tato: Venti anni di Futurismo* (Milan, 1941), p. 132.

7 See, for example, Andrew Hewitt, *Fascist Modernism: Aesthetics, Politics, and the Avant-Garde* (Stanford, CA, 1993); Ruth Ben-Ghiat, *Fascist Modernities: Italy, 1922–1945* (Los Angeles, 2001).

8 See Robert Wohl, *The Spectacle of Flight: Aviation and the Western Imagination, 1920–1950* (New Haven, CT, 2005). See Nizzoli's work (plate 92) in Maria Morris Hambourg and Christopher Phillips, *The New Vision: Photography between the World Wars*, exh. cat., Metropolitan Museum of Art (New York, 1989).

9 My current research has uncovered photographs by Filippo Masoero published in *L'Ala d'Italia* (February 1935; July 1935, with an article by Anton Giulio Bragaglia titled 'Fotodinamismo e aerodinamica').

10 This research was presented during a panel organized by Emily Braun at Hunter College, New York, on 11 November 2009, titled *Shock and Awe: The Troubling Legacy of the Futurist Cult of War*. For Munari's work during the 1930s see Luigi Di Corato, 'Bruno Munari illustratore e grafico futurista: 1927–1933', in Cecilia De Carli and Francesco Tedeschi, eds, *Il presente si fa storia: Scritti in onore di Luciano Caramel* (Milan, 2008), pp. 209–26; Gerard Silk, 'The Photo-Collages of Bruno Munari', in Sally Metzler and Elizabeth Lovett College, eds, 'Cultural and Artistic Upheavals in Modern Europe 1848 to 1945', *Cummer Studies*, I (1996), pp. 41–76;

Pierpaolo Antonello's essay in Gunter Berghaus, ed., *Futurism and the Technological Imagination* (Amsterdam, 2009).

11 A. M. Mazzucchelli, 'Stile di una mostra', *Casabella*, LXXX (August 1934), p. 6; see comments on this exhibition in Romi Golan, *Muralnomad: The Paradox of Wall Painting, Europe 1927–1957* (New Haven, CT, 2009).

12 Luigi Veronesi, 'Del Fotomontaggio', *Campo Grafico*, II (December 1934), reprinted in Paolo Fossati, ed., *Luigi Veronesi e la fotografia: Spazio e struttura per un'immagine*, exh. cat., Galleria Martano, Turin (Turin, 2003), p. 92.

13 Antonio Boggeri, 'L'uovo di Colombo', in *Campo Grafico*, II (December 1934), p. 270. For a discussion of graphic arts in the 1930s, see Renato Barilli and Vittorio Fagone, eds, *Gli Annitrenta: Arte e Cultura in Italia* (Milan, 1982).

14 Cited in Dario Reteuna, ed., *Sentieri di luce. Artisti fotografi a Torino dal 1930 al 1946* (Florence, 2002), p. 23.

15 Gio Ponti, 'Discorso sull'arte fotografica', *Domus*, IV/5 (May 1932), reprinted in Italo Zannier *Leggere la fotografia* (Rome, 1993), p. 88.

16 Edoardo Persico, 'Camille Recht: Atget', *La Casa Bella*, XXXVIII (February 1931), reprinted in Paolo Costantini and Italo Zannier, eds, *Cultura fotografica in Italia* (Milan, 1985), pp. 291–3.

17 See Giuseppe Turroni, *Nuova fotografia italiana* (Milan, 1959), p. 11, and Silvia Paoli, 'L'Annuario di Domus del 1943', in Tiziana Serena, ed., *Per Paolo Costantini: Fotografia e raccolte fotografiche*, I (Pisa, 1998), pp. 99–130.

18 E. F. Scopinich, 'Considerazioni sulla fotografia italiana', *Fotografia: Prima Rassegna dell'attività fotografica in Italia* (Milan, 1943), p. 7.

19 E. F. Scopinich, 'Ritratti Ambientati di Carlo Mollino', *Occhio Magico*, IV (Milan, 1945). See Fulvio and Napoleone Ferrari, *Carlo Mollino: Photographs 1956–1962* (Turin, 2006), pp. 19–24.

20 Carlo Mollino, *Il messaggio della camera oscura* (Turin, 1949), p. 41.

21 Giuseppe Pagano, 'Un cacciatore di immagini (1938)', cited in Cesare De Seta, ed., *Giuseppe Pagano fotografo* (Milan, 1979), p. 156.

six: **Postwar Narratives**

1 Federico Patellani, 'Il giornalista nuova formula', in Cesare Colombo, ed., *Lo sguardo critico: Cultura e fotografia in Italia 1943–1968* (Turin, 2003), pp. 151–5. It is significant that Patellani briefly engaged with filmmaking. In 1939 he was producer with Carlo Ponti of the film *Piccolo Mondo Antico*, directed by Mario Soldati; in 1953 he was assistant to director Alberto Lattuada for the film *La Lupa*, shot in Matera. See Kitti Bolognesi and Giovanna Calvenzi, eds, 'Federico Patellani. Fotografie e cinema 1943–1960', *Quaderni di AFT*, IV (2005), pp. 2–9. My thanks to Arianna Bianchi and Paola Chiodi for information on Patellani at *Tempo*.

2 See Jeffrey Schnapp, 'Bruno Munari's Bombs', in Jordana Mendelson, ed., *Magazines, Modernity and War* (Madrid, 2008),

pp. 141–59.

3 See Enny Taramelly, *Viaggio nell'Italia del Neorealismo: La fotografia tra letteratura e cinema* (Turin, 1995); Claudio Pastrone, ed., *Gli anni del Neorealismo: Tendenze della fotografia italiana* (Turin, 2001); Keith De Lellis, *Neorealismo: Scenes of Life in Post-War Italy* (New York, 2001); Enrica Viganò, *Neorealismo: La nuova imagine in Italia 1932–1960* (Milan, 2006). The definition of this photography as 'neo-realist' is still open to debate. See Cesare Colombo, 'Mario Giacomelli: un italiano fino in fondo', in Simona Guerra, *Parlami di lui* (Ancona, 2007), p. 103: 'The term 'neo-realism' has been adopted by photographic culture much later . . . In the 1950s, photographers would never say "we are comparable to neo-realism, our role is like that of directors of neo-realist cinema".'

4 Cesare Colombo, 'Paper Dreams: News Weeklies, 1945–60', in Giovanna Calvenzi, *Italia: Portrait of a Country throughout 60 Years of Photography* (Rome, 2003), pp. 180–85. See David Forgacs and Stephen Gundle, *Mass Culture and Italian Society from Fascism to the Cold War* (Bloomington, IN, 2007).

5 For a story of *fotoromanzi*, see Dario Reteuna, *Cinema di carta: Storia fotografica del cinema italiano* (Alessandria, 2000). Regarding fashion magazines, see Lapo Cianchi, ed., *Italian Eyes: Italian Fashion Photographs from 1951 to Today*, exh. cat., Rotonda di Via Besana, Milan (Milan, 2005).

6 Colombo, 'Paper Dreams', p. 183.

7 Calvenzi, *Italia: Portrait of a Country*, p. 17.

8 Elio Vittorini, 'La foto strizza l'occhio alla pagina', in Maria Rizzarelli, ed., *Elio Vittorini: Conversazione illustrata*, exh. cat., Ex Convento del Ritiro, Siracusa, and Ex Monastero dei Benedettini, Catania (Acireale, 2007), p. 38.

9 Luigi Crocenzi, '1957: Storie Italiane: Cronache e racconti per immagini fotografiche', in Colombo, *Lo sguardo critico*, p. 66. On Crocenzi see also Antonio Giusa et al., *Luigi Crocenzi: Un racconto per immagini* (Spilimbergo, 2003).

10 Cesare Zavattini, '1958: Quattro chiacchiere con gli italiani fotografi', in Colombo, *Lo sguardo critico*, p. 64.

11 Cesare Zavattini, '1955: Introduzione ai Fotodocumentari di Cinema Nuovo', Colombo, *Lo sguardo critico*, pp. 57–8. The photographers were Samugheo, Enzo Sellerio, Carlo Cisventi, Carlo Bavagnoli, Arturo Zavattini, Franco Pinna and Benedetto Benedetti.

12 Enzo Sellerio, *A Photographer in Sicily* (London, 1996), p. 4. Regarding the dispute between Sellerio and *Cinema Nuovo*, see Paolo Morello, *Enzo Sellerio fotografo: Tre studi siciliani* (Milan, 1998), p. 50.

13 *L'Espresso*, V/22 (1959). See Giuseppe Pinna, ed., *Franco Pinna: Fotografie 1944–1977* (Milan, 1996), p. 19.

14 See Lawrence W. Levine, 'The Historian and the Icon', in Beverly Brannan and Carl Fleischauer, *Documenting America, 1935–1943* (Berkeley, 1988), p. 25.

15 See Giorgio Tani et al., *Alfredo Camisa* (Turin, 2007).

16 See Marina Miraglia, ed., *La fotografia in Sardegna: lo sguardo esterno 1854–1939* (Nuoro, 2008).

17 Ernesto De Martino, *L'opera a cui lavoro: Apparato critico e documentario alla 'Spedizione etnologica' in Lucania* (Lecce, 1996), p. 12.

18 For these thoughts on Maddalena La Rocca, see Pinna, *Franco Pinna*, p. 12.

19 See Diego Mormorio, *Tazio Secchiaroli: Greatest of the Paparazzi* (New York, 1999).

20 Anita Margiotta and Federica Pirani, *Giuseppe Cavalli fotografie 1936–1961* (Rome, 2006).

21 See Piero Berengo Gardin, *Alberto Lattuada fotografo: Dieci anni di Occhio Quadrato 1938/1948* (Florence, 1982).

22 Giovanna Calvenzi and Renate Siebenhaar-Zeller, *Pietro Donzelli* (Rome, 2006).

23 See Giovanna Calvenzi and Roberta Valtorta, *Il Mondo dei fotografi 1951–1966* (Prato, 1990), p. 22.

24 Silvana Turzio, *Gianni Berengo Gardin* (Milan, 2009), pp. 27–8. See also Paolo Morello, *Gianni Berengo Gardin: Venezia* (Palermo, 2006), p. 29, who reveals that this frame was cropped from an original vertical view. One counts more than 200 books published by Berengo Gardin.

seven: The Margin of the Frame

1 The exhibition was in the small Dryden Gallery. Among the 26 were Borghesan, Camisa, Cirello, Clari, Crovatto, De Biasi, Di Biase, Di Blasi, Del Tin, Donzelli, Ferri, Fontana, Foresti, Berengo Gardin, Giacomelli, Delaini, Giovannini, Niccolai, Inutili, Migliori, Moder, Novaro, Orsi, Parmiani, Salani, Zannier, Zovetti.

2 Giorgio Gabriele Negri, *Storie di Terra: Mario Giacomelli* (Milan, 1992), p. 83. For a chronology of Giacomelli's landscapes, the first dating to 1956, see Arturo Carlo Quintavalle, *Mario Giacomelli* (Milan, 1980).

3 Alistair Crawford, *Mario Giacomelli* (London, 2001), p. 16.

4 Angelo Schwarz, 'Intervista con Paolo Monti', *Il Diaframma*, CCXLIV (December 1978), p. 37.

5 Manfredo Manfroi, 'Circolo "La Gondola"; una microstoria', in Italo Zannier, ed., *Fotografia a Venezia nel dopoguerra da Ferruccio Leiss al Circolo 'La Gondola'* (Florence, 2005), p. 21.

6 Roberta Valtorta, 'Monti, artista e lavoratore', in Andrea Emiliani, ed., *Pieve di Cento nelle foto di Paolo Monti* (Milan, 1995), p. 22.

7 For an overview of these years, see Anna Lisa Carlotti, ed., *Fotografia e fotografi a Milano dall'Ottocento ad oggi* (Milan, 2000); Uliano Lucas and Tatiana Agliani, eds, 'L'immagine fotografica 1945–2000', in *Storia d'Italia: Annali 20* (Turin, 2004).

8 I thank Cesare Colombo for information on this series.

9 Carrieri's words cited in Giovanna Calvenzi, *Italia: Portrait of a Country* (Rome, 2003), p. 240.

10 Cerati (from *A Traumatic Experience*, 1998), cited in Giovanna Calvenzi, *Italia: Portrait of a Country*, p. 257. I wish to thank the photographer for informing me that the work of Avedon, exhibited at Palazzo Reale during those years, was a prime inspiration for this work.

11 See Arturo Carlo Quintavalle's analysis of Mulas's temporality in his book *Ugo Mulas: La Fotografia* (Turin, 1973).

12 See 'Ugo Mulas: Percorsi e Verifiche', in Carlotti, *Fotografia e fotografi*, pp. 169–73; Lapo Cianchi, ed., *Italian Eyes: Italian Fashion Photographs from 1951 to Today*, exh. cat., Rotonda di Via Besana, Milan (Milan, 2005).

13 Mulas in Quintavalle, *Ugo Mulas*, p. 44.

14 See www.ugomulas.org (accessed February 2010) with original translations.

15 Campagnano's 'Inventing Femininity: Roles' (1975) was published in Calvenzi, *Italia: Portrait of a Country*, pp. 78–9.

16 See Cianchi, *Italian Eyes: Italian Fashion Photographs*, p. 390; Liz Wells, ed., *Photography: A Critical Introduction* (London and New York, 2000), pp. 206–14.

17 Paolo Gioli, wall text of the exhibition *Corps et Thorax* curated by Alain Sayag, Centre Georges Pompidou, Paris, 1983. I wish to thank Paolo Vampa for sharing this information.

18 Roberta Valtorta, ed., *Paolo Gioli: Fotografie, Dipinti, Grafica* (Udine, 1996), p. 23.

19 For a complete description of Vaccari's projects and anthology of writings, see Nicoletta Leonardi, ed., *Feedback: Scritti su e di Franco Vaccari* (Milan, 2007).

20 See Roberta Valtorta, 'Mario Cresci's Circular Time', in Pier Giovanni Castagnoli and Riccardo Passoni, eds, *Mario Cresci: Le case della fotografia, 1996–2000*, exh. cat., Galleria d'Arte Moderna, Turin (Turin, 2004), pp. 48–9.

21 Ghirri's essays have been collected in a book – translated, so far, only into French. See Paolo Costantini and Giovanni Chiaramonte, eds, *Luigi Ghirri: Niente di antico sotto il sole: Scritti e immagini per un'autobiografia* (Turin, 1997).

22 Ghirri cited in Arturo Carlo Quintavalle, *Muri di carta: Fotografia e paesaggio dopo le avanguardie* (Milan, 1993), p. 134.

23 Ghirri reviewed Eggleston's work (in Costantini and Chiaramonte, *Luigi Ghirri*, pp. 49–52). Significantly, Eggleston wrote the Preface to Germano Celant, ed., *It's beautiful here, isn't it . . . Photographs by Luigi Ghirri* (New York, 2008), pp. 9–11.

24 Arturo Carlo Quintavalle, *Viaggio in Italia* (Bari, 1984), p. 11.

25 Cited in Quintavalle, *Muri di carta*, p. 162.

26 *Walker Evans*, with an introduction by John Szarkowski, exh. cat., Museum of Modern Art (New York, 1971). My thanks to Guidi for this email exchange in April 2009.

eight: Alienation and Belonging

1 Gabriele Basilico, *Milano ritratti di fabbriche* (Milan, 1981). This was Basilico's first project planned out as a book. See Andrea Lissoni, ed., *Gabriele Basilico. Architettura, città, visioni: Riflessioni sulla fotografia* (Milan, 2007).

2 See Yona Friedman, Hans Ulrich Obrist and Stefano Boeri, *Scattered City* (Milan and Paris, 2005). Basilico's output of books is impressive, with an average of more than one per year since 1981. For an overall view, see *Gabriele Basilico: Photo Books 1978–2005* (Mantova, 2006).

3 Gabriele Basilico, 'Fotografare l'architettura, fotografare in paesaggio', in Marisa Galbiati, ed., *Fotografia e paesaggio: la rappresentazione fotografica del territorio* (Milan, 1996), p. 40.

4 For an overview of European exhibitions during these years, see Roberta Valtorta, 'Stupore del paesaggio', in the issue 'Racconti dal paesaggio: 1984–2004' of *Quaderno di Villa Ghirlanda*, III (2004), pp. 11–49.

5 Walter Guadagnini and Francesco Zanot, eds, *Olivo Barbieri: Lugo e il mare* (Rome, 2006), p. 1. His recent work *Site Specific* has been published, so far, only for individual projects, for example, Rome, Las Vegas, Lugo, Shanghai, New York, Montreal, Zimbabwe Waterfalls, Jordan, Milan, Florence, Catania.

6 Jan Thorn-Prikker, *Olivo Barbieri: Fotografie dal 1978* (Udine, 1996), p. 11.

7 William Guerrieri and Tiziana Serena, *TAV: Walter Niedermayr* (Rubiera, 2006).

8 See Val Williams, 'Partial Neutrality', in *William Guerrieri: Oggi nessuno puo' dirsi neutrale* (Bolzano, 1998).

9 See Antonella Russo and Roberta Valtorta's essays in the publication that celebrated ten years of *Linea di Confine*, titled *Via Emilia: Fotografie, luoghi e non luoghi 2* (Rubiera, 2000). See also William Guerrieri's presentation in Frits Gierstberg, ed., *SubUrban Options: Photography Commissions and the Urbanization of the Landscape* (Rotterdam, 1998), pp. 112–14.

10 Roberta Valtorta, 'Archivio dello spazio: Point of Arrival, Point of Departure', in Gierstberg, *SubUrban Options*, p. 102. See also Valtorta, 'La fotografia dei luoghi come fotografia', in Achille Sacconi and Roberta Valtorta, *1987–1997: Archivio dello spazio: Dieci anni di fotografia italiana sul territorio della provincia di Milano* (Udine, 1997), pp. xxxiii–xxxix.

11 From an email conversation with Guidi, December 2009.

12 See Eleonora Fiorani, 'Il territorio diverso della citta' attuale', in *Milano senza confini* (Milan, 2000), pp. 17–25.

13 Luc Sante, 'Under the Boardwalk, Down by the Sea', *Condé Nast Traveler* (2007), pp. 98–105.

14 See Roberta Valtorta, 'The Body as Interface of the Landscape', in *Idea di Metropoli*, exh. cat., Museo di Fotografia Contemporanea, Cinisello Balsamo (Milan, 2003), p. 12.

15 Paola Di Bello, 'Homeless Home', in *Idea di Metropoli*, p. 62.

16 Francesco Jodice, 'Introduction', in *What We Want: Landscape as a Projection of People's Desire* (Milan, 2004).

17 Moira Ricci's statement about this work, which she shared on email. Moira Ricci and Paolo Ventura (as well as Barbieri) were included in the international exhibition *Realtà manipolate: Come le immagini ridefiniscono il mondo*, Palazzo Strozzi, Florence, 2009–10.

18 See A. D. Coleman, 'The Directorial Mode', in *Light Readings. A Photography Critic's Writings 1968–1978* (Oxford, 1979), pp. 246–57.

19 I thank Wolf for sharing his statement, written in 2008.

Select Bibliography

Fotologia, 1984–

Fotostorica, 1998–

AFT. *Rivista di Storia e Fotografia*, 1985–

Alinovi, Francesca, 'Fotografia', in Renato Barilli and Vittorio Fagone, eds, *Gli Annitrenta: Arte e Cultura in Italia*, exh.cat., Palazzo Reale, Milan (Milan, 1982), pp. 409–34

Altamira, Adriano, *La vera storia della fotografia concettuale* (Milan, 2007)

Amendola, E. P., *Uno sguardo privato, memorie fotografiche di Francesco Chigi* (Turin, 1978)

——, ed., *Mario Nunes Vais*, exh. cat., Gabinetto Fotografico Nazionale, Rome, (Rome, 1974)

Amodeo, Fabio, and Antonio Giusa, eds, *Luigi Crocenzi: Un racconto per immagini* (Spilimbergo, 2003)

Audisio, Aldo, and Claudio Fontana, eds, *Vittorio Sella: Fotografie e montagna nell'Ottocento*, exh. cat. Museo Nazionale della Montagna 'Duca degli Abruzzi', Turin (Ivrea, 1982)

Becchetti, Piero, *Fotografi e fotografia in Italia 1839–1880* (Rome, 1978)

——, *Giacomo Caneva e la scuola fotografica romana 1847–1855*, exh. cat., Palazzo Rondanini, Rome (Florence, 1989)

—— and Carlo Pietrangeli, eds, *Rome in Early Photographs: The Age of Pius IX. Photographs 1846–1878 from Roman and Danish Collections* (Copenhagen, 1977)

——, *Roma in dagherrotipia* (Rome, 1979)

——, *Un inglese fotografo a Roma: Robert Macpherson* (Rome, 1987)

Benassati, Giuseppina, and Angela Tromellini, eds, *Fotografia & Fotografi a Bologna 1839–1900*, exh. cat., Assessorato all'Urbanistica, Cultura e Beni Culturali, Bologna (Bologna, 1992)

Bertelli, Carlo, ed., *Mario Nunes Vais fotografo*, exh. cat., Palazzo Vecchio, Florence (Florence, 1974)

—— and Giulio Bollati, 'L'immagine fotografica 1845–1945', in *Storia d'Italia*, Annali 2 (Turin, 1979)

Bertolini, Francesca, ed., *Paolo Monti: Scritti scelti 1953–1983* (Palermo, 2004)

Bonami, Francesco, et al., *Walter Niedermayr: Momentary Resorts* (Bolzano, 1998)

Bonetti, Maria Francesca, and Monica Maffioli, eds, *L'Italia d'Argento 1839–1859: Storia del dagherrotipo in Italia*, exh. cat., Sala d'Arme di Palazzo Vecchio, Florence, and Palazzo Fontana di Trevi, Rome (Florence, 2003)

——, ed., *Roma 1840–1870. La fotografia, il collezionista e lo storico: Fotografie della collezione Orsola e Filippo Maggia*, exh. cat., Calcografia, Rome, and Fotomuseo Giuseppe Panini, Modena (Rome, 2008)

Brugnoli, Pierpaolo, Sergio Marinelli, and Alberto Prandi, eds, *Lotze: Lo studio fotografico 1852–1909*, exh. cat., Verona, Museo di Castelvecchio (Verona, 1984)

Burns, Karen, 'Topographies of Tourism: "Documentary" Photography and "The Stones of Venice"', *Assemblage*, 32 (April 1997), pp. 22–44

Calvenzi, Giovanna, *Italia: Portrait of a Country throughout 60 Years of Photography* (Rome, 2003)

—— and Renate Siebenhaar-Zeller, *Pietro Donzelli* (Rome, 2006)

——, ed., *Ereditare il paesaggio*, exh. cat., Museo dell'Ara Pacis, Rome (Milan, 2008)

—— and Roberta Valtorta, *Il Mondo dei fotografi 1951–1966* (Prato, 1990)

Carlotti, Anna Lisa, ed., *Fotografia e fotografi a Milano dall'Ottocento ad oggi* (Milan, 2000)

Cartier-Bresson, Anne, and Anita Margiotta, eds, *Roma 1850: Il Circolo dei pittori fotografi del Caffè Greco*, exh. cat., Musei Capitolini, Rome, and Maison Europeenne de la Photographie, Paris (Milan, 2004)

—— and Monica Maffioli, eds., *Eloge du négatif: Les débuts de la photographie sur papier en Italie, 1846–1862*, exh.cat., Petit Palais, Paris (Paris, 2010)

Cassanelli, Roberto, ed., *Luigi Sacchi: Un artista dell'Ottocento nell'Europa dei fotografi* (Turin, 1998)

Castagnoli, Pier Giovanni, and Riccardo Passoni, eds, *Mario Cresci: Le case della fotografia, 1996–2000*, exh. cat., Galleria d'Arte Moderna, Turin (Turin, 2004)

Cavanna, Pierangelo, and Paolo Costantini, *Mario Gabinio: dal paesaggio alla forma, fotografie, 1890–1938* (Turin, 1996)

——, *Stefano Bricarelli Fotografie*, exh. cat., Galleria civica d'arte moderna e contemporanea, Turin (Turin, 2005)

Cavazzi, Lucia, ed., *La fotografia a Roma nel secolo XIX: La veduta, il ritratto, l'archeologia* (Rome, 1991)

——, Anita, Margiotta, Simonetta Tozzi, *Un Inglese a Roma 1864–1877: La Raccolta Parker nell'Archivio fotografico Comunale* (Rome, 1989)

Celant, Germano, ed., *The Italian Metamorphosis 1943–1968*, exh. cat., Guggenheim Museum, New York (New York, 1994)

——, *Mario Giacomelli* (Milan, 2001)

——, *It's beautiful here, isn't it . . . Photographs by Luigi Ghirri*, exh. cat., Aperture Gallery, New York (New York, 2008)

Cianchi, Lapo, ed., *Italian Eyes: Italian Fashion Photographs from 1951 to today*, exh. cat., Rotonda di Via Besana, Milan (Milan, 2005)

Colombo, Cesare, ed., *Professione fotoreporter: l'Italia dal 1934 al 1970 nelle immagini della Publifoto di Vincenzo Carrese* (Milan, 1983)

——, *Scritto con la luce: Un secolo di fotografia e di cinema in Italia* (Milan, 1987)

—— and Susan Sontag, *Italy: One Hundred Years of Photography*, exh. cat., Museo Fratelli Alinari, Florence (Florence, 1988)

——, ed., *Lo sguardo critico: Cultura e fotografia in Italia 1943–1968* (Turin, 2003)

——, 'Fotografia: nuovi linguaggi per un paese antico', in *Annicinquanta: La nascita della creatività italiana*, exh.cat., Palazzo Reale, Milan

(Milan, 2005), pp. 322–8

Costantini, Paolo and Giovanni Chiaramonte, eds, *Luigi Ghirri: Niente di antico sotto il sole: Scritti e immagini per un'autobiografia* (Turin, 1997)

Costantini, Paolo, and Italo Zannier, eds, *Cultura fotografica in Italia: Antologia di testi sulla fotografia 1839–1949* (Milan, 1985)

——, *Venezia nella fotografia dell'Ottocento* (Venice, 1986)

——, *I dagherrotipi della collezione Ruskin* (Venice and Florence, 1986)

——, *Luci ed Ombre. Gli annali della fotografia artistica italiana 1923–1934*, exh. cat., Museo Fratelli Alinari, Florence (Florence, 1987)

——, *L'insistenza dello sguardo: Fotografie italiane 1839–1989*, exh. cat., Palazzo Fortuny, Venice (Florence, 1989)

——, *'La Fotografia Artistica' 1904–1917: Visione italiana e modernità* (Turin, 1990)

Crawford, Alistair, 'Robert Macpherson 1814–1872', *Papers of the British School at Rome*, 67 (1999), pp. 353–403

——, *Mario Giacomelli* (London, 2001)

Critelli, Maria Pia, ed., *Stefano Lecchi: Un fotografo e la Repubblica Romana del 1849* (Rome, 2001)

De Lellis, Keith, *Neorealismo: Scenes of Life in Post-war Italy* (New York, 2001)

——, *La Strada: Italian Street Photography* (New York, 2006)

De Seta, Carlo, ed., *Giuseppe Pagano fotografo* (Milan, 1979)

Del Barbarò, Falzone Michele, Monica Maffioli and Emanuela Sesti, eds, *Alle origini della fotografia: un itinerario toscano 1839–1880*, exh. cat., Palazzo Vecchio, Florence (Florence, 1989)

Del Barbarò, Falzone Michele and Italo Zannier, eds, *Fotografia luce della modernità: Torino 1920/1950: dal Pittorialismo al Modernismo*, exh. cat., Museo dell'Automobile Carlo Biscaretti di Ruffia, Turin (Florence, 1991)

——, Marina Miraglia and Italo Mussa, *Le fotografie di von Gloeden* (Milan, 1980)

Del Pesco, Daniela and Mariantonietta Picone Petrusa, *Immagine e città: Napoli nelle collezioni Alinari e nei fotografi napoletani fra Ottocento e Novecento*, exh. cat., Courtyard of Monastery of S. Chiara, Naples (Naples, 1981)

Faeta, Francesco, *Fotografi e fotografie: Uno sguardo antropologico* (Milan, 2006)

Ferrari, Fulvio and Napoleone, *Carlo Mollino: Photographs 1956–1962* (Turin, 2006)

——, *Carlo Mollino: a occhio nudo: L'opera fotografica, 1934–1973*, Museo Fratelli Alinari, Florence (Florence, 2009)

Fossati, Paolo, ed., *Ugo Mulas: La fotografia* (Turin, 1973)

——, ed., *Luigi Veronesi e la fotografia: Spazio e struttura per un'immagine*, exh. cat., Galleria Martano, Turin (Turin, 2003)

Gabriele Basilico Photo Books 1978–2005 (Mantova, 2006).

Galbiati, Marisa, ed., *Fotografia e paesaggio: la rappresentazione fotografica del territorio* (Milan, 1996)

Ghirri, Luigi, *Paesaggio italiano / Italian Landscape* (Milan, 1989)

—— and Gianni Celati, *Il Profilo delle Nuvole* (Milan, 1989)

Ghirri, Paola, and Ennery Taramelli, *Vista con camera: 200 fotografie in Emilia Romagna*, exh. cat., Galleria d'Arte Moderna, Bologna (Milan, 1992)

Gilardi, Ando, *Storia sociale della fotografia* (Milan, 1976)

——, 'Creatività e informazione fotografica', in *Storia dell'arte italiana*, II/2 (Turin, 1981), pp. 545–86

——, *Wanted! Storia, tecnica ed estetica della fotografia criminale, segnaletica e giudiziaria* (Milan, 2003)

Ginex, Giovanna, 'Fotografia e pittura nel laboratorio divisionista', in Gabriella Belli and Franco Rella, *L'età del divisionismo*, exh. cat., Museo d'arte contemporanea di Trento e Rovereto (Milan, 1990), pp.232–249

——, *Divine: Emilio Sommariva fotografo: opere scelte 1910–1930* (Busto Arsizio, 2004)

Guadagnini, Walter, ed., *Modena per la fotografia: L'idea di paesaggio nella fotografia italiana dal 1850 ad oggi*, exh. cat., Palazzo Santa Margherita, Modena (Milan, 2000)

Guerra, Simona, *Parlami di lui: le voci di Scianna, Berengo Gardin, Ferroni, Camisa, Colombo, Branzi, Manfroi, de Biasi, Permunian, Biagetti, su Mario Giacomelli* (Ancona, 2007)

Harris, Melissa, ed., 'Immagini Italiane', *Aperture*, 132 (Summer 1993)

Jacob, Mike, 'The Daguerreotype in Italy', *The Daguerrean Annual* (1992), pp. 165–80

Lassam, Robert E., and Michael Gray, *The Romantic Era: La calotipia in Italia* (Florence, 1988)

Leonardi, Nicoletta, ed., *Feedback: Scritti su e di Franco Vaccari* (Milan, 2007)

Lissoni, Andrea, ed., *Gabriele Basilico: Architettura, città, visioni. Riflessioni sulla fotografia* (Milan, 2007)

Lista, Giovanni, *Futurismo e fotografia* (Milan, 1979)

——, *Futurism and Photography*, exh. cat., Estorick Collection, London (London, 2001)

Lucas, Uliano, and Mario Bizzicari, eds., *L'informazione negata: Il fotogiornalismo in Italia 1945–1980* (Bari, 1981)

—— and Tatiana Agliani, eds, 'L'immagine fotografica 1945–2000' in *Storia d'Italia: Annali 20* (Turin, 2004)

Lundberg, Bruce W., and John Pinto, eds, *Steps off the Beaten Path: Nineteenth-century Photographs of Rome and its Environs*, exh. cat., American Academy in Rome, New York and Rome (Milan, 2007)

Madesani, Angela, et al., *Vincenzo Castella: Siti 98–08* (Milan, 2009)

Maffioli, Monica, *Il Belvedere: Fotografi e architetti nell'Italia dell'Ottocento* (Turin, 1996)

——, ed., *I Macchiaioli e la fotografia*, exh. cat., Museo nazionale Alinari della fotografia, Florence (Florence, 2008)

Maggia, Filippo, ed., *Da Guarene all'Etna, via mare, via terra*, exh. cat., Fondazione Sandretto Re Rebaudengo, Turin (Milan, 2000)

Margiotta, Anita, and Federica Pirani, *Giuseppe Cavalli fotografie 1936–1961* (Rome, 2006)

Mimmo Jodice: Retrospettiva, Galleria civica d'arte moderna e contemporanea, Turin (Turin, 2001)

Miraglia, Marina, *Francesco Paolo Michetti fotografo* (Turin, 1975)

——, Daniela Palazzoli and Italo Zannier, eds., *Fotografia italiana dell'Ottocento*, (Florence and Venice, 1979)

——, Daniela Palazzoli, Italo Zannier, eds, *Fotografia pittorica 1889–1911*, exh. cat., Ala Napoleonica, Venice, and Palazzo Pitti, Florence (Venice and Florence, 1979)

——, 'Note per una storia della fotografia italiana (1839–1911)', in *Storia dell'arte italiana*, II/2, (Turin, 1981), pp. 421–544

——, 'I luoghi dell'epopea garibaldina: reportage bellico e 'veduta' nella fotografia dell'Ottocento', in *Garibaldi: Arte e Storia*, exh. cat., Museo del Palazzo di Venezia, Rome, and Museo centrale del Risorgimento, Rome (Florence, 1982), pp. 274–334

——, *Culture fotografiche e società a Torino 1839–1911* (Turin, 1990)

——, Ulrich Pohlmann, *Un viaggio fra mito e realtà: Giorgio Sommer fotografo in Italia 1857–1891* (Rome, 1992)

——, *Alle origini della fotografia: Luigi Sacchi lucigrafo a Milano 1805–1861* (Milan, 1996)

——, *Il '900 in fotografia: Il caso torinese* (Turin, 2001)

——, 'Michetti tra pittura e fotografia', in Claudio Strinati, ed., *Francesco Paolo Michetti: Il Cenacolo delle arti: tra fotografia e decorazione*, exh. cat., Palazzo Venezia, Rome (Naples, 1999), pp. 13–64

——, ed., *La fotografia in Sardegna: lo sguardo esterno 1854–1939* (Nuoro, 2008)

Mollino, Carlo, *Il messaggio della camera oscura* (Turin, 1949)

Morello, Paolo, *Enzo Sellerio fotografo: Tre studi siciliani* (Milan, 1998)

——, *Briganti. Fotografia e malavita nella Sicilia dell'Ottocento* (Palermo, 1999)

——, *Gli Incorpora, 1860–1940* (Florence, 2000)

——, *Amen fotografia 1839–2000: Immagini e libri dall'Archivio di Italo Zannier* (Milan, 2000)

——, 'Verifiche intorno la fotografia in Italia 1943–1953', in Luciano Caramel, ed., *Realismi: arti figurative, letteratura e cinema in Italia dal 1943 al 1953* (Milan, 2001)

——, ed., *Alfredo Camisa: carteggio* (Palermo, 2003)

——, *Gianni Berengo Gardin: Venezia* (Palermo, 2006)

——, *La fotografia in Italia 1945–1975* (Milan, 2010)

Mormorio, Diego, *Tazio Secchiaroli: Greatest of the Paparazzi* (New York, 1999)

Munsterberg, Marjorie, 'A Biographical Sketch of Robert Macpherson', *Art Bulletin*, LXVIII/1 (March 1986), pp.142–53

Mussini, Massimo, *Luigi Ghirri* (Milan, 2001)

Negro, Silvio, *Mostra della fotografia a Roma dal 1840 al 1915* (Rome, 1953)

Palazzoli, Daniela, and Luigi Carluccio, eds., *Combattimento per un' immagine: Fotografi e pittori*, exh. cat., Civica Galleria d'Arte Moderna, Turin (Turin, 1973)

——, *Giuseppe Primoli* (Milan, 1979)

——, 'Le origini della fotografia in Italia', in Helmut Gernsheim, *Le origini della fotografia* (Milan, 1981)

Paoli, Silvia, 'L'Annuario di Domus del 1943', in Tiziana Serena, ed.,

Per Paolo Costantini: Fotografia e raccolte fotografiche, I (Pisa, 1998), pp. 99–130

——, ed., *Lamberto Vitali e la fotografia: Collezionismo, studi e ricerche* (Milan, 2004)

——, ed., *Ex Fabrica: Identities and Mutations on the Outskirts of the Metropolis* (Milan, 2006)

Passoni, Riccardo, ed., *Nino Migliori: Materie e memoria*, exh. cat., Galleria d'Arte Moderna, Turin (Turin, 2002)

Pastrone, Claudio, ed., *Gli anni del Neorealismo: Tendenze della fotografia italiana* (Turin, 2001)

Pelizzari, Maria Antonella, 'Bourgeois Spaces and Historical Contexts: Facets of the Italian City in Nineteenth-century Photography', *Visual Resources*, XII/1 (1996) pp. 1–18

——, 'Pompeo Bondini: *Della Via Appia* (1853)', *History of Photography*, XX/1 (Spring 1996), pp. 12–23

——, 'Mario Cresci's "Inadvertent Little Gestures"', *History of Photography*, XXIV/3 (Fall 2000), pp. 202–8

——, 'Retracing the Outlines of Rome: Intertextuality and Imaginative Geographies in Nineteenth-century Photographs', in Joan M. Schwartz and James R. Ryan, eds, *Picturing Place: Photography and the Geographical Imagination* (London and New York, 2002), pp. 55–73

Pinna, Giuseppe, ed., *Franco Pinna: Fotografie 1944–1977* (Milan, 1996)

Pizzo, Marco, *Fotografie del Risorgimento italiano* (Rome, 2004)

——, *L'Album dei Mille di Alessandro Pavia* (Rome, 2004)

Pohlmann, Ulrich, *Wilhelm von Gloeden: Sehnsucht nach Arkadien* (Berlin, 1987)

—— and Françoise Heilbrun, eds., *Voir l'Italie et mourir: Photographie et peinture dans l'Italie du XIXe siècle*, exh. cat., Musée d'Orsay, Paris (Paris, 2009)

Porretta, Sebastiano, *Ignazio Cugnoni fotografo* (Turin, 1976)

Quintavalle, Arturo Carlo, ed., *Ugo Mulas: La Fotografia* (Turin, 1973)

—— and Massimo Mussini, *Luigi Ghirri* (Parma, 1979)

——, *Mario Giacomelli* (Milan, 1980)

——, *Messa a fuoco: Studi sulla fotografia* (Milan, 1983)

——, *Muri di carta: Fotografia e paesaggio dopo le avanguardie*, exh. cat., Biennale di Venezia, Padiglione Italia (Milan, 1993)

——, *Gli Alinari* (Florence, 2003)

—— and Monica Maffioli, eds, *Fratelli Alinari Fotografi in Firenze: 150 anni che illustrarono il mondo 1851–2002* (Florence, 2003)

Reteuna, Dario, *Cinema di carta: Storia fotografica del cinema italiano* (Alessandria, 2000)

——, ed., *Sentieri di luce: Artisti fotografi a Torino dal 1930 al 1946* (Florence, 2002)

——, *L'occhio del Gattopardo: Filippo Cianciàfara Tasca di Cutò e la fotografia d'arte in Sicilia* (Messina, 2008)

Ritter, Dorothea, *Rom 1846–1870: James Anderson und die Maler-Fotografen, Sammlung Siegert* (Munich, 2005)

Rodeschini Galati, Maria Cristina and Italo Zannier, eds, *Mario Finazzi*, exh. cat., Galleria d'Arte Moderna, Bergamo (Bergamo, 2006)

Romano, Serena, ed., *L'immagine di Roma, 1848–1895: la città, l'archeologia, il medioevo nei calotipi del fondo Tuminello. Catalogo della collezione di Piero Becchetti*, exh. cat., Istituto Centrale per il Catalogo e la Documentazione, Rome (Naples, 1994)

Schwarz, Angelo, 'Fascist Italy', in Jean-Claude Lemagny and André Rouillé, eds., *A History of Photography: Social and Cultural Perspectives* (Cambridge, MA, 1998), pp. 136–40

Scimé, Giuliana, *Bauhaus e razionalismo nelle fotografie di Lux Feininger, Franco Grignani, Xanti Schawinsky, Luigi Veronesi*, exh. cat., Galleria Fonte dell'Abisso Arte, Milan (Milan, 1993)

Sella, Lodovico, ed., *Paesaggi verticali: La fotografia di Vittorio Sella 1879–1943*, exh. cat., Galleria d'Arte Moderna, Turin (Turin, 2006)

Serena, Tiziana, 'La Venise de Piot', in *Actes Ecole du Louvre, Venise en France: Du romantisme au symbolisme* (Paris, 2006), pp. 289–305

Settimelli, Wladimiro, 'La fotografia italiana', in Jean Keim, *Breve storia della fotografia* (Turin, 1970)

——, *Giovanni Verga, specchio e realtà: 84 foto inedite dello scrittore siciliano, accompagnate da una scelta antologica* (Rome, 1976)

—— and Filippo Zevi, eds, *Gli Alinari Fotografi a Firenze 1852/1920*, exh. cat., Forte di Belvedere, Florence (Florence, 1977)

——, ed., *Garibaldi: L'album fotografico* (Florence, 1982)

Shanahan, Patrick, ed., 'Italian Cultural Landscape', *History of Photography*, XXIV/3 (Fall 2000)

Siegert, Dietmart, ed., *Italien: Sehen und Sterben: Photographien der Zeit des Risorgimento (1845–1870)* (Heidelberg, 1994)

Szegedy-Maszak, Andrew, 'Roman Views', in *Six Exposures: Essays in Celebration of the Harrison D. Horblit Collection of Early Photography* (Cambridge, MA, 1999), pp. 89–106

Taramelli, Ennery, *Viaggio nell'Italia del Neorealismo: La fotografia tra letteratura e cinema* (Turin, 1995)

Thorn-Prikker, Jan, ed., *Olivo Barbieri Fotografie dal 1978* (Udine, 1996)

Tognon, Paola, *Vincenzo Castella. Photo Works* (Milan, 2003)

Turroni, Giuseppe, *Nuova fotografia italiana* (Milan, 1959)

——, *Paolo Monti. Trent'anni di fotografia 1948–1978* (Reggio Emilia, 1979)

——, *Luxardo: l'italica bellezza* (Milan, 1980)

Turzio, Silvana, Renzo Villa and Alessandra Violi, *Locus Solus: Lombroso e la fotografia* (Milan, 2005)

——, *Gianni Berengo Gardin* (Milan, 2009)

Vaccari, Franco, *Fotografia e inconscio tecnologico* (Modena, 1979)

Valtorta, Roberta, ed., *Paolo Gioli: Fotografie, Dipinti, Grafica* (Udine, 1996)

——, 'La fotografia dei luoghi come fotografia', in Achille Sacconi and Roberta Valtorta, *1987–1997: Archivio dello spazio: Dieci anni di fotografia italiana sul territorio della provincia di Milano* (Udine, 1997)

——, *Pagine di fotografia italiana, 1900–1998* (Milan, 1998)

——, *Milano senza confini*, exh. cat., Museo di Fotografia Contemporanea, Cinisello Balsamo (Milan, 2000)

——, ed., *Idea di Metropoli*, exh. cat., Museo di Fotografia Contemporanea, Cinisello Balsamo (Milan, 2003)

——, ed., 'Racconti dal paesaggio. 1984–2004 A vent'anni da Viaggio in Italia', *Quaderno di Villa Ghirlanda*, 3 (Milan, 2004)

——, *Volti della fotografia: Scritti sulla trasformazione di un'arte contemporanea* (Milan, 2005)

Viganò, Enrica, *Neorealismo: La nuova imagine in Italia 1932–1960* (Milan, 2006)

Vitali, Lamberto, 'La fotografia italiana dell'Ottocento', in Peter Pollack, *Storia della fotografia dalle origini a oggi* (Milan, 1961), pp. 258–80

——, *Un fotografo fin de siecle: Il conte Primoli* (Turin, 1968)

——, *Il Risorgimento nella fotografia* (Turin, 1979)

Weinberg, Adam D., *The Photographs of Giorgio Sommer* (Rochester, NY, 1981)

Zannier, Italo, 'La fotografia in Italia negli Anni Venti', in Renato Barilli and Franco Solmi, eds, *La Metafisica: gli anni Venti*, exh. cat., Galleria d'Arte Moderna, Bologna (Bologna, 1980), pp. 655–62

——, *Storia della fotografia italiana* (Bari, 1986)

——, ed., *Segni di luce: Alle origini della fotografia in Italia* (Ravenna, 1991)

——, ed., *Segni di luce: La fotografia italiana dall'età del collodio al pittorialismo* (Ravenna, 1992)

——, ed., *Segni di luce: La fotografia italiana contemporanea* (Ravenna, 1993)

——, *Leggere la fotografia: Le riviste specializzate in Italia (1863–1990)* (Rome, 1993)

——, ed., *The Self and its Double: A Century of Photographic Portraiture in Italy*, exh. cat., Venice Biennale, Padiglione Italia (Florence, 1995)

——, ed., *Luigi Crocenzi: Cultura della fotografia* (Spilimbergo, 1996)

——, *Piergiorgio Branzi* (Turin, 1997)

——, *Sperimentalismo fotografico in Italia, 1970–2000* (Lestans, 2001)

——, ed., *Riccardo Moncalvo: Figure senza volto*, exh. cat., Galleria civica d'arte moderna e contemporanea, Turin (Turin, 2001)

——, ed., *Fotografia a Venezia nel dopoguerra da Ferruccio Leiss al Circolo 'La Gondola'* (Florence, 2005)

——, ed., *Wilhelm von Gloeden: Fotografie: Nudi, paesaggi, scene di genere*, exh. cat., Palazzo della Ragione, Milan (Florence, 2008)

Acknowledgements

The challenge of this book has been that of keeping two centuries of history and pictures within an established format. My thanks for enabling this process go to Vivian Constantinopoulos, who commissioned this book and followed each phase with great dedication, and to Mark Haworth-Booth and Peter Hamilton, who gave me thoughtful suggestions.

Due to the bi-cultural nature of this project, the help and dialogue with colleagues in Italy has been indispensable. I am grateful, for their time and generosity, to Cesare Colombo, Marina Miraglia, Maria Francesca Bonetti, Silvia Paoli, Luigi Tomassini, Alberto Prandi, Roberta Valtorta – their informative messages and pictures sent via the web have enriched my understanding of this history. A particular thank you goes to Bruce W. and Dee Lundberg, Hans P. Kraus Jr, Keith De Lellis, Marco Antonetto and Guido Bertero, who graciously opened up their outstanding collections of photographs of Italy, and shared important information with me.

As I inquired into small and large holdings, I was able to discuss particular subjects with historians, photographers and dealers, who were of great help for particular queries and issues: Roger Taylor, Ken Jacobson, Mary Panzer, Geoffrey Batchen, Marta Braun, Maria Pia Critelli, Pierangelo Cavanna, Giovanna Calvenzi, Silvia Berselli, Antonio Giusa, Antonello Ricci, Paola Ghirri, Martina Caruso, Fulvio and Napoleone Ferrari. All the photographers I included in the later chapters were prompt in sending me statements and ideas that helped me interpret their work.

My archival research was enabled by Arianna Bianchi and Diletta Zannelli (Museum of Contemporary Photography at Villa Ghirlanda); Monica Maffioli, Angela Barbetti and Adriana Possenti at the Museo Alinari, Florence; Deborah Virgili at the ICCD, Rome; the staff of the Biblioteca Reale in Turin; Laura Gasparini at the Biblioteca Panizzi of Reggio Emilia; Claudio Pastrone at the FIAF, Turin; Manfredo Manfroi at La Gondola, Venice; Angelica Sella at the Fondazione Sella, Biella; Paolo Barbaro and Claudia Cavatorta at CSAC, University of Parma; Louise Desy and Anne-Marie Seguin at the Canadian Center for Architecture, Montreal; Mia Fineman and Emily Darragh at the Metropolitan Museum of Art, New York; Alison Nordstrom, Joe Struble and Jessica Johnson at the George Eastman House Rochester, New York; Ruth Kitchin at the National Media Museum in Bradford, Yorkshire, England. The holdings in the libraries of the Museum of Modern Art, Avery Architectural Library at Columbia University, and the New York Public Library were a treasure trove for my research on secondary sources, and made me feel very fortunate to be working in New York. My thanks to the staff there as well as to the library at Hunter College, City University of New York, which provided me with important interlibrary loans.

This book received the support of two PSC-CUNY awards – an essential help for travel and coverage of copyright costs. I am grateful to Thomas Weaver and Emily Braun, and to the librarians and faculty in the Department of Art at Hunter College for allowing me the time to research and write this book.

Finally, a huge personal thank you to my husband, Robert Astle, for his constant support, constructive criticism and intelligent notes, and to the little Leonardo, for being so patient with his mamma.

Photo Acknowledgements

The author and publishers wish to express their thanks to the below sources of illustrative material and/or permission to reproduce it:

Courtesy of Accademia di Belle Arti di Brera, Milan, Fototeca storica, in temporary storage at Istituto Nazionale per la Grafica, Rome: p. 29; Alinari Archives, Florence: pp. 37, 72; Courtesy of Marco Antonetto, Lugano: pp. 35, 43 top right, 76, 120; Archivio Crocenzi, CRAF, Centro di ricerca e archiviazione della fotografia, Spilimbergo: p. 107; © Archivio Giuseppe Pagano: p. 100; Archivio Primoli, Rome: p. 66; © Marina Ballo Charmet: p. 162; © Olivo Barbieri and courtesy of Yancey Richardson Gallery, New York: pp. 152, 153; © Gabriele Basilico: p. 151; © Gianni Berengo Gardin: pp. 125, 126; Courtesy of Estate Italo Bertoglio, Turin: p. 95; Courtesy of Biblioteca Comunale di Mineo: p. 68; Biblioteca Reale, Turin, with the permission of Ministero per i Beni e le Attività Culturali: pp. 39, 49; Biblioteca di Scienze e Antropologia, University of Florence: p. 75 top left and top right; Courtesy of Biblioteca di storia moderna e contemporanea, Rome, with permission of Ministero per i Beni e le Attività Culturali: p. 32; © Piergiorgio Branzi: p. 124; © Alfredo Camisa and courtesy of Collection Bertero, Turin: p. 112; © Luca Campigotto: p. 158; © Mario Carrieri: p. 132; © Vincenzo Castella: p. 159; © Giuseppe Cavalli by SIAE, 2010: p. 118; Collection Centre Canadien d'Architecture/Canadian Centre for Architecture, Montréal: pp. 24, 46, 47, 51, 59; © Carla Cerati and courtesy of Collection Bertero, Turin: p. 133; Courtesy of Massimo & Sonia Cirulli Archive: p. 89; Courtesy of Civica Raccolta delle Stampe 'Achille Bertarelli', Milan: pp. 17, 34 ; Civico Archivio Fotografico, Milan: pp. 62, 69; © Cesare Colombo: p. 131; © Mario Cresci: pp. 142, 143; © Mario De Biasi and courtesy of Collection Bertero, Turin: p. 104; © Paola De Pietri and courtesy of Museo di Fotografia Contemporanea, Cinisello Balsamo, Milan: p. 161; © Paola Di Bello: p. 163; © Eredi of Luigi Ghirri: pp. 144, 145; © Eredi Patellani and courtesy of Collection Bertero, Turin: p. 101; © Eredi Patellani and courtesy of Museo di Fotografia Contemporanea, Cinisello Balsamo, Milan: pp. 103, 104; © Eredi Ugo Mulas. All rights reserved: pp. 135, 136; Courtesy of Barnaba Ferruzzi Balbi, Venice: p. 12; © Fondazione BEIC and courtesy of Collection Bertero, Turin: p. 130; Courtesy of Fondazione Sella, Biella: p. 77; Fondazione Torino Musei, Archivio Fotografico, Fondo Bricarelli: p. 94; Fondazione Torino Musei, Archivio Fotografico, Fondo Gabinio: p. 96; © Franco Fontana and courtesy of Collection Bertero, Turin: p. 146; © Vittore Fossati: p. 147; Courtesy of Fototeca Storica Gilardi, Milan: pp. 44, 115; General Research Division, The New York Public Library, Astor, Lenox and Tilden Foundations: pp. 87, 92; Courtesy of George Eastman House, International Museum of Photography and Film: pp. 56, 57; © Simone Giacomelli and courtesy of George Eastman House, International Museum of Photography and Film: p. 129; © Simone Giacomelli and courtesy of Collection Paolo Vicentini, Milan: p. 6; © Paolo Gioli and courtesy of Collection Paolo Vampa, Rome: p. 140; © Daniela Grignani and Mario Bellavista: p. 97; © William Guerrieri: p. 155; © Guido Guidi: p. 149; © Guido Guidi and courtesy of Museo di Fotografia Contemporanea, Cinisello Balsamo, Milan: p. 156; ICCD, Rome, MAFOS, Fondo Mario Nunes Vais: p. 70; Courtesy of K & J Jacobson, UK: pp. 15, 16; © Francesco Jodice: p. 164; © Mimmo Jodice: p. 148; Hans P. Kraus, Jr, Fine Photographs, New York: p. 25; Collection W. Bruce and Delaney H. Lundberg: pp. 13, 14, 20, 23, 26, 27, 36, 41, 42, 43 bottom left, 52, 53, 54, 61, 65, 85; Courtesy of Collection Mallandrino, Messina: p. 80, 81; © Tancredi Mangano: p. 165; The Metropolitan Museum of Art/Art Resource, New York: pp. 83, 86; © Nino Migliori: p. 113; Courtesy of Museo Casa Mollino, Turin: p. 99; Courtesy of National Media Museum / Science and Society Picture Library, UK: pp. 19, 21; © Walter Niedermayr and courtesy of Robert Miller Gallery + Galleria Suzy Shammah, Milan: p. 154; © Franco Pinna and courtesy of Collection Bertero, Turin: pp. 114, 116; Private Collection: p. 90; Private Collection, Turin: p. 78; © Francesco Radino and courtesy of Museo di Fotografia Contemporanea, Cinisello Balsamo, Milan: p. 157; Collection Dario Reteuna, Turin: pp. 79, 108; © Moira Ricci: p. 166; © Fulvio Roiter and courtesy of Collection Bertero, Turin: p. 123; © Chiara Samugheo and courtesy of Collection Bertero, Turin: p. 110; © David Secchiaroli and courtesy of Marco Antonetto, Lugano: p. 117; © Enzo Sellerio: p. 111; © Renate Sienbenhaar, Frankfurt/Main, courtesy of Collection Bertero, Turin: p. 121; © Oliviero Toscani, Benetton Group S.p.A.: p. 138; © Franco Vaccari: p. 141; Courtesy of Giuseppe Vanzella, Treviso: p. 11; © Paolo Ventura and courtesy of Hasted Hunt Kraeutler, New York: p. 167; © Massimo Vitali and courtesy of Bonni Benrubi Gallery, New York: p. 160; © Silvio Wolf: p. 168.

Index

Numbers in *italic* refer to pages on which illustrations are reproduced.